Andrew Martindale
was educated at Westminster School,
at New College, Oxford (where he read for a degree in
modern history), and at the Courtauld Institute of Art. He is
the author of *The Rise of the Artist* (1972) and *The Triumph of
Caesar by Andrea Mantegna* (1979). Currently, he is Professor
of Visual Arts at the University of
East Anglia.

WORLD OF ART

This famous series
provides the widest available
range of illustrated books on art in all its aspects.
If you would like to receive a complete list
of titles in print please write to:
THAMES AND HUDSON
30 Bloomsbury Street, London WC1B 3QP
In the United States please write to:
THAMES AND HUDSON INC.
500 Fifth Avenue, New York, New York 10110

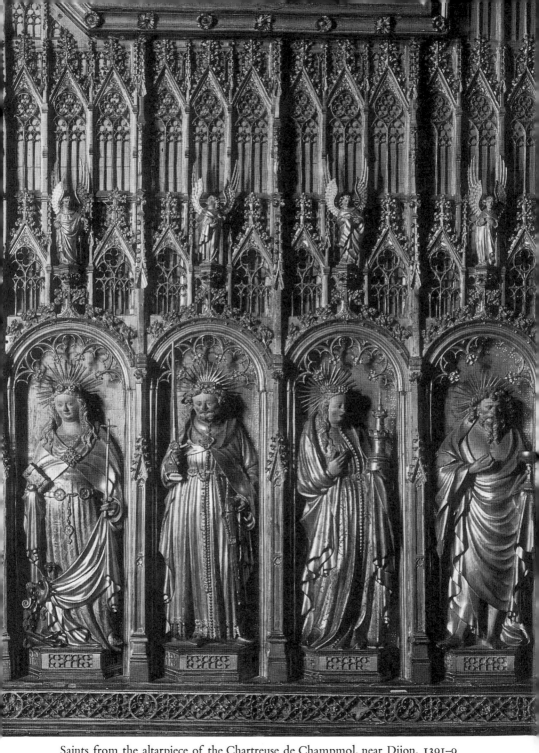

Saints from the altarpiece of the Chartreuse de Champmol, near Dijon, 1391–9

Gothic Art

Andrew Martindale

206 illustrations, 32 in colour

THAMES AND HUDSON

For Jane

ACKNOWLEDGMENTS
The author wishes to acknowledge the talks and discussions with colleagues,
past and present, which underlie many of the ideas in this book. He
owes a special debt to Mr Christopher Hohler and Dr Peter Kidson.

Printed and bound in Spain by Artes Graficas Toledo S.A.
D.L. TO–1840–85

Contents

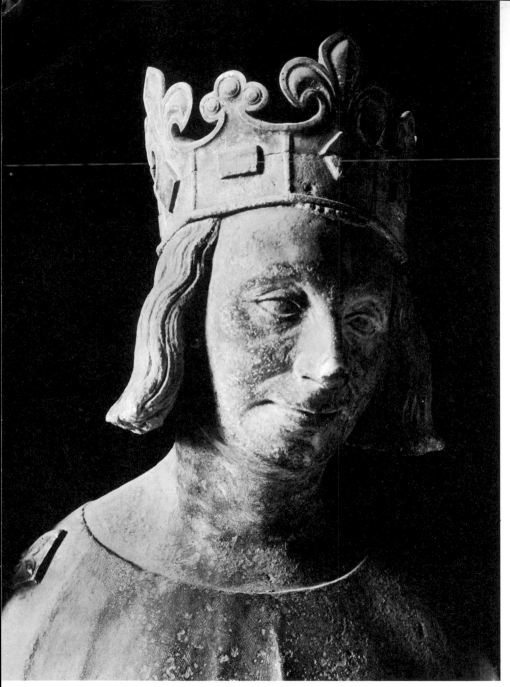

1 St Louis, from the portal of the Chapelle des Quinze-Vingt, Paris

Introduction

It is traditionally held that Gothic art makes its debut with the patronage of the Abbot Suger, of the monastery of St Denis near Paris. Suger ruled from 1122 to 1151, and during the period of his abbacy a start was made on the rebuilding of the abbey church. The decoration and architecture of this building contained features which were to make it important and influential in the development of French art; and it is with this development and with its effect outside the territory of its origin that the first part of this book is concerned. This is one of the great transition periods in the history of European art. It was a period of intense experiment, unevenly and untidily distributed. But by c. 1250, European art had been transformed, and in all media what might be called a recognizably Gothic style was in the process of emerging.

It is always wise to be cautious in the use of the word 'Gothic'. The hunt for 'Gothic characteristics' is hampered from the start by the vague and imprecise nature of the term. As is well known, it was first applied to art in the sixteenth and seventeenth centuries in a derogatory sense to denote art which possessed in general a pre-Renaissance and non-Italianate appearance. It was never a precise descriptive word, since it was coined by men who were uninterested in making it precise. It meant, in effect, 'barbarian'. At the time of the Gothic revival in the eighteenth century it ceased to be abusive, and became merely descriptive of all medieval art up to the time of the Italian Renaissance. Subsequent to this, at the beginning of the nineteenth century, a large section was split off at one end to be labelled 'Romanesque' or 'Norman'. Thus, by a rather unsatisfactory process of elimination, 'Gothic' came to describe that art which was produced between the Romanesque and Renaissance periods.

This period actually extends for at least two hundred years, and during this time, not unexpectedly, European art underwent so many changes that it is hardly possible to divine a 'Gothic style' underlying the whole process. Insight into these changes is moreover hampered by one serious lack. To trace the changes in art in any detail almost inevitably entails some comment on the apparent *purpose* of the artists. The processes of artistic creation are hard enough to divine even in cases with copious documentation. In medieval studies, the lack of documents containing useful comment on actual works of art even by interested spectators – let alone practising artists – is almost complete. Renaissance writers, rightly or wrongly, thought that they knew what art was about and what artists were trying to do, and educated people made it their business to be interested in the subject. Medieval artists appear to have escaped this type of interest, but, as a result, the art historian is deprived of a very important and illuminating source of information. There are almost no explanations by contemporaries of works of art around them.

This feature creates such a deep division between the writing of medieval and post-medieval art history that some comment is worth while. The exaltation of art and the artist is, and has been for about four centuries, a common feature of western European culture. One might perhaps think that this is an attitude immutable and unchanging, but in fact it is one which was entirely alien to the Middle Ages. There can be little doubt that people did on occasion exercise intelligent patronage in the arts. But there is no sign that a sustained interest in art and artists was anything but exceptional. The main reason for this must have been that anyone passing through any form of academic training was instilled with certain prejudices which made such an interest very difficult to sustain.

The influence of the Schools was felt particularly in two ways. In the first place, there was a prejudice against any occupation involving manual work – against the so-called mechanical arts, among which painting, sculpture and building were certainly numbered. This prejudice can be traced back to Aristotle but it was incorporated into the teaching of the Christian Church, which set contemplation above action, thinking above performing, and, after the example of Christ, Mary above Martha. Artificers were not worth serious thought; and

neither were their artefacts, or, at least, not for any inherent characteristics which they might possess.

One here passes to the second important strand of scholastic thought which inhibited perceptive thinking about art. Material things, it was taught, were of value only in as far as they revealed some aspect of the eternal world and of the nature of God. The roots of this attitude are also to be found in the ancient world, particularly in the writings of Plato and later in those of the neo-Platonists. To these writers, the highest task of man was to attempt to know the truth which resided in the eternal world. Christian thought was profoundly affected by this outlook, and Christian philosophers came to teach that the visible world was only worthy of attention to the extent that it reflected and revealed some aspect of the Divinity. This automatically created a division between matter and its revealed content. As John Scotus Erigena, the ninth-century scholar, wrote, 'We understand a piece of wood or stone only when we see God in it'. Earlier and later examples of this type of thought are not difficult to find, and it will be apparent that reflection of this kind effectively excluded all appreciation of style in art. Art derived its importance from *what* it represented and not *how* this was achieved.

It would be wholly unrealistic to suppose that, because this type of approach to art was the recommended one, all educated people adopted it to the exclusion of any other. There is every reason to suppose that more recognizably normal attitudes to art existed, if only because they were specifically ridiculed by Christian writers. St Augustine was very firm with those who professed an instinctive enjoyment of music, saying that this placed them on a level similar to birds. True appreciation consisted in knowing the intervals and consonances and understanding in them the reflection of the divine harmony of the universe. John Scotus, already mentioned, makes it clear that looking at an object with what today would be called a collector's eye was frowned on because it almost certainly invoked cupidity and avarice. This general attitude or prejudice cannot have prevented people from entertaining views about artists and exercising preferences. But it did effectively prevent them from publicizing their preferences in writing; and it effectively prevented the growth of any sort of tradition of informed comment on art.

One therefore enters a period of art history deprived of two important classes of evidence. Almost nothing is known during the Middle Ages of people's reactions to art. There are no accounts of how a monastic chapter reacted when faced by three different designs for a new abbey church. It was probably much like any modern committee, but one does not know for certain. The second lack is more serious since it concerns the individual artists and works. Almost no biographical material exists. For instance, William of Sens, one of the great names of English twelfth-century architecture, had no biographer. Nothing is known about his training from direct contemporary testimony or early life – where he was born, where he travelled, what other buildings he was responsible for apart from Canterbury Cathedral, and so on. This is true of most of the names in medieval art; and usually, of course, not even the names survive. This means that much medieval art history becomes a rather depersonalized study. The historian has perforce to deal in 'Schools', by which he means rough groups of monuments which appear to have a stylistic affinity. This is an unavoidable misfortune, to be deplored the more because it leads on the one hand to accounts of works of art as if they were 'untouched by human hand', or rather by 'human foibles'; and on the other hand, to a great deal of sentimental nonsense about the 'anonymity' of medieval artists which is best relegated to the pages of romantic fiction. It also results in misleading discussions on the 'meaning of Gothic art', about which, by the nature of the surviving literary evidence, we can never know very much.

We can, however, gather up some of the shreds of evidence that remain concerning attitudes to art. In practice, medieval patrons appear to have approached art in an ordinary businesslike way. From the mid-thirteenth century contracts begin to survive, and these sometimes specify another work to be used as a model for the undertaking involved. The exemplar is found set up as a point of reference for beauty as well as size, and this at least suggests what one would expect, namely that medieval patrons knew what they liked and were anxious to have their requirements met. Alberti, the fifteenth-century scholar and architect, wrote the following advice to architects: 'Lastly, I advise you not to be so far carried away by the desire

of glory rashly to attempt anything entirely new or unusual. . . . Remember . . . with how much grudging and unwillingness people will spend their money in making trial of your fancies.' This advice would seem to be entirely appropriate at almost any period in history, not excluding the Middle Ages, and to all forms of art.

Addiction to sight-seeing is not a modern phenomenon but has probably always existed. At its lowest level, it seldom does any service to art. But at an intelligent level it must in the Middle Ages have helped the circulation of ideas and objects. Pilgrimages and diplomatic missions provided fruitful possibilities from which people returned armed with both ideas and souvenirs. Rome was, of course, at all times much visited, and there is a series of medieval handbooks on the sights to be noted. The Abbot Suger, we know, cast envious eyes on the marble columns of the Baths of Diocletian, but in the end contented himself with imitating the Roman basilicas by including a small portion of mosaic on the west front of St Denis. The Bishop of Winchester, Henry of Blois, bought a number of antique statues while on a visit to Rome in 1151 and sent them home to Winchester. The Abbot of Westminster, returning from the Court of Rome in 1269, brought back men and materials to construct a marble pavement in the new church of Westminster after the Roman manner.

Not much is known about local arrangements for dealing with sight-seers. But it is perhaps worth noting that in the Monastic Constitutions compiled for Christchurch, Canterbury, in the third quarter of the eleventh century, special provision was made for sight-seers wishing to see the domestic quarters of the monks. The duty of showing people round was entrusted to the monk responsible for receiving guests. Presumably all monasteries of any splendour or size found similar arrangements necessary.

It was observed above that by c. 1250 a European Gothic style was beginning to emerge. Books of this nature are liable to get entangled in definitions of 'Gothic', and in order to avoid this, something should be said at the start about the position taken in this book. 'Gothic art' has here been taken in the first instance as that art which was developed in the Île-de-France and northern France between c. 1140 and 1240. It is the art of an area taken over a rather long period of development and the story to be followed concerns the process by

which other areas of France and other countries surrounding France
came by degrees to accept the idea that it was desirable to copy this
art. In this story, the reign of Louis IX (1226–70) forms a central
point. In most countries before this time, the influence of France and,
by this definition, the Gothic style of art, is confused. Questions
concerning what is or is not Gothic are difficult and occasionally
acrimonious. The first chapter of this book deals with this develop-
mental period. An attempt is made to sketch out events in the north
of France and around Paris and then to set alongside this the art of
other countries in order to see at what point these came to be affected
by Gothic ideas.

During the period covered by the second chapter, 1240–1350, the
position clarifies briefly. During the reign of Louis IX, there was a
sudden wave of enthusiasm for north-French artistic ideas both in
the peripheral areas of France itself and outside. This emerges with
particular clarity in architecture but it is true of all the arts. From
this time, Paris became an important European centre of fashion
and art.

The third chapter deals with what is perhaps the joker in this art-
historical pack – Italian art. The Italian resistance to orthodox French
Gothic art as it materialized around 1240 seems to have been con-
siderable. Italian artists were certainly impressed by particular details
of French art. But at no point did any Italian try to build a rayonnant
cathedral or to carve a French type of portal; and not until the
fourteenth century are there signs of anyone imitating the dainty
style associated with the court of Louis IX. Such resistance arouses
a certain admiration, but makes it impossible to deal with Italian
Gothic art at the same time as that of Germany or England.

The final chapter is concerned with the period c. 1350–1400
throughout Europe, and including Italy. There appears to have been
an increased exchange of ideas across the Alps during that period
which lends some justification to this grouping. Certainly the
Parisian painters showed more and more awareness of Italian art.
The one unexpected phenomenon during these years was the sudden
emergence of Prague as a centre of curious hybrid culture, when it
became for a comparatively short time the centre of the empire and
the seat of the imperial court.

The historian of art is usually held to be under some obligation to explain his subject-matter as the emanation of the age with which he is dealing. Art may be a reflection of the human spirit, but it is notoriously difficult to explain how the spirit of an age renders inevitable the type of art which is produced during that age. There is always a residue of doubt left at the end which leads one to reflect that in history nothing is inevitable until it has actually happened. To try to explain artistic form in terms of history seems to be an occupation of doubtful value. It is, of course, easy enough, and illuminating, to reverse something of this process and to use art to throw light on history. Every major work of art is an expression of some aspect of the people and society that produced it. It is not fanciful to see the power of a monastery reflected in a great monastic church. The splendour of the east end of St Denis in Paris will tell us a great deal about the Abbot Suger who built it, just as the bareness of the abbey church of Fontenay will illustrate general propositions about the austerity of St Bernard and the early Cistercians. Likewise, the sumptuous fittings of the surviving medieval basilicas in Rome form an appropriate background to claims of the thirteenth-century papacy. Art, in fact, has and had a function both then and now as a background against which major events were played out and against which they may still be imagined.

But can one deduce from the surviving evidence why a particular individual in a particular society produced a particular form of art? This would lead to a complex line of speculation which sought a connection between the history of changing forms and the flux of ideas. There are, on the other hand, certain quite obvious ways in which ideas influence the *content* of art. Emile Male began his book on thirteenth-century art by saying that 'art in the Middle Ages is a script'. Every large and complicated assembly of art represents a certain amount of book-work on the part of somebody; this applies to secular as well as religious art. A cathedral portal was almost certainly worked according to a programme laid down by a scholar – probably a canon – and its significance is generally to be apprehended through some text with which the man was familiar. To this extent, such art will express some aspect of contemporary thought, and in its content will be the product of its historical background.

Art is also to a large extent the product of economic circumstance. The raw material and the labour have to be obtained and paid for, and expensive art (most good art is expensive) appears in places where funds are available. The most obvious instances of this are to be found in architecture – by far the most expensive of the arts. Architecture on a large scale flourished mainly in areas where commerce flourished. This means that in almost any century during the Middle Ages, the greatest *concentration* of important building activity in Europe is to be found in the vicinity of a line drawn on the map from Bologna to London, allowing a slight divergence to take in the Rhine Valley. This was the central 'corridor' of European trade, and the presence of money is obvious from the amount of significant architecture.

The directness of this dependence emerges when one considers the sources tapped in order to raise money for church building. The bishop, of course, almost always contributed, if the work was a cathedral. The ruling chapter might divert funds from revenues to aid the work. But many of the means depended directly on the presence of a large quantity of people with surplus money. Indulgences were sold, and gifts were solicited in return for perpetual prayers for benefactors. Offerings were taken from pilgrims at shrines and the relics were taken on a tour of the surrounding countryside and even farther afield. Local confraternities were organized in the area to raise funds, and the perennial box or trunk was left in evidence for people to drop contributions into. All these devices depended for their yield on ready access to money. A tour of the relics through an area populated only by impoverished peasants was not going to help the church fabric even though it might help the peasants.

One change in the nature of buildings erected began to take effect during the period covered by the first chapter of this book. Much of the major building is *cathedral* architecture. With certain obvious exceptions (St Denis in Paris is one), monastic church building dwindled in importance. This does not in itself denote some sort of monastic decline, but probably means that by 1200 the greater monasteries had on the whole got churches with which they were satisfied. By contrast, many towns were not satisfied with their chief ecclesiastical buildings, and were willing to pay a great deal in order

14

to make it possible for the bishop and chapter to replace them. The years 1140–1250 were a period in which it became possible to build churches the size and height of which had not been known since the fall of the Roman Empire. The initial driving force behind these various enterprises must have gathered part of its momentum from civic pride.

One further development had important consequences for art during this period, namely the growth of the universities and the increasing demands of scholarship. This slow process which was spread across the twelfth and thirteenth centuries produced an increasing demand for texts, and this demand came to be satisfied by workshops of scribes working independently of monastic *scriptoria*. The era of commercial book-production had dawned. This type of production did not, of course, necessarily involve high-quality artistic endeavour. The point at which illumination became primarily a secular craft carried out by professionals is harder to judge. There were still eminent monastic *scriptoria* in Italy during the fifteenth century. But the change had already begun in the twelfth.

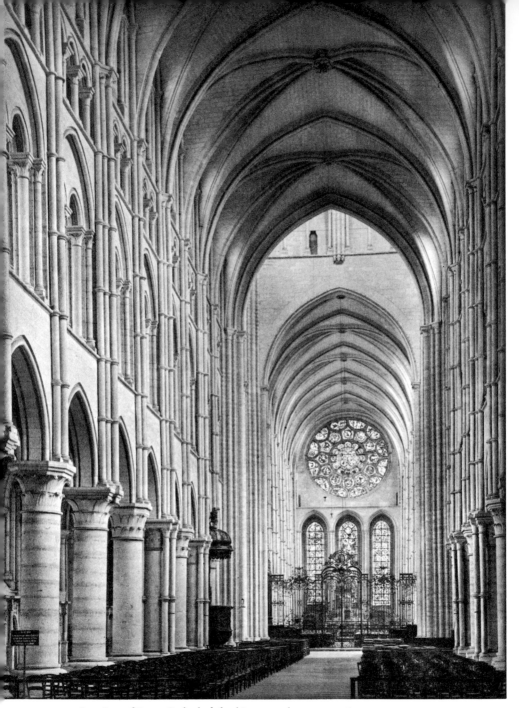

2 Interior of Laon Cathedral, looking east; begun *c.* 1165

The Age of Transition 1140-1240

ARCHITECTURE

The transitional period opens in the middle of a development. Certain architectural features such as the ribbed vault and the pointed arch were already being employed by architects. Exposed flying buttresses were still unacceptable, but the principle of the flying buttress was already known, and such buttressing was concealed beneath the roofs of tribune galleries. The history of this period is one of gradual realization of the potentialities of these features and of increasing expertise in their use.

Abbot Suger began his rebuilding of the abbey church of St Denis in *c.* 1137. For various reasons unconnected with architecture he was unable to adopt the usual course of beginning at the east end and working through to the west. Instead he began by adding to the Carolingian building a massive western block intended to be surmounted by two towers. Next, in 1140, he began to add to the east of the old church a new choir intended to replace the Carolingian apse. This addition has not come down to us complete, since the inner parts of the apse from the arcade to the vault were subsequently remodelled. The ambulatory and chapels, however, still survive (*Ill. 4*). The general plan was traditional but the difference in St Denis is that the architect dispensed with divisions between the chapels, and there is, in effect, some ambiguity whether these form a row of chapels or a second ambulatory. Whatever the liturgical implications of this, the visual effect is a very striking one of a spacious pillared hall with an undulating boundary of stained glass (*Ill. 3*). The minimization of the divisions between the chapels, had, as it were, a streamlining effect on the external boundary. Other architects were not slow to copy and to extend this, even to the point of eliminating completely the excrescences of the chapels (this, for

instance, was a feature of the original plans of Notre Dame in Paris and Laon Cathedral, of Notre Dame in Mantes and the destroyed cathedral of Arras).

The architect of St Denis was more than an artistic genius; he required considerable technical skill in order to realize his ideas successfully. The unification of the east end, brought about by the partial elimination of the chapel divisions, would have failed entirely if the vaulting had been irregular or amateurish. He had set himself a ground plan which included a large number of arch spans of varying widths. All these arches had to be raised to approximately the same height, with the apex at a preconceived point. His achievement is very considerable, for the key-stones *are* all roughly equivalent in height, and they are aligned with each other and with the main radial axes of the apse.

This type of expertise must have seemed a *tour de force* in its time, and have set new standards of technical excellence. But with certain exceptions already mentioned, the plan which made them necessary had a limited popularity. There are no direct copies of St Denis, although an interesting derivation exists at Pontoise (St Maclou). In general, it is probable that the absence of a substantial division between one chapel and the next ultimately proved inconvenient. However, the idea of streamlining the exterior wall of the apse, inside and out, was effectively extended elsewhere to the rest of the church.

The interior elevation of Abbot Suger's apse is lost, and it is uncertain to which of the surviving great churches it might have been compared. Among these there is considerable variety of treatment. Twelfth-century art still developed along regional lines, and not until the thirteenth century does anything emerge approaching a standard idea of what a great church should look like. In northern and north-eastern France a common feature, derived directly from Romanesque precedent, was the division of the elevation into a series of arcaded storeys. One feature, the great tribune gallery, was particularly characteristic of this architectural convention. For the architect the tall tribune gallery served not only to heighten the church, but also to enclose the lateral buttressing needed to support this height.

18

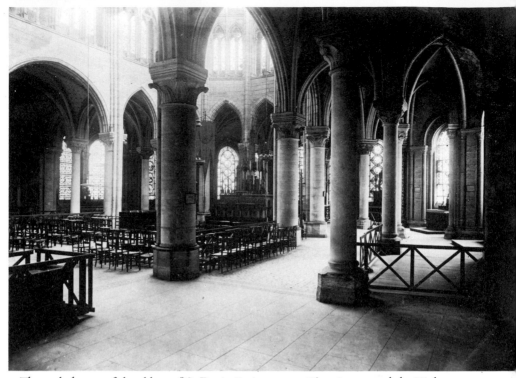

3 The ambulatory of the abbey of St Denis, Paris, 1140–4. The piers around the High Altar were rebuilt after Suger's time

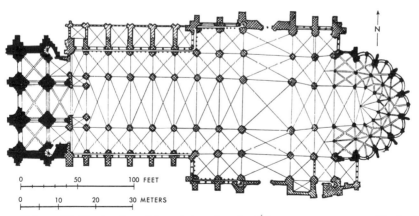

0 50 100 FEET

0 10 20 30 METERS

4 Abbey of St Denis, plan of the existing church. Abbot Suger was responsible for those parts shaded black

To the three storeys (arcaded, tribune, clerestory), a fourth was sometimes added. This, placed between the tribune and clerestory, is called a *triforium*. The twelfth-century fashion for four-storey churches was confined mainly to northern and north-eastern France and the western parts of the Empire. A Romanesque example exists in Tournai Cathedral (nave *c.* 1140–60), and two notable cathedrals at Arras and Valenciennes are known to have possessed four-storeyed elevations, although both churches have been destroyed. Important existing examples include Noyon and Laon and the south transept of Soissons Cathedral.

Laon Cathedral (*Ills. 2, 6*) may be taken to demonstrate the main features of this particular transitional style. The original building was constructed from *c.* 1165 to *c.* 1205. (This excludes the eastern arm of the church which dates for most of its length from the years after 1205.) The four storeys are clearly in evidence although it is equally clear that the architect was concerned to break up the 'horizontality' of the building by using groups of colonnettes of alternating numbers. These colonnettes are one of Laon's most characteristic features, and are also to be found in many other places. The arch mouldings of Laon are very similar to those of St Denis but in the course of building a new type of capital came into fashion. This is a type of simplified Corinthian capital, called a 'crocket' capital. Once again it achieved widespread popularity. To vault his church, the architect used a system of ribs known from its six divisions as *sexpartite*. By vaulting two bays under a single pair of diagonal ribs, this arrangement has the optical effect of binding the church more effectively together. Again, it is already to be found in Romanesque churches (for instance, added at St Etienne in Caen, *c.* 1100–25).

Laon is important also for its exterior (*Ill. 5*). It is clear that the architect sought to make his effect through the judicious placing of seven towers – one over the crossing and six on the main exterior angles (only five in all were built). The many-towered exterior is an architectural fashion associated particularly with the Empire. The placing of towers on transept extremities has a precedent at Tournai and is part of a general fashion for giving external emphasis to the main apse and transepts. Abbot Suger apparently planned transept towers at St Denis, and the two destroyed cathedrals of

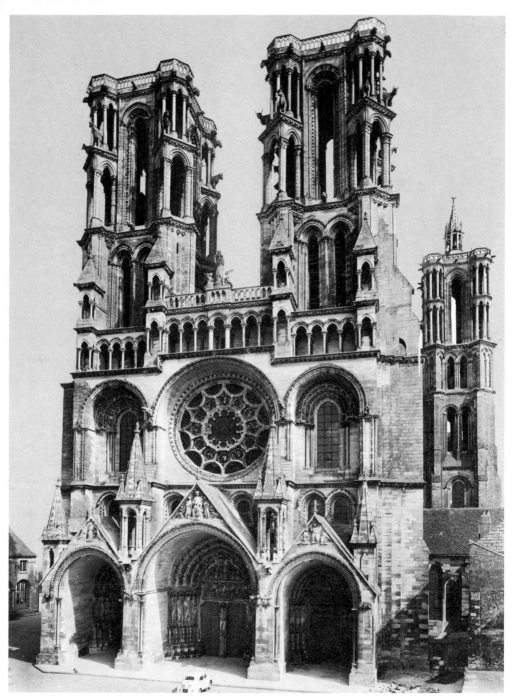

5 West front of Laon Cathedral, probably 1190–1200

Arras and Cambrai had them. This emphasis was also made by adding to the transepts a north or south apse in imitation of the eastern 'chevet'. Laon does not possess transept apses, but Noyon (*Ill. 7*), Tournai and Soissons all possess them, as did the destroyed church at Cambrai. Romanesque examples include St Lucien in Beauvais (destroyed) and St Maria in Kapitol in Cologne. In plan the result produces a trefoiled effect.

Important as this group of churches is, other concepts of what a great church ought to look like also existed. The cathedral of Sens (begun *c.* 1140) has a three-storeyed elevation in which the arcade is considerably taller than the tribune, although in its repertoire of mouldings and capitals and its use of a sexpartite vault it is similar to contemporary buildings already mentioned. Sens merely belongs to a different tradition of great church building and may be compared in many respects to the nave of Le Mans Cathedral (finished 1158). To yet another tradition belongs the cathedral of Poitiers (begun 1162; *Ill. 10*) which is a hall-church – that is, the aisles are approximately the same height as the central nave, which consequently has no tribune or clerestory. Romanesque examples of this type of church are also numerous.

In many details Notre Dame in Paris (begun 1163) is like Laon, but from the outside its effect was totally different. At Laon, the architect emphasized the transepts by making them project and giving them towers. At Paris, the transepts did not project at all originally (*Ill. 8*), and there were (and are still) no towers apart from those at the west end. Other architects went farther than this and eliminated transepts altogether, although usually they have been inserted at a later date (as at Sens, Senlis, begun 1153, and Mantes).

One other group of French churches should be mentioned, namely, those built by the Cistercian order. Its architectural outlook was originally dominated by the ideas of St Bernard (d. 1153) who had very definite views on the desirability of simplicity. A Cistercian church such as Fontenay (1139–47; *Ill. 9*), built within the saint's lifetime, reflects these views clearly. Other churches, built or completed after the saint's death (for instance, the third church of Clairvaux itself, begun 1153, and the apse of Pontigny, begun *c.* 1185), reflect opposing pressures from within the Order to build churches

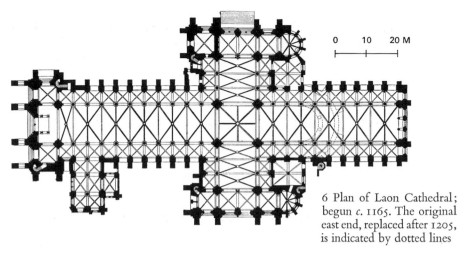

6 Plan of Laon Cathedral;
begun *c.* 1165. The original
east end, replaced after 1205,
is indicated by dotted lines

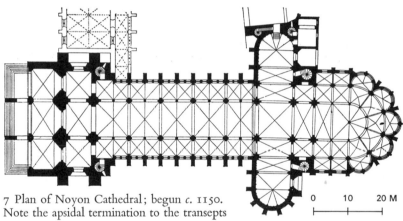

7 Plan of Noyon Cathedral; begun *c.* 1150.
Note the apsidal termination to the transepts

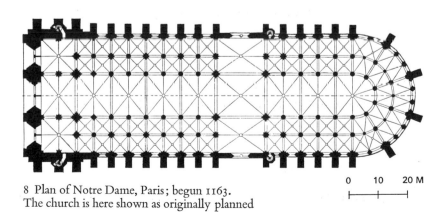

8 Plan of Notre Dame, Paris; begun 1163.
The church is here shown as originally planned

which adequately matched the power and prestige of the Cistercians. The potential interest of the Cistercians in the development of Gothic architecture lay in the degree of centralized control exercised from Cîteaux. This control might be expected to extend to church architecture and within France this is partially true. Both beyond the borders of France, and within France itself, however, the results vary considerably; after some initial similarity, local preferences and traditions tended to reassert themselves.

Soon after the middle of the twelfth century, a change of attitude took place towards buttressing which had decisive effects on architecture. It became acceptable to expose externally buttressing which had formerly been concealed beneath tribune and triforium roofs.

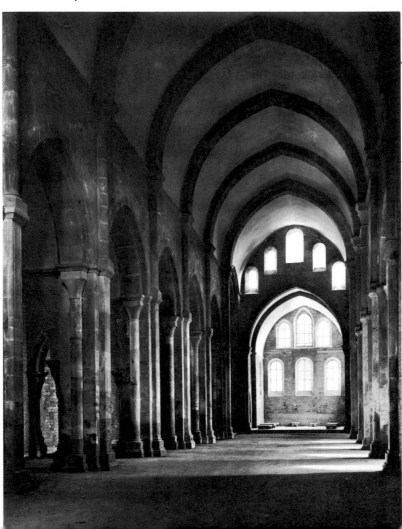

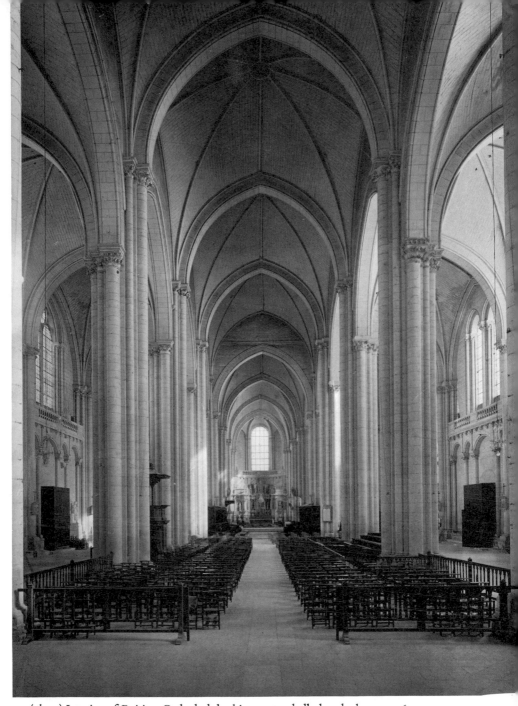

10 (*above*) Interior of Poitiers Cathedral, looking east; a hall-church; begun 1162

9 (*opposite*) Interior of the Cistercian Abbey of Fontenay, looking east; begun 1139

These 'flying' buttresses which rise up outside above the surrounding roofs were probably already used at Notre Dame in Paris and thereafter became an accepted feature of large French churches. Up to this point, the height of any church had been regulated mainly by the number and size of the horizontal storeys of which it was composed, and which in themselves contained the buttressing for the high vault. Once the problem of buttressing was divorced from that of the interior elevation, it became possible to rethink the internal appearance.

The most important change which became possible was the enlargement of the clerestory, since these windows could now be extended down into the zone formerly occupied by the tribune and triforium galleries. In fact, almost at once the tribune gallery vanished from major French architecture and the space occupied by it was distributed between the main arcade and the clerestory, separated now by a narrow triforium gallery. In the development of this scheme the cathedral of Chartres (rebuilding begun 1194) played an important part.

The architect of Chartres was in some respects a traditionalist, for this cathedral, had it been completed, would have been a many-towered building similar to Laon. The interior (*Ill. 11*) is remarkable, however, for the size of the clerestory and for the narrow band of the triforium sandwiched between the clerestory and arcade. This pattern of building was imitated at Rheims (*Ill. 12*; begun 1210) and Amiens (begun 1218) and, with important modifications and developments, spread thence to other parts of Europe (see Chapter Two).

In the course of this development, however, one very important innovation must be noted. This is the evolution of bar tracery in windows, which occurred at Rheims. The effect of this can be seen by comparing the windows of Rheims with those of Chartres. At Chartres, the masonry dividing the glass is still so thick that it may be thought of as part of the adjoining wall. But at Rheims, the divisions have been greatly diminished in thickness and from now on came to be formed of narrow shafts or bars of stone assembled to form patterns of ever increasing complexity.

In all this, one major cathedral stands apart – Bourges. Begun shortly before 1200, this building presents an architectural contrast both to Chartres and to other French building deriving from the

26

11 Interior of Chartres Cathedral, the north transept looking north-east; first quarter of the thirteenth century

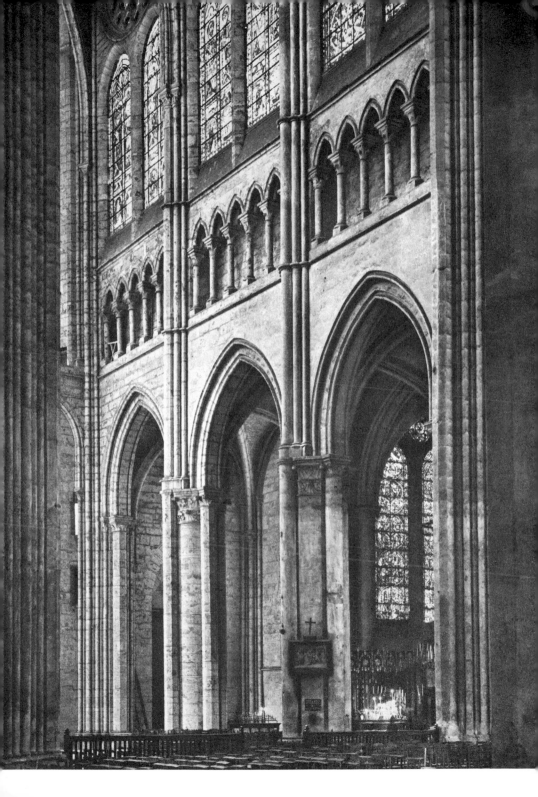

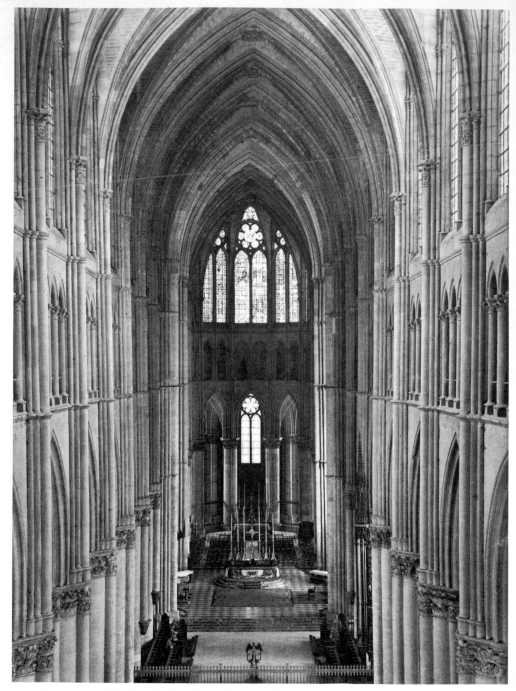

12 Interior of Rheims Cathedral, looking east; begun 1210

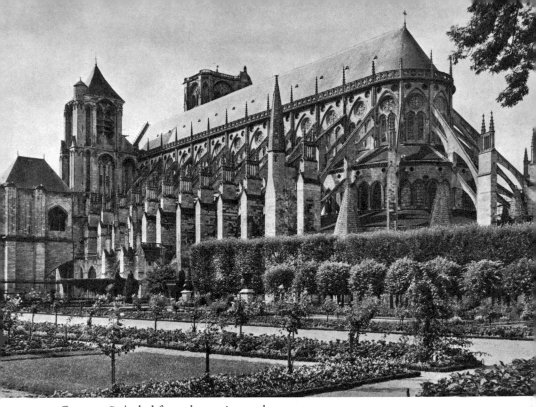

13 Bourges Cathedral from the south-east; begun *c.* 1195

Chartres pattern. It is, to begin with, on a huge scale and its five aisles had only one previous Gothic rival in Notre Dame in Paris. Bourges belongs in plan to the streamlined Parisian tradition. The eastern chapels hardly project and there are no transepts (compare Mantes or Senlis). The interior elevation, however, belongs to a quite different tradition, that of the giant arcade (*Ill. 14*). Romanesque churches in which the chief impression is made by an arcade of gigantic proportions are not uncommon (one major surviving example in France is at Tournus, early eleventh century) and it was this tradition which the architect of Bourges now brought up to date. He too dispensed with the tribune gallery; but the whole of the vertical space formerly occupied by the tribune gallery was devoted to the arcade. The clerestory is left as a comparatively small element lodged up within the curve of the vault. The result is breath-taking;

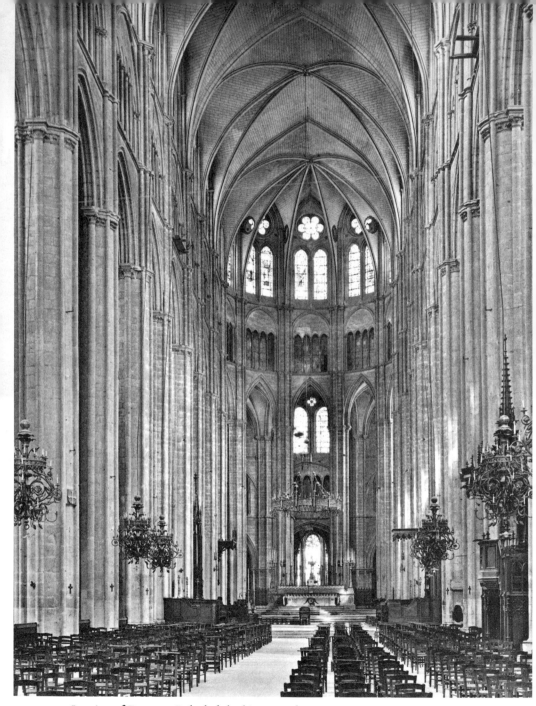

14 Interior of Bourges Cathedral, looking east; begun *c.* 1195

but it had curiously few French imitators (two only, in the choirs of Le Mans, begun 1217; and Coutances c. 1250–75). One obvious reason may have been its expense. The effect of Bourges depends partly on the immense width of its five aisles which balance its height. This automatically committed any imitators to an unusually large church. Yet, the number of major medieval churches which were never completed in the Middle Ages would suggest that the problem of ultimate cost was not an immediate concern of an ambitious patron. There must have been other pressures at work which made Chartres the model for patrons and architects. Bourges remained an isolated phenomenon; a superb aesthetic conception and a most impressive application of the lately devised flying buttress (Ill. 13).

The regional character of French twelfth-century architecture is not peculiar to France. Local preferences and prejudices existed throughout Europe and frequently led to the survival up to the last decades of the century of a style which was basically Romanesque. If the first phase of French Gothic architecture extends from c. 1140 to 1230, in almost every other part of Europe it occupies the period c. 1170–1250. In England, the most important building of the transition in the south was undoubtedly the choir of Canterbury Cathedral (begun 1175; Ill. 16). For some reason, the four-storeyed elevation never became popular in England; on the other hand, the tribune gallery and the clerestory passage of Anglo-Norman tradition survived well into the thirteenth century. They appear at Canterbury in a church which was designed by a French architect, William of Sens, and which in many respects is extremely up to date by French standards. The use of coloured marble and the coupled columns of the arcade had already appeared in France; and the grouped colonnettes are familiar from Laon.

In other parts of England, however, a rather different, more ornate type of Gothic architecture developed. The nave of the cathedral of Wells (Ill. 15) has a thickness and solidity not far removed from Anglo-Norman work, but the solidity was relieved by a multiplication of Gothic mouldings and shafts and by heavy foliage carving on the capitals. Something similar is also to be found in the north of England, where a series of great churches and additions to churches rely for their effect on similar means (there is a good

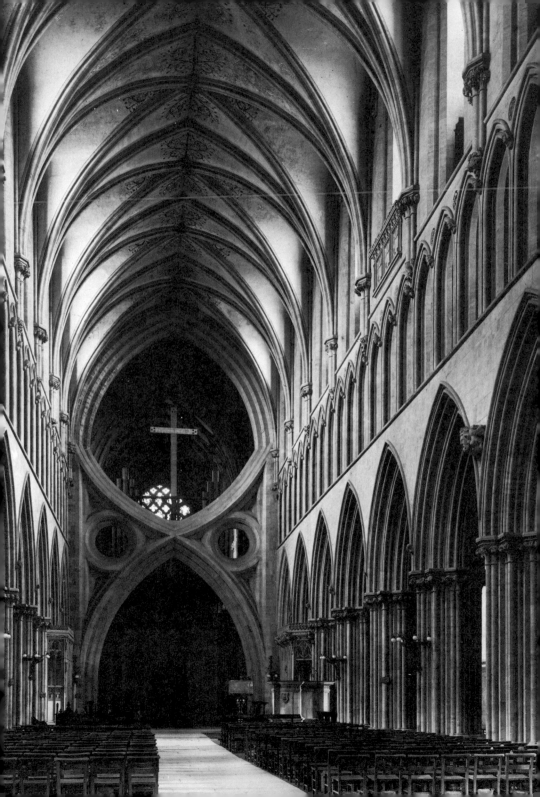

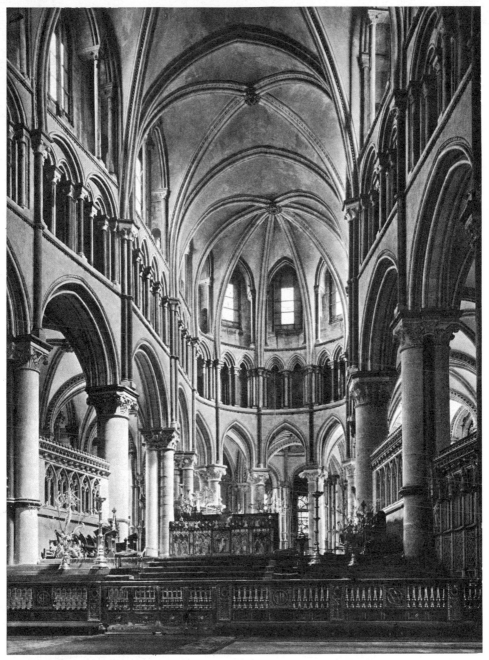

16 (*above*) Canterbury Cathedral, the Trinity Chapel from the west, 1179–84

15 (*left*) Interior of Wells Cathedral, the nave looking east. Rebuilding begun *c.* 1180, nave probably *c.* 1200–20. The 'strainer arch' at the crossing was added *c.* 1338

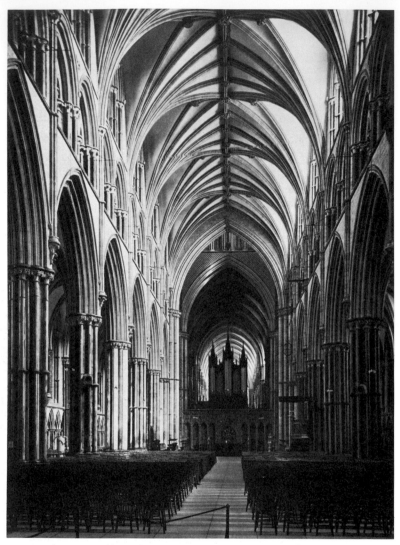

17 Lincoln Cathedral, the nave looking east; begun *c.* 1225

example in the choir and transepts of the abbey church of Hexham, *c.* 1200–25). The evident pleasure in surface ornament became a feature of English Gothic architecture and reached a first measured climax in the rebuilding of Lincoln Cathedral (begun 1192). Here, besides the attached colonnettes, the multiplicity of moulding and the foliage carving, there were added extra ribs in the nave vault

(begun 1225; *Ill. 17*), giving to that level of the church a surface pattern richer than was yet to be seen anywhere else in Europe.

These effects were not apparently to everyone's taste, for the designer of Salisbury (begun 1220) ignored many of the more decorative aspects of Lincoln (*Ill. 18*). For instance, the piers are surrounded by four colonnettes only, the vault-ribs are not multiplied, and the supports of the vault are not extended down to the arcade. In this restraint, however, Salisbury is unusual, and apart from some detailed influence on the design of Westminster Abbey, the design was not popular.

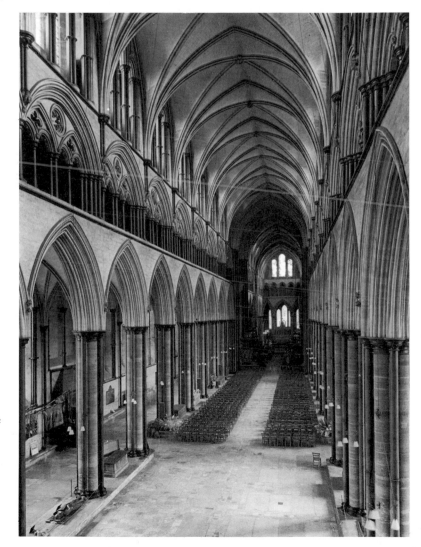

18 Salisbury Cathedral, the nave looking east; begun 1220

19 (*left*) Cathedral of Limbourg-an-der-Lahn. The nave looking east; begun *c.* 1220

20 (*right*) Liebfrauenkirche, Trier. Choir from south transept; begun *c.* 1235

21 (*far right*) Elizabethkirche, Marburg. Nave looking west; begun 1235

The transitional architecture of the Continent outside the area already discussed has far less coherence than that of England. Churches of a Romanesque massiveness continued to be built well into the thirteenth century – buildings which followed prototypes of considerable variety. For instance the cathedral of Limbourg-an-der-Lahn (begun *c.* 1220; *Ill. 19*) is interesting in that it perpetuates the type of four-storeyed building at a time when it was already out of date in France. The cathedral of Munster (begun 1221) appears to derive from a western French prototype of *c.* 1160 such as Angers Cathedral. Not until the 1230s does one find churches in which the execution of the detail could by French standards be called Gothic. Two churches exist, both begun during the 1230s and both 'Gothic' in execution, but both for different reasons distinctively un-French. The first, begun *c.* 1235, is the Liebfrauenkirche at Trier (*Ill. 20*). The nave is the same length as the transepts so that, apart from the projecting apse of the high altar, the church may be said to be centrally planned; this makes it unique among churches built in a

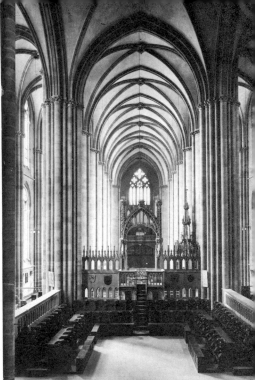

developed Gothic style. Apart from this, much of the detail such as the shape of the crossing piers or the arch mouldings is recognizably French; and the window tracery is reasonably up to date.

The church of St Elizabeth at Marburg (begun 1235; *Ill. 21*) has the peculiarity of being a hall-church. It has an eastern termination of the trefoiled plan already found earlier (see above, p. 22). In Germany this is not very surprising, since these plans were still being used in the early years of the thirteenth century (for instance, at the church of the Holy Apostles, Cologne, begun 1192). The detailed working and window tracery are all more or less abreast of developments in France, but the hall-church elevation, unused in large French churches since the designing of Poitiers Cathedral (see above, p. 22) is unexpected. It had already reappeared in Paderborn Cathedral and was to be extremely popular in Germany for the rest of the Gothic period. But as far as French architectural standards went, German architects really stepped into line only with the foundation of the new cathedral of Cologne in 1248.

37

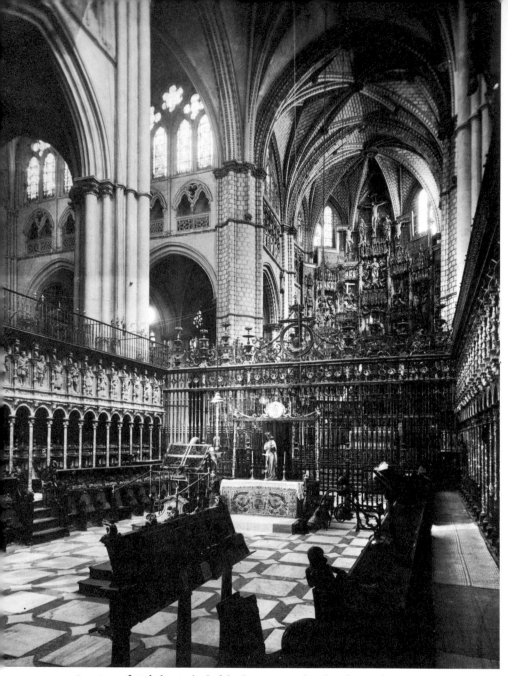

22 Interior of Toledo Cathedral looking east. The church was begun in 1226 but the building of the transept and nave belongs to the later thirteenth and fourteenth centuries

In Spain, the spread of the new Gothic architectural ideas from France was as slow as in England or in Germany. The Cistercians were responsible for the introduction of a number of Gothic features, in the shaping of arches and vault-ribs and the use of the pointed arch itself. However, as in Germany, many buildings of the early thirteenth century still possess a heavy Romanesque appearance; it is difficult to remember that a church such as Lerida Cathedral (founded 1203) is contemporary with Chartres.

One twelfth-century building, the cathedral of Avila, incorporates in the plan and architecture of the east end (begun before 1181) various elements which seem to derive from St Denis. The cathedral of Cuenca (begun c. 1200)·has a visibly Gothic character, for its main parts are enlivened by a mass of shafts and mouldings, the high vaults are sexpartite, and many capitals have crocket decoration. The little church of the Hospederia at Roncevalles (begun c. 1209 and conse-crated in 1219) has a cathedral-like triforium gallery. This is sur-mounted by large round windows which have a serrated border constructed rather after the fashion of the plate tracery used up to that time in large French buildings. The church was roofed with a sexpartite vault, by that date a slight anachronism; and the main pillars have crocket capitals.

However, the first churches in Spain to imitate the scale of French Gothic cathedrals were the cathedrals of Burgos (begun 1222) and Toledo (begun 1226). It is interesting that in neither case did the respective architects look to Chartres and its derivatives, but to Bourges and its French derivative, the east end of Le Mans Cathedral (begun 1216). Toledo (*Ill. 22*) comes closer to these models, partly on account of its plan, for it has double aisles and non-projecting transepts. Toledo also has a giant arcade with the inner aisle rising to a height greater than the outer. Burgos has only a single aisle and no giant arcade. But the original design of the triforium, where it survives, is unmistakably linked to that of Bourges; and certain pier forms also seem to be derived from Bourges.

Perhaps only once, in the cathedral of Leon (begun c. 1255), did a Spanish architect join the mainstream of French architecture (see below, p. 106). In fact, the Spaniards clung to the Bourges-Le Mans cathedral type long after it had been abandoned by the French.

Barcelona (late thirteenth century), Palma de Majorca (fourteenth), Seville (fifteenth), Segovia and Salamanca (both sixteenth), all testify to the popularity of gigantic arcades. This type of church seems to have remained the Spanish ideal of what a great church ought to look like.

SCULPTURE

Abbot Suger's second mason, as we have already seen, built an eastern termination for the church of St Denis which, in its plan, its construction and the detailed treatment of the architecture, merits the word 'Gothic'. Suger's first mason, who in 1137–40 planned the western block with its two towers, was not very remarkable as an architectural engineer, but as a decorator, his contribution to the history of Gothic art was of fundamental importance. The west front (*Ill. 23*) which he designed became the point of departure for an illustrious line of Gothic church façades in France and elsewhere.

The features found combined in this façade were almost all drawn from Romanesque sources of one kind or another. The main elements, which became the stock-in-trade of façade designers, were the twin towers, the triple portals, the arcading and the round window. In the portals themselves, the architect combined tympana, voussoirs carved with figures and, at the sides of the portals, standing figures attached to columns. Unfortunately, the standing figures were destroyed in the eighteenth century and the rest of the sculpture was heavily restored in the nineteenth. It is therefore hard to assess the quality of the original work, which seems to have been done by sculptors from the south or west of France. The fate of these men is mysterious, for their style was very soon superseded by something far more distinctive which appears to have derived from Burgundy. The relations between the Île-de-France and Burgundy are hard to disentangle, on account of the number of works subsequently destroyed. However, it is certain that sculpture in the abbey of St Bénigne in Dijon is closely related to sculpture formerly in the cloisters at St Denis; and that both sets of sculpture were and are in turn related to the sculpture on the west front of the cathedral at Chartres (*c.* 1150).

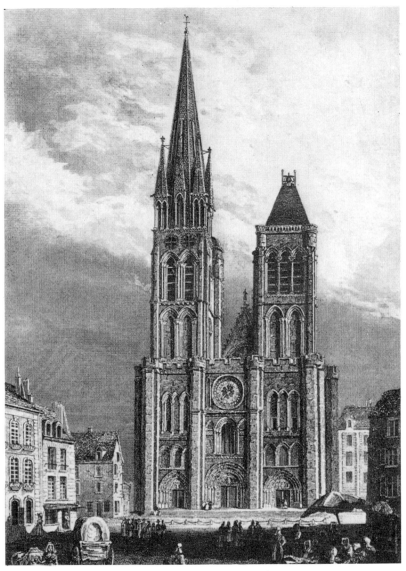

23 Abbey of St Denis, Paris. The façade, *c.* 1832, before restoration

The west portals of Chartres, to judge from their imitators, were justly famous in the twelfth century. During construction they underwent various changes of plan, and a number of individual styles can be distinguished in the carving itself. Nevertheless, the main impact is made by the style of the tympana and the central column

figures, all of which have a very characteristic and easily imitated treatment of the drapery (*Ill. 24*). This is drawn out in long thin parallel folds which sometimes splay out into box-shaped pleats along the lower borders. By their repetition, these lines give the portals a unity and stability which is matched by the restraint and gravity of the whole conception. There is, for instance, very little movement, and individual figures hardly communicate with each other or with the spectator.

The layout and style of these portals are also found at the cathedrals of Bourges and Le Mans. The figure style was imitated even where much of the original restraint was ignored. At Avallon, for instance, although the column figures were extremely similar to those of Chartres, the doorway is heavily encrusted with ornament; and two of the figures (now lost) representing the Annunciation, must by the nature of the subject-matter have seemed dramatic, in contrast to the detachment of the Chartres figures.

The fate of this Chartres style is obscure. Apart from the sculpture of the St Denis cloister, it does not appear to have been developed in Paris. Instead, one finds developing on the south-west portal of Notre Dame (*c.* 1165) and on the transept portal of St Denis (Porte des Valois *c.* 1175) a linear damp-fold style of great force and vigour, and in this respect very unlike the restrained dignity of Chartres. Akin to these are a number of major portals and other works now surviving in a more or less fragmentary condition. Such, for example, are the sculptures of Mantes Cathedral and Notre-Dame-en-Vaux in Chalons-sur-Marne. The west portal of Senlis (*c.* 1175; *Ill. 26*), although heavily restored, shows this late twelfth-century style at its most idiosyncratic. The figures are extremely agitated in attitude, and the drapery, throughout the portal, describes extraordinary convolutions. Whatever the exact sequence of these developments (and it is by no means clear) it does seem that they must be seen against the background of the Romanesque traditions of the Meuse area. In fact, comparisons with metalwork and manuscripts indicate that the whole of this area formed an artistic unity.

The west front of Laon (*c.* 1200) should possess the most important complex of late twelfth-century sculpture in France. Unfortunately, the church has suffered much mutilation and restoration, and

42

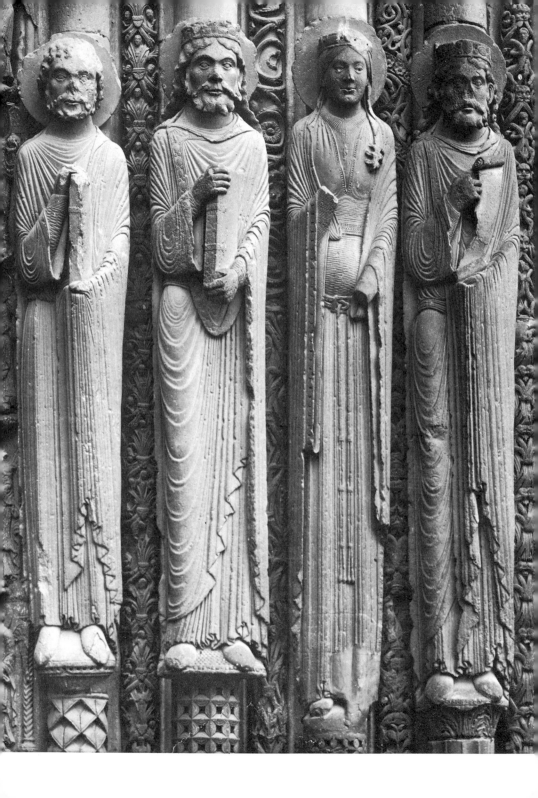

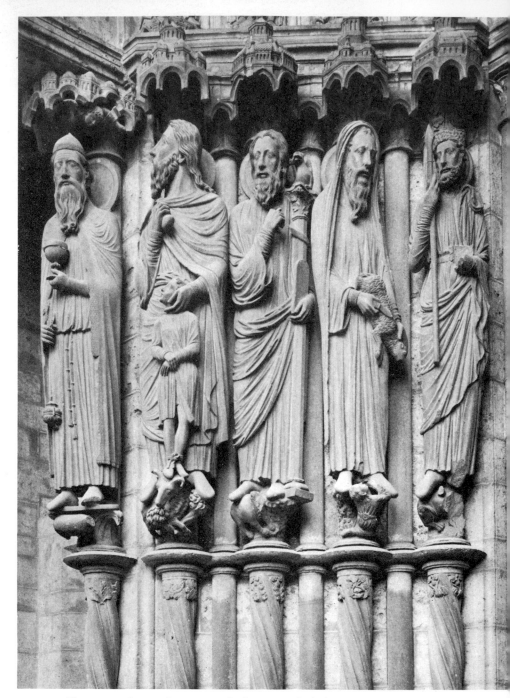

25 Figures on the north transept of Chartres Cathedral, *c.* 1200–10

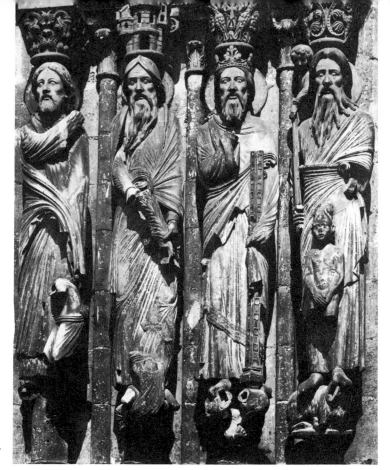

26 Senlis Cathedral,
west portal figures,
c. 1175

although the quality of the original fragments is not in question,
these fragments have now to be sought amid a mass of nineteenth-
century restorations. The iconography of Laon has much in com-
mon with Senlis but the style is indeed very different. Where the
Senlis tradition stressed movement and mannerism, the figure
sculpture at Laon is in general relaxed and graceful. The figures are
not contorted but elegant, and the drapery falls in delicate curves.
This change in taste is more easily followed on the transepts of
Chartres (earliest sculpture c. 1200–10; Ill. 25). Although this sculp-
ture does not appear to have been of as high a quality as that of
Laon, it survives virtually complete. It will be observed that the
change in expressive character was accompanied by a change in
drapery convention. The fine linear appearance of the twelfth

45

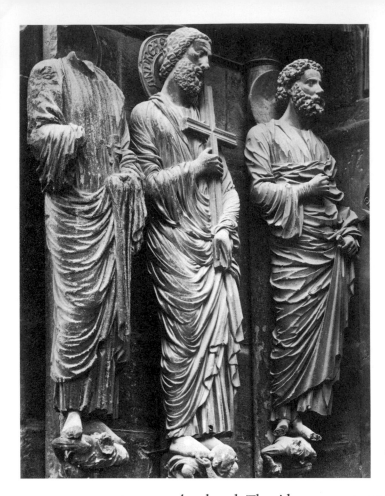

27 Figures from the Judgement Portal, north transept, Rheims Cathedral, *c.* 1220

century was abandoned. The ridges are more pronounced and more emphasis is given to the spaces and hollows in between. Other sculpture in a comparable style exists at Sens (after 1184), at St Yved de Braisne (*c.* 1205) and on the west front of Notre Dame in Paris (begun *c.* 1208). Some Chartres sculptors appear to have travelled to Rheims, when the rebuilding of that cathedral was undertaken after a fire in 1210. At Rheims, however, much of the earliest sculpture, while belonging indubitably to this stylistic phase, leans obviously and elaborately towards the antique. The reasons for this are not clear, but the stylistic point of departure is once again the Meuse area; and the artist who comes into prominence at this point was a metalworker called Nicolas of Verdun.

46

There is scattered evidence throughout the twelfth century for a spasmodic interest in antique remains. This is to be seen in the architecture of the abbey of Cluny, for instance; or in the architecture and sculpture of the church of St Gilles-en-Provence. Metalworkers of the Meuse area had also produced works indebted to classical antiquity, so that, although the precise circumstances of the revival of an antique drapery style effected by Nicolas of Verdun are now lost, its appearance is not entirely a surprise. What is certain is that his earliest work, an *ambo* (later transformed into an altarpiece) for Klosterneuburg near Vienna was finished, according to an inscription, in 1181, and antedates all the larger works of stone sculpture already mentioned. Nicolas himself was still at work in the early years of the thirteenth century.

The drapery style which he developed (*Ill. 28*) appears to be derived from sculpture of the fourth century B C, although it is no longer possible to say precisely what it was that he could have studied. Some reflection of this style is certainly to be seen at Chartres, but the most obvious direct imitations of the antique took place at Rheims in the years *c.* 1211–25. Of these imitations, the two figures of the Visitation on the west front are probably the most famous. It is possible that the original intention was to decorate the whole west façade with sculpture of this style (*Ill. 27*).

28 NICOLAS OF VERDUN
Klosterneuburg Altar 1181

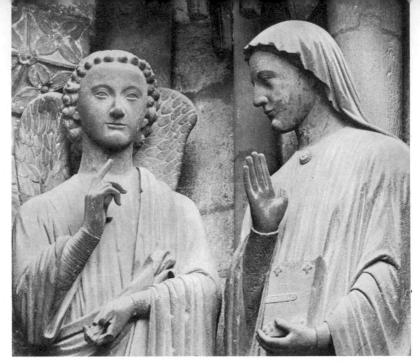

29 The Annunciation from the south-west portal of Amiens Cathedral, *c.* 1225

That this never happened, and that this sculpture was almost all relegated to the transepts was the result of a change in master mason, and a change in taste. The changes probably took place around 1230; and we know that the figures already executed were replaced by sculpture in a style which came in the first instance from Amiens (rebuilding begun in 1220; *Ill. 29*), and ultimately from Paris where it had appeared in the north-west portal of the west façade of Notre Dame.

By comparison this new style is extremely austere. It has little of the grace of the earlier style; and the drapery falls in plain broad folds with practically none of the curving interplay of ridge and trough found in the style which it replaced. The figures are striking for their rather square upright appearance and the restraint of gesture; and it has convincingly been suggested that their genesis lies in Byzantine ivories of the tenth century.

Almost at once, this style in turn changed (*Ill. 30*), developing a liveliness and movement not found at Amiens. The proportions of

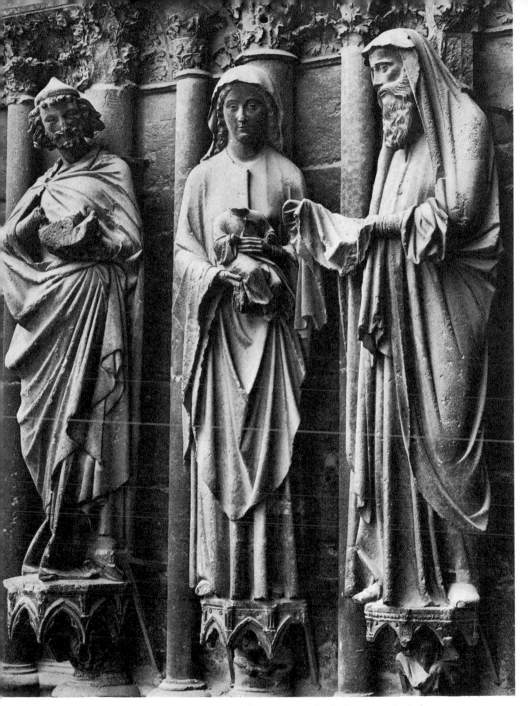

30 The Presentation in the Temple, from the west portal of Rheims Cathedral, c. 1230–40.
The two right-hand figures belong to the restrained 'Amiens' style, that on the left is the
name-piece of the slightly later 'Joseph' Master

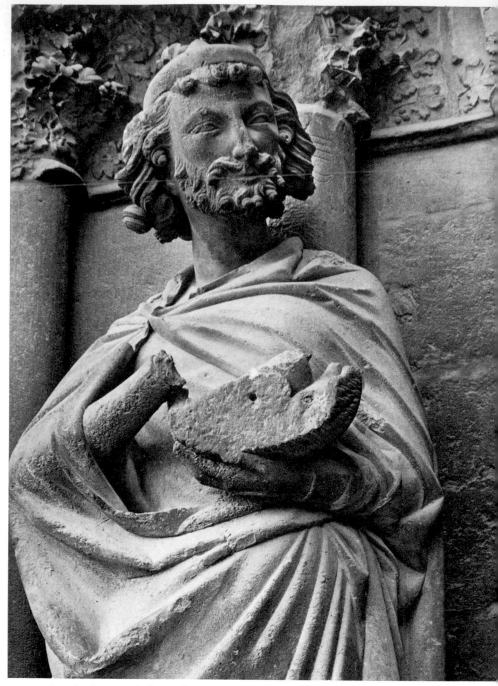

31 Detail of St Joseph from Rheims Cathedral, *c.* 1240 (*see Ill. 30*)

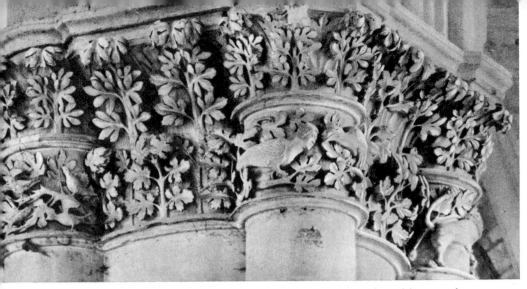

32 Capital from the nave of Rheims Cathedral with elaborate naturalistic foliage-work

the figures remained similar but their grace became more marked; and, probably towards *c*. 1240, one begins to find that character-istic daintiness which is famous from the figure of Joseph on the west front (*Ill. 31*). The broad folds of the Amiens style were emphasized and caught up into long pronounced V-shaped curves. It is really at this point that French Gothic sculpture acquired characteristics which it was to retain for the next one hundred and fifty years. It is probable that this development may also be referred back to Paris, for sculpture similar to this is already to be found *c*. 1230 in the central tympanum of Notre Dame.

One feature of the sculpture of Rheims must be noted. This is the naturalistic foliage carving on the capitals of the main piers (*Ill. 32*). The beginnings of this are already to be found on the earliest piers round the choir and apse; and as the building proceeded westwards, the imitation of nature became more precise and the foliage more profuse. The actual proportions of the Rheims capitals were seldom imitated, but the naturalistic foliage became very popular. Good examples in France are to be found at Chartres and Noyon (chapter house). The fashion then became diffused throughout Europe (see below, pp. 64, 117, 123).

It has been said that Suger's first architect incorporated into St Denis certain elements which became the stock-in-trade of façade designers. It remains to ask how these elements were used. The first major façade to develop significantly the features of St Denis was that of Laon (*Ill. 5*), for it was here that the first real use was made of the rose window as a central feature. At the same time, the portals were deepened and emphasized by the addition of porches. This general pattern was followed in the final designs for the transepts of Chartres. But already at Chartres certain problems were looming connected with the general increase in the height of buildings. This tended always to draw the central rose upwards away from the portals, making it more and more difficult to give the façade cohesion. The first attempt to correct these faults and to draw the composition together again is found at Amiens (*Ill. 33*). Here the architect made the porches coalesce with the portal to form enormous embrasures opening outwards and upwards. The column figures were now spread right across the façade instead of being confined to their separate embrasures. The portals are set between heavy buttresses which themselves mount up in tiers towards the rose window three storeys above. The result, however, was still not really satisfactory and one solution is to be found in the final façade at Rheims (*Ill. 34*). Here the architect, dispensing with the carved tympana, elevated the portal gables to such an unprecedented height that the point of the centre gable penetrates well into the zone of the rose window itself. Naturally this entailed disposing the intermediate storeys elsewhere and the gallery of kings was now placed above the rose. The window storey has gone, but the architect ingeniously placed windows in the spaces usually occupied by the tympana. Rheims, in fact, embodies a great deal of radical rethinking about the arrangement of elements traditional to French façade design.

In England, French influence made itself felt only slowly. Portals after the French manner, complete with carved tympana and column figures are almost unheard of in the twelfth century. Lincoln Cathedral appears to have had a pair of column figures (in the 1140s extremely up to date, unfortunately now destroyed), and a pair were added at Rochester in *c.* 1150. The first door with a complete range of column figures appears at York (St Mary's Abbey, *c.* 1210; *Ill. 35*).

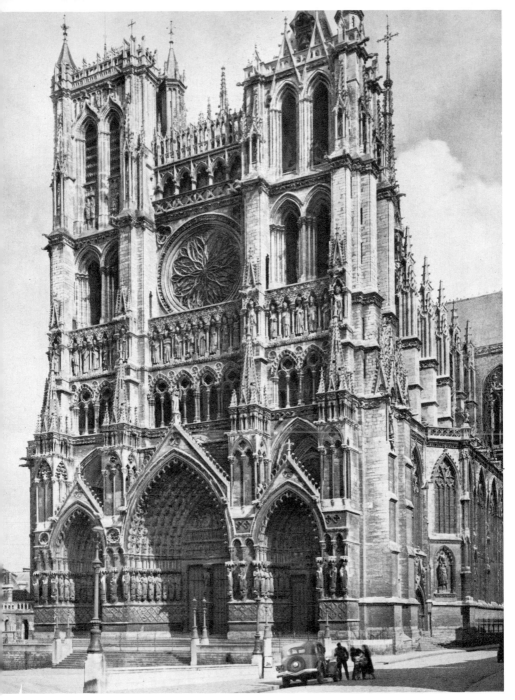

33 West front of Amiens Cathedral, begun *c.* 1220

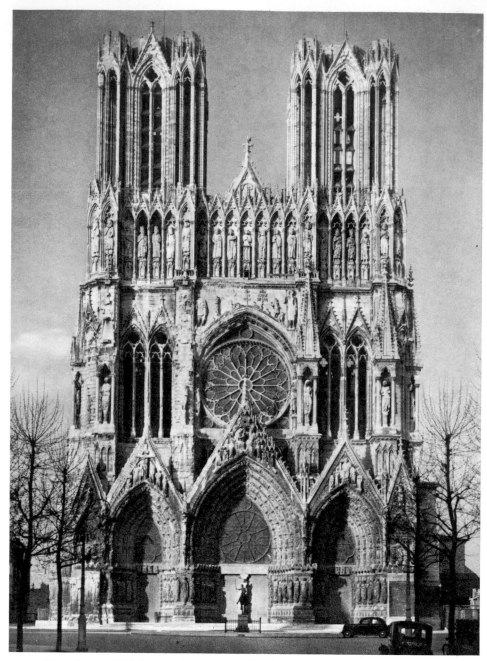

34 West front of Rheims Cathedral; second quarter of the thirteenth century. The cathedral was intended to have spires although these were never built

Very little is known about this portal, since, apart from the main figures, almost nothing survives. The style of these figures has, however, convincingly been linked with the earlier style of the façade of Sens. In England they remain an isolated phenomenon.

It appears that the normal type of French portal really failed to gain a foothold in England. The south choir portal of Lincoln had some of its features and the same was true of the north transept portals of Westminster Abbey, although only that of Lincoln survives in anything approaching its original state (see below, p. 117).

35 St John, one of the jamb figures from a destroyed portal, St Mary's Abbey, York, c. 1210

The first major monument of Gothic sculpture is the façade of Wells Cathedral (*c.* 1225–40; *Ill. 36*). Here, for the most part, the sculptural style is allied to the contemporary Amiens–Rheims style already described. Yet the layout of the façade, with its tiny portal, has nothing to do with the Île-de-France; and inasmuch as it is French at all, it derives from the Romanesque façades of the west of France, for there too the major sculpture was placed in the zone above the portals.

36 West front of Wells Cathedral; begun *c.* 1225. The towers belong to the late fourteenth and early fifteenth centuries

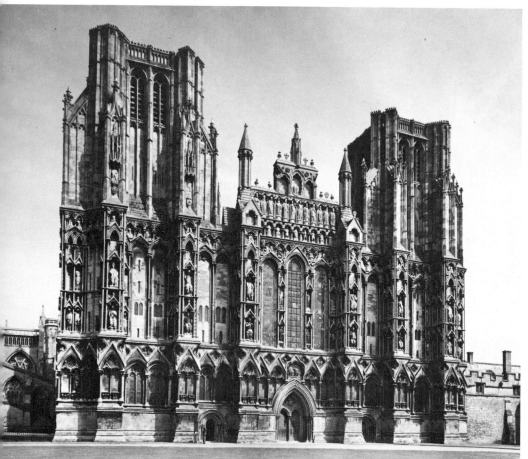

37 The Coronation of the Virgin above the centre west portal, Wells Cathedral, *c.* 1230

The quality of the sculpture on the façade of Wells varies consider-ably. Much of it can hardly be rated very highly by international standards, but the best is confined to the lower ranges. The Corona-tion of the Virgin (*Ill. 37*) in the centre comes close in style to one extremely impressive fragment now at Winchester, which is probably as good as anything on the Continent. This is a graceful carving of a standing female figure which may have formed part of the decoration of the porch of the prior's house at Winchester. It has obvious affiliations with the sculpture at Strasbourg which is datable to *c.* 1230.

In Germany, it does not seem that any attempt was made to imitate the style of the west front of Chartres at all closely, and the development of Gothic sculpture there really begins in the 1220s. The first clear example of first-class sculpture derived in style from

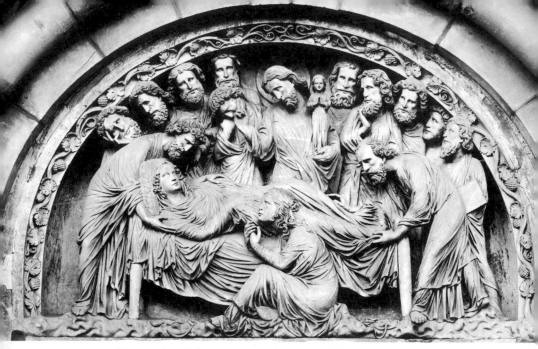

38 The Death of the Virgin, Strasbourg Cathedral, exterior of south transept, *c.* 1230

France occurs on the south transept at Strasbourg (*Ill. 38*). These figures must date from *c.* 1230 and are dependent on the style of the best transept sculpture of Chartres Cathedral, with influence in the drapery and the grace of the figures from the intervening sculpture at Rheims. Strasbourg is also notable for the excited, dramatic tone of the work. Here one is introduced to a feature which survives with extraordinary persistence throughout German sculpture – namely, a *penchant* for highly-pitched emotion and an evident desire to involve and excite the feelings of the spectator.

This reappears at Bamberg (probably before 1237) in a group of sculptures designed by masons very well acquainted with the work at Rheims (*Ill. 39*). As a sculptural complex, these works are extremely puzzling, but the style of Rheims underlies almost every detail; and once again, the emotive features which were almost all hinted at in Rheims, were here raised to an intensity of quite a different order.

The portals at Bamberg and Strasbourg are Romanesque in the heaviness of their mouldings and their round arches. No complete

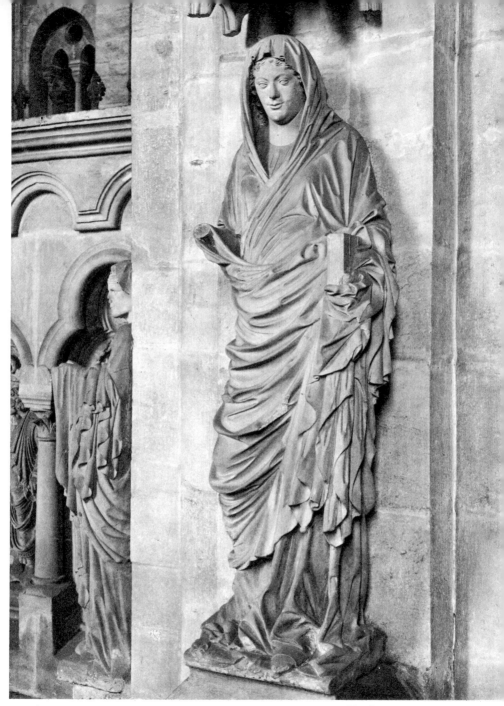

39 The Virgin Mary, Bamberg Cathedral; figure from a Visitation group now set in choir aisle, *c.* 1230–5

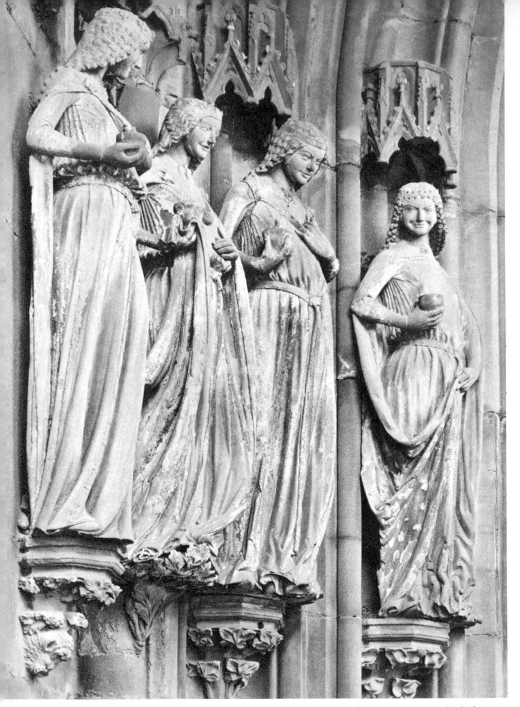

40 The Wise Virgins from the jamb of the Paradise Portal, Magdeburg Cathedral, *c.* 1245

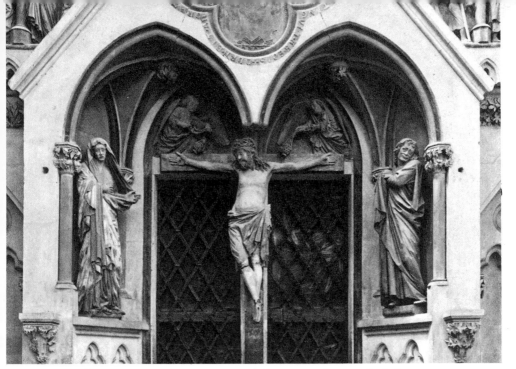

41 Crucifixion group on the entrance to the choir, Naumburg Cathedral, c. 1245

large portal exists between these and the west front of Strasbourg (c. 1280–90) to indicate whether during this period any German mason tackled the problem of integrating a French figure style into a French type of portal. This may have been the case at Magdeburg, for the Wise and Foolish Virgins of the Paradise Portal (c. 1245; *Ill. 40*) were certainly not originally intended for the existing door. They were evidently intended for a Last Judgment Portal of some sort, although here they were given unexpected importance, being elevated to a size and status usually reserved for figures of Apostles. However, the intentions for the original doorway are now lost. The style of these figures is unmistakably German. The sculptor made a bold attempt to register suitable expressions of joy and despair; yet the desire to impress the spectator has outrun his sensitivity and it is clear that the step from life-like to grotesque is a short one.

This sense of dramatic tension is also marked in the sculpture of the west choir of Naumburg Cathedral (*Ill. 42*). Where the Magdeburg sculptures are related to work at Strasbourg, those at

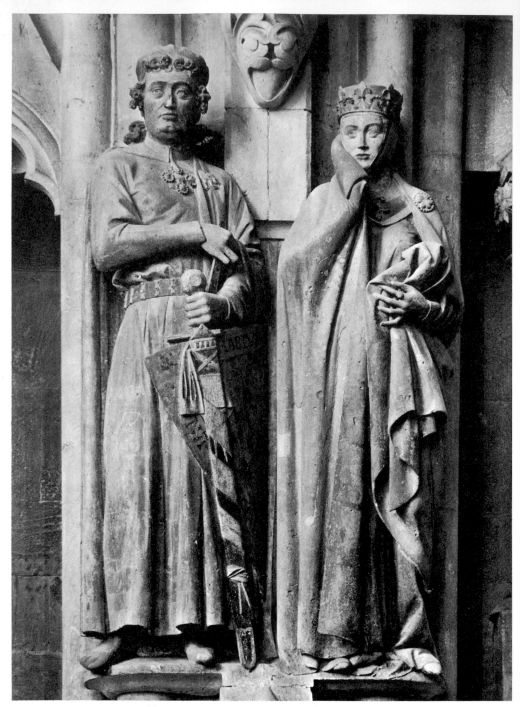

42 Count Eckhart and Uta, Naumburg Cathedral, c. 1245

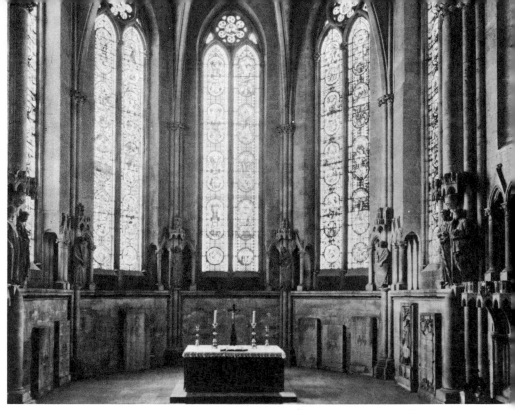

43 West choir of Naumburg Cathedral, showing the placing of the sculpture (*Ill. 42*)

Naumburg appear to have derived from Bamberg. The drapery is thick and heavy and the figures lack the elegance of the Strasbourg tradition. The sculptors may have worked already on a choir-screen at Mainz, of which now only fragments survive; and, after working at Naumburg in the 1240s they would have gone on to Meissen, where figures in the same general style survive from a portal. The work at Naumburg is complete. The west choir is closed off from the body of the church by a screen or *pulpitum* (one of the few thirteenth-century examples to survive intact on the Continent). On this are carved in relief scenes from the Passion. A Crucifix stands against the *trumeau* of the entrance to the choir (*Ill. 41*). Inside, the walls are decorated with large figures, after the manner of the Ste Chapelle in Paris (see *Ill. 62*). Here, the figures are not Apostles but the secular benefactors of the cathedral. They are given unexpectedly dramatic poses (*Ill. 42*), appearing to communicate with each other

across the breadth of the church. However, in the general context of German sculpture, the sensitivity and restraint of these figures within the choir is very remarkable. Although they register a wide variety of different human types and different emotional states, the sculptors in general avoided the grotesque and the over-emphatic, and in this respect contrast strongly with the masons responsible for the Virgins of Magdeburg.

It will be seen that the capitals at Naumburg (*Ill. 44*) are adorned with a highly naturalistic type of foliage decoration. They represent a fashion already found at Rheims which spread through France and to other places in Europe, for instance to Magdeburg and Gelnhausen, to Southwell in England and Leon in Spain (see p. 117).

Up to *c.* 1220, Spanish sculpture remained almost untouched by the styles of French sculpture already described. Miscellaneous French influence certainly appears in portals such as those of Sta Maria at

44 Foliage capital from the west choir of Naumburg Cathedral, *c.* 1245

45 La Portada del Sarmental, south transept, Burgos Cathedral, *c.* 1235

Sanguesa, S. Vincente at Avila, or in the Portico della Gloria of
Santiago, Compostella. But on analysis the ideas appear to have been
drawn more often from the peripheral regions of Burgundy and
Aquitaine.

It is only in the 1220s that one reaches a period of what is perhaps
a more servile interest in French sculpture. Indeed, unlike Germany,
there follow a number of complete portals directly inspired by
French models. The greatest complex of Early Gothic sculpture is on
the cathedral at Burgos. Here, the stylistic inspiration comes from
Amiens; indeed, it seems likely that the sculptor of the portal on the
south transept ('La Portada del Sarmental', 1230s; *Ill. 45*) had actually
worked there, so close are some of the figures to the style of the
Beau Dieu of Amiens. The south transept façade may have actually
been built in the 1250s and contains a number of features from
Rheims. The shape of the rose window is similar to the transept roses
of Rheims, and the Gallery of Kings is placed up above it. In a
manner similar to Amiens, the lateral figures of the portal tend to
spread out towards and round the flanking buttresses.

65

46 'Pentecost', a page from the so-called Ingeborg Psalter; before 1210

Turning to painting, the different medium brings a different set of problems. Once again, we find a period of transition at the very end of which, as in architecture, Paris emerged as the centre of a style which was eventually to affect profoundly the rest of Europe. Between 1140 and 1200, however, we are dealing with a series of regional styles more or less connected by the dominating force of Byzantine art. The degrees of Byzantinism were innumerable, and the problem of dating and interrelation are very considerable. It should be observed that, if we were to confine our discussion exclusively to Gothic art we might justifiably ignore most twelfth-century painting, for there is scarcely anything in the entire gamut that one can comfortably call 'Gothic'. It is only at the very end of the century that the Byzantine conventions softened or were replaced. In some areas, mainly within the Empire, the conventions survive well into the thirteenth century. To ignore this art would be doubly unjustifiable; firstly, much of it is of first-rate quality, and falls chronologically within the confines of this book; secondly, it formed the basis of the 'Early Gothic' of the thirteenth century.

The Empire of the West possessed by the twelfth century a pictorial tradition of great distinction. Readers of the previous volume in this series (*Early Medieval Art*, John Beckwith) will be aware of the quality of the tradition of manuscript illumination. From this tradition were derived quite clear ideas about what an important and sumptuous manuscript ought to look like, how its pages ought to be laid out, what type of border decoration was permissible and so on. And from this tradition, fluctuating and changing as it had been, were also derived many of the conventions of figure style and drapery.

The contributions of the twelfth century were numerous. The manuscript needs of one century differ from those of another. The twelfth century was marked by an intensified study of the biblical text and it is therefore a century of Great Bibles and Glossed Bibles. Another type of manuscript which became popular in this period was the psalter. This was a private devotional book, often owned by people in some religious vocation. The most sumptuous of these are in effect expensive picture books with long series of beguiling

47 Initial B of Psalm 1 from the Munich Psalter, *c.* 1200, an elaborate example of this type of initial decoration

48 (*below*) VILARS DE HONNECOURT Unidentified subject, *c.* 1220. From the famous notebook compiled by Vilars and his followers

illustrations prefaced to the main text. They were often owned by well-born nuns, and became increasingly popular in the second half of the century.

The twelfth century was one of peculiarly brilliant initial decoration. A type of initial which gained great popularity towards the end of the century was that composed of spiralling plant tendrils, interlaced with the octopus-like petals of large Byzantine blossoms (*Ill. 47*). It will also be clear from *Early Medieval Art* that some entirely original experiments were made (in England particularly) in the Byzantine damp-fold drapery style. These should, however, be seen as distinguished and idiosyncratic embellishments on an established type of figure and drapery painting.

This damp-fold style is so called on account of the clinging, damp appearance of the drapery. It provides a method of distinguishing the substance of the body beneath the material without losing the decorative character of the surface, and the finished effect is one of smooth areas of surface surrounded by decorative lines. These conventions were shared by both painters and sculptors alike. Correspondences can be found between the twelfth-century sculpture of north-eastern France, the metalwork of the Meuse region, and manuscripts produced in northern France and what is today Belgium.

As a result of these correspondences, it might be expected that painters, like sculptors, would develop the classical style of Nicolas of Verdun, and that there would be a pictorial equivalent to the 'classical' sculpture of Rheims (see pp. 46–7). This indeed exists, but it had a curiously limited popularity. There is one major manuscript, a psalter owned by the French queen Ingeborg, wife of Philip Augustus (*Ill. 46*). It was produced before 1210 and is an excellent example of the style of Nicolas transposed to manuscript illumination. The book itself is a sumptuous example of this new *genre* of devotional manual, owned by a lady of high rank and, like the earlier Albani Psalter, lavishly (indeed gaudily) illustrated. Its style is not uniform, but the full-page decoration includes some figure painting in the 'troughed' style of Nicolas and Rheims.

Not very much later, another manuscript of a quite different sort was produced which also uses the troughed style. This is the sketchbook of the mason Vilars de Honnecourt (*Ill. 48*) who, we know, was

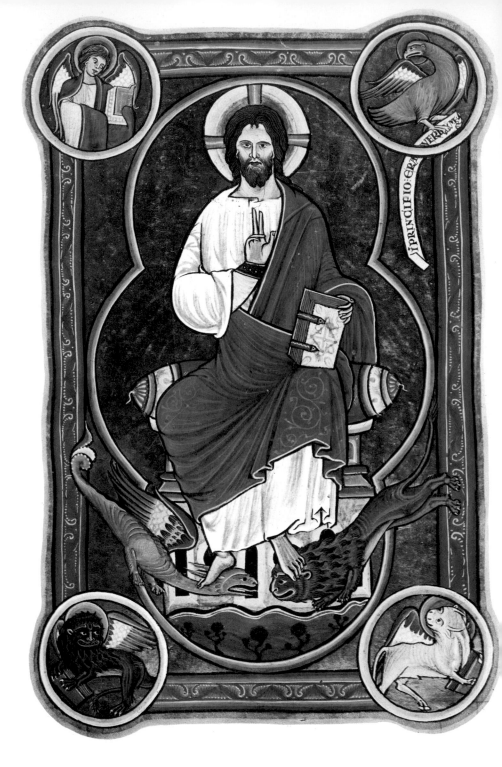

much impressed by Rheims and presumably adopted the style from the sculpture. Further manuscripts exist but of an inferior quality. There is a missal from Anchin (Douai, Bib. Mun., Ms 90), an associated leaf from another missal (Cologne, Wallraf-Richartz Museum) and an Evangeliary from the church of Gross St Martin, Cologne (Brussels, Bib. Royale, Ms 9222). All these examples come from the same general area as Nicolas of Verdun and one might suppose that the Ingeborg Psalter was produced in this area too.

There is a considerable amount of stained glass in France and England in which the style is visible. It appears to have been particularly popular with the glaziers, as reference to the early glass (c. 1200) of Canterbury Cathedral will show.

The adoption of the troughed style was part of a general trend towards a more naturalistic type of drapery. It still has something of the quality of the clinging damp-fold convention – indeed it represents in a purer form the same classical style from which the damp-fold ultimately derived. There are still plain areas of surface surrounded by linear patterns. But the stuff of the material now possesses a real substance of its own. A new softness and roundness has permeated the rather harsh linearity of the old style.

It is not difficult to find previous evidence of a move in this direction – a move associated particularly with England and (once again) northern France and the Low Countries. For instance, in the third great manuscript life of St Amand, produced perhaps in c. 1175 (Valenciennes, Bib. Mun., Ms 500), large parts of the surface areas are modelled in colour; whereas before, the contours had been marked out with lines. The great Manerius Bible (Paris, Bib. Ste Geneviève, Ms 10), produced perhaps at St Bertin in c. 1180, is also painted in a softer style. Manerius, who directed the production of this work, was an English monk from Canterbury, and this serves as a reminder of the close stylistic links between this area and England during the second half of the century. A further instance of a more naturalistic style of painting is to be found in the decoration of the leper-house founded by the English King Henry II at Petit-Quevilly (1183).

Finally, from the end of the century may be mentioned a number of psalters produced in England (*Ill. 49*) which also show this change

49 Christ in Glory, a page from the Munich Psalter, c. 1200

in drapery style. The most lavish, now at Munich (Statt. Bib., Ms Clm 835), possesses the extraordinary number of eighty full-page illustrations. It appears to have originated in the Gloucester area. Naturally, in an undertaking of this size several artists took part. But the most advanced style is strikingly soft, and has moved a long way from the mannerisms of the Lambeth Bible. To a lesser extent the same observations may be made about two other psalters both now in the British Museum (Mss Arundel 157 and Royal 1DX). In the previous volume in this series, *Early Medieval Art*, this development was observed taking place within one large and imposing manuscript, the Winchester Bible. In this work, the latest hand brings us very close to the artist who executed in *c.* 1200 a psalter for Westminster Abbey (now British Museum Ms 2 A XXII; *Ill. 50*). The painting of this psalter is remarkable for the fullness and softness of the style of the drapery. The material falls in large rounded curves and there is no longer the tautness associated with the damp-fold style. It is not certain whether the Westminster Psalter was executed by a man trained in London since our ignorance of London painting at this date is almost complete.

The psalter of Queen Ingeborg was the first court manuscript to be introduced in this book. On account of its unusual style, it must appear somewhat isolated. But it was followed by other French royal books, in which the influence of the troughed style lingers on perceptibly. One of these is a psalter (Paris, Bib. Arsenal Lat. 1186) said according to a fourteenth-century tradition to have belonged to Blanche of Castile (d. 1252), the mother of Louis IX. It is a richly decorated book with illustrations arranged in roundels (*Ill. 52*). This idea almost certainly derives from stained glass, and, at this point, the art of the glazier seems to impinge on that of the illuminator. A correspondence of style has already been noted above (p. 71). Since the glazier was, in effect, a specialized sort of painter, it is not surprising to find the two professions overlapping. Stained glass frequently mirrors the style of manuscript painting; and here the illuminator seems to be adapting to a page layout an idea taken over from the glazier.

The so-called psalter of Blanche of Castile is similar in style to a psalter of slightly inferior quality (Paris, Bib. Nat. Nouv. Acq.

72

50 Christ in Glory from the Westminster Psalter, *c.* 1200

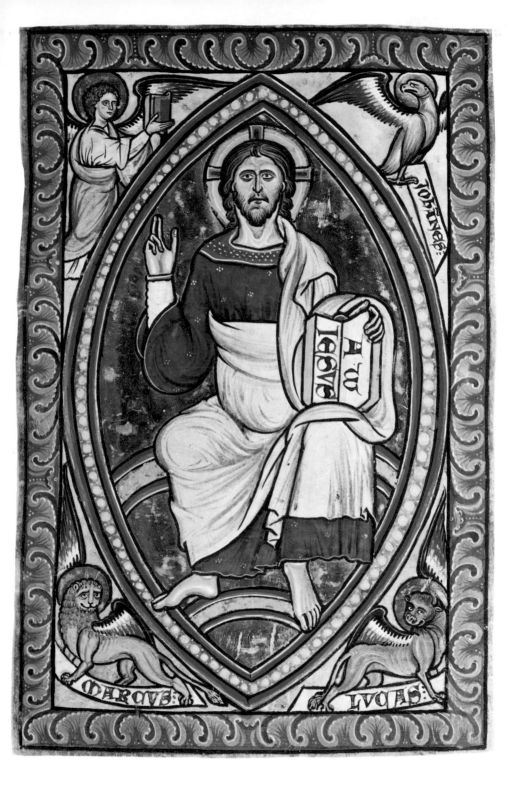

1392), part of an Evangeliary executed for the Ste Chapelle, presumably during the 1240s (Paris, Bib. Nat. Lat. 8892), and four large *Bibles Moralisées*. The latter are a new type of Bible in which events of the Old and New Testaments are paired with symbolic interpretations. The page layout involved the continuous juxtaposition of these scenes in roundels, eight to a page, beside an appropriate text. Among the *Bibles Moralisées* one (Vienna, Ost. Nationalbib. 1179) has the image of a king together with that of a scribe on the back page. These sometimes rather tenuous royal connections suggest that we have here the beginnings of a tradition of manuscript-painting based on the French court in Paris in 1225–50. One must add, however, that this is extremely hypothetical. Paris in the earlier part of this period plays no part, as far as we know, in the production of high quality manuscripts or in the direction of fashions connected with them. It is striking that there are no books attributed to the patronage of the Abbot Suger. If what has been suggested above is correct, something of a landmark in the history of art has been reached. From now on Paris becomes very important as an influence on style and fashion.

In England, a long series of psalters and other books runs parallel to the French books just discussed. Here too, roundels and allied shapes were popular in page layouts, although, with one exception, the precise layout of the psalter of Blanche of Castile was never imitated. One of these psalters, that of Robert de Lindeseye, abbot of Peterborough, can fortunately be dated to before 1222. The style of the main artist of this book is more graceful than that of his Parisian counterparts (*Ill. 51*), but the modelling of the drapery is very similar, as is also the light shading of the flesh and the rather round faces. One feature, the graceful looping folds into which the drapery is caught, became particularly popular in England.

This is indeed one of the chief decorative mannerisms of a group of manuscripts, many of which have, rather surprisingly, connections with the West Country. (There is still nothing to suggest that London was a significant centre of book illumination.) They are the Amesbury Psalter (Oxford, All Souls Ms Lat. 6; *Ill. 53*), the Missal of Henry of Chichester (a canon of Exeter; Manchester, John Rylands Lib. Ms Lat. R24), the Evesham Psalter (B. Mus. Add.

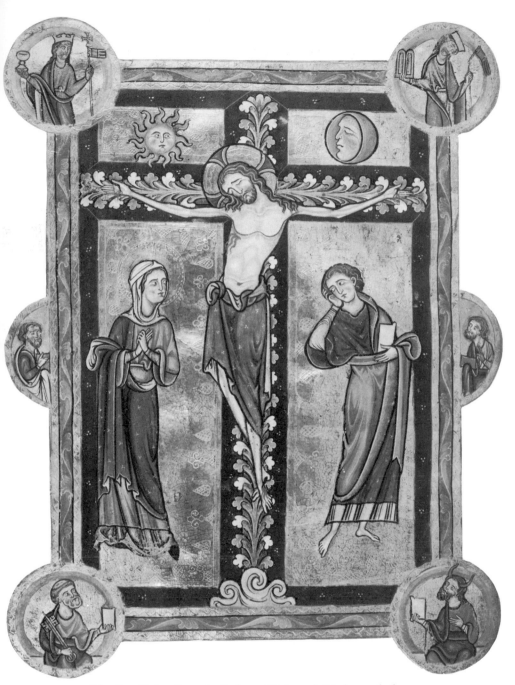

51 The Crucifixion from the Psalter of Robert de Lindeseye, before 1222

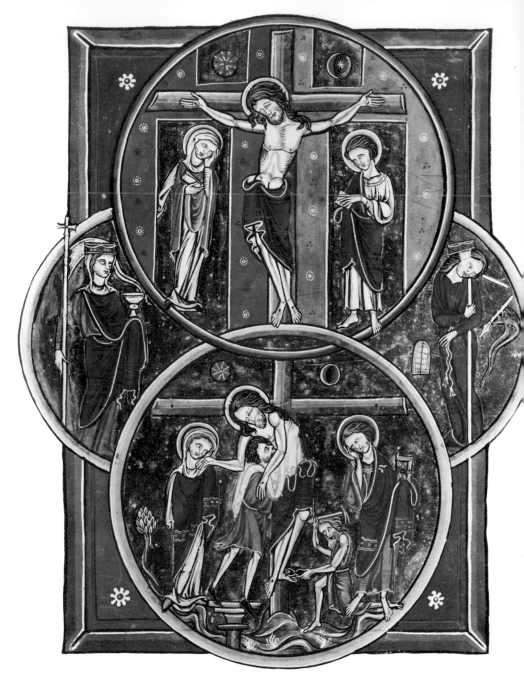

52 The Crucifixion and Deposition, a page from the so-called Psalter of Blanche of Castile, *c.* 1235

53 (*opposite*) Virgin and Child with donor, from the Amesbury Psalter, *c.* 1240–50

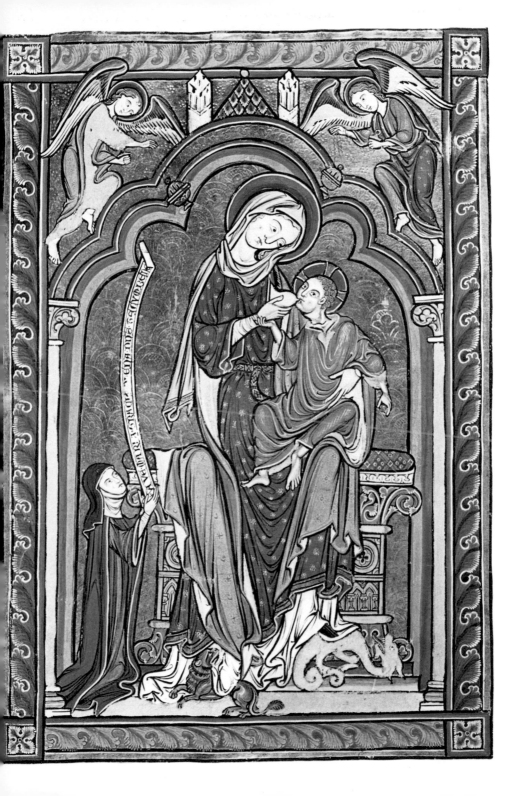

44874) and the Trinity Apocalypse (Camb. Trin. Coll. Lib. Ms R. 16.2). Together these may represent English illumination around 1250. Only the Evesham Psalter has any sort of a date (after 1246), and since it seems to push the general characteristics of the group to a point of mannerism, it may be considered the latest. Perhaps the most distinguished member is the Amesbury Psalter, for here the sumptuous quality of the production is balanced by the great delicacy and refinement in the gestures of the figures and the general feeling of the work (*Ill. 53*).

Contemporary with this style are two further groups of manuscript illuminations. The first group seems to have been based on St Albans, and is associated with the artist and historian Matthew Paris (*Ill. 55*). Fragments of wall-painting at Windsor, however, make it clear that the King's painters worked in a similar style on a large scale, and it is conceivable that Paris was in fact following a metropolitan fashion. The style was one of outline drawing, tinted with colour, and a number of manuscripts, not all by Paris himself, testify to its popularity. The technique of the tinted outline drawing was, of course, a very old one. It had been momentarily revived by one of the artists of the Lindeseye Psalter, and Matthew Paris and his associates were really continuators of this tradition in the current style of *c.* 1250. Paris himself probably died in 1259.

The second group of manuscripts involve a man who signed himself on three different manuscripts 'W. de Brailes'. He also depicted himself as a tonsured cleric. The villages of Upper and Lower Brailes are near Banbury in Oxfordshire, and in 1260 a William de Brailes appears in an Oxford street register. There is therefore reason to associate these manuscripts with the university town of Oxford. W. de Brailes and his collaborators were not refined, sophisticated artists. Brailes appears to have been a vivid pictorial *raconteur* and, as a transitional figure, he has a considerable historical interest. His figures are clothed in the long looping tubular drapery folds of the period, and in his page layouts he frequently used those configurations of geometric shapes reminiscent of the layout of a stained glass window. The faces of his figures, however, are not like those of the Matthew Paris style nor the Amesbury Psalter. Instead of these round, modelled faces, de Brailes produced minute essays in penmanship, in

54 WILLIAM DE BRAILES Christ walking on the waters, from a set of illustrative leaves, *c.* 1240–60

which the whole effect depends entirely on a sort of calligraphic dexterity (*Ill. 54*). This type of face belongs properly speaking to the following chapter. It appears in Parisian painting *c.* 1250, alongside the dainty refinement associated with the court manuscripts of Louis IX. One would hesitate to call de Brailes' work refined; and where he derived this idea from is obscure.

The story in Germany is very different. Here the Byzantinizing damp-fold style survived into the thirteenth century with extraordinary persistence. An extreme example of a linear version of this style is to be seen in an Evangeliary given to the collegiate church of St Cyriacus, Neuhausen, in *c.* 1197 (Karlsruhe Landesbibl. Cod. Bruchsal 1). More striking in quality are a group of manuscripts associated with Berthold, abbot of the Swabian monastery of Weingarten from 1200 to 1232. The most impressive, a missal (probably *c.* 1216; now New York, Pierpoint Morgan Lib. Ms F10; *Ill. 56*)

79

55 MATTHEW PARIS Virgin and Child with the artist kneeling; the frontispiece of the *Historia Anglorum*, *c*. 1250

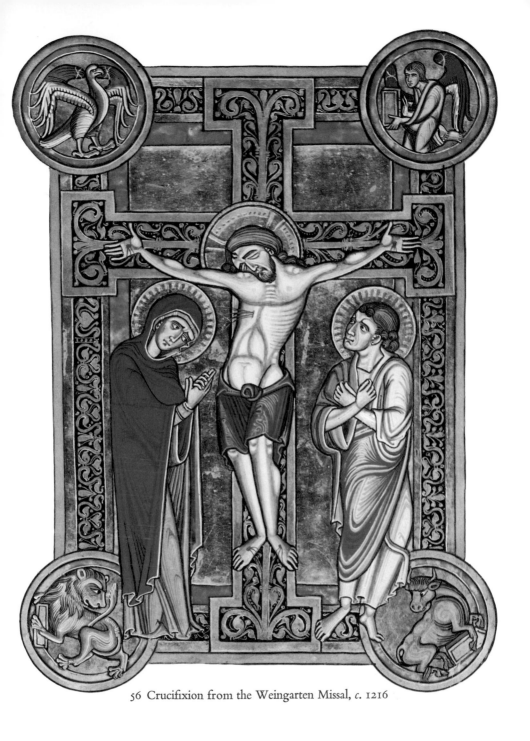

56 Crucifixion from the Weingarten Missal, c. 1216

is interesting in that it reflects in many details work produced in England and northern France during the twelfth century. For instance, the initials are of the spiralling acanthus variety with large Byzantine blossoms, already mentioned (see above, p. 69). The faces are in many cases close to Byzantine types; and the drapery definitely still clings to the figures.

It was during these years that there developed in the Empire what may be seen as the German equivalent of the graceful modelled style of England and France during the first half of the thirteenth century. It is not in the least similar, since the drapery, far from falling in elegant curves, tends to form spikes and harsh angular shapes. It is

57 Jesse asleep; part of a tree of Jesse painted on the ceiling of St Michael's Church, Hildesheim, *c.* 1230–40

58 Altarpiece of Trinity with Sts Mary and John; formerly at Soest; probably *c.* 1230–40

still basically a Byzantinizing style, and the spiky, angular folds are a sort of mannered interpretation of features visible, for instance, in the twelfth-century mosaics in Sicily. The style appears already in the late twelfth century in the northern parts of the Empire, in Thuringia and Saxony. From there it spread west and south along the Rhine, so that this area possesses a series of monuments in this style. Notable are two psalters produced for the Landgrave Hermann of Thuringia who died in 1217 (now Stuttgart Landesbibl. H.B. II Bibl. 24 and Cividale. Bibl. Comm. Codici Sacri 7). From the second quarter of the century a number of larger works survive. These include a ceiling and altarpiece at Soest, Westphalia (now in Berlin; *Ill. 58*), a ceiling on St Michael's, Hildesheim (*Ill. 57*), and a wall-painting of the Crucifixion in St Kunibert, Cologne (*c.* 1247). Late in the series (perhaps *c.* 1260) is an Evangeliary formerly at Mainz (Aschaffenburg Hofbibl. No. 13). The style of the Hildesheim ceiling is less idiosyncratic in its zigzag drapery, more closely modelled on Byzantine art, and is linked with two magnificent books stemming from the same area. The first is an Evangeliary, formerly in the possession of a Provost of Kloster Neuwerk, Goslar (*c.* 1235–40, now

83

in Rathaus, Goslar; *Ill. 59*). The second is a missal bought between 1240 and 1245 for the cathedral of Halberstadt (Halberstadt Domgymnasium Ms No. 114).

The whole of this group is very hard to explain. The style is expressive in its abrupt gestures and unexpected contortions of the drapery; and the best work is extremely rich. The style survived for about eighty years and then, in the face of prevailing Parisian fashion, was replaced, like so much 'local' art, by something more refined, elegant and (perhaps one might add) less interesting.

59 The Adoration of the Magi, the dream of St Joseph and the Evangelist St Matthew; title-page, Evangeliary from Goslar, *c.* 1235–40

The Pre-eminence of Paris 1240–1350

During this period many of the most important artistic achievements north of the Alps were oriented towards Paris. The pre-eminence of Paris as a cultural centre depended mainly on the existence of the French court, and the interest shown in most forms of art by King Louis IX (1226–70). Louis was not, however, merely a patron; his international reputation was founded on his justice and piety. (He was canonized in 1297.) Important people deferred to his judgments and sought to emulate his achievements. His person was set off by the cultural and artistic background which he fostered, and as a result his patronage encouraged the whole idea of secular art patronage. Certainly his own successors appear to have accepted as a normal perquisite of kingship the facilities for ordering works of art to be added to the artistic patrimony of the family. The astonishing history of French royal patronage really begins with Louis IX. It is also true that the sort of art produced in and around Paris under Louis became internationally fashionable. These aspects of St Louis' reign will be pursued in the chapters which follow.

THE DEVELOPMENT OF RAYONNANT ARCHITECTURE

The *rayonnant* style takes its name from the radiating patterns of the great rose windows which are one of its hall-marks. These windows, however, were merely part of a general development of the size of windows, of their tracery and of the part they played in the articulation of a building. This new importance of tracery marks in effect a significant shift of interest.

Up to *c.* 1225–30, major architects were still preoccupied with structure and engineering. The limitations of the flying buttress were unknown, and the series of churches, already mentioned, at Rheims,

Amiens and to a lesser extent Beauvais were intended originally to be enlarged versions of the pattern set by Chartres.

This tendency towards increasing size led ultimately to a technical crisis, with the collapse of the high vaults of the choir of Beauvais in 1284. This disaster proved that large buildings could and would collapse if the architect miscalculated the relationship between the height and the supports beneath. No medieval building ever surpassed Beauvais in the height of its vault, 158 ft, and with the exception of Cologne (150 ft) and Palma (141 ft), none approached it. It is perhaps partly an accident of survival, but the subsequent architectural history of Europe is punctuated by a series of technical *expertises*, both north and south of the Alps, all concerned with the stability of buildings, either existing or projected. It seems to have been in the fourteenth century that the 'expert opinion' came into its own, the idea being that if one could get a unanimous declaration from a group of experts that an existing or projected building was safe, then this was probably the case. The earliest surviving recommendations by such committees come from Chartres (1316) and Siena (1322).

However, long before this the new interest had emerged in architectural decoration, and in the uses of tracery. It followed the mastery of the flying buttress, and the realization that, since almost none of the wall surface between the agglomerations of buttresses was essential to the support of the vault above, it could be opened up to form windows. In the eastern parts of Amiens (after 1236) the window area is extended to the rear wall of the triforium which is glazed. Thus the whole of the area from the apex of the vault down to the main arcade coalesces into one huge window. In creating this impression, tracery plays an important part, since the lines of the clerestory mullions are continued down to link with the triforium arcade.

It is to St Denis (after 1231) that one must return in order to find one of the earliest and most important churches in the new style. Here the architect glazed the triforium and linked it, in a way similar to Amiens, to very large clerestory windows. These are composed of four lights surmounted by three *oculi*. The vertical shafts descend to the base of the triforium and the whole area is thus unified by a

86

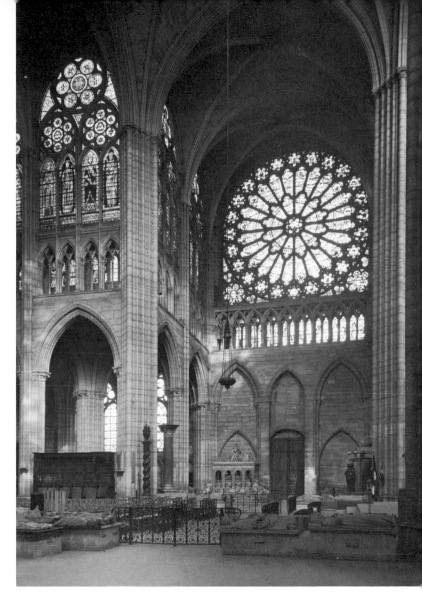

60 Interior of north transept, Abbey of St Denis, Paris; after 1231

continuous surface pattern. St Denis also possesses the first of the very large rose windows of the rayonnant style (*Ill. 60*). One important development is the way the lower spandrels at St Denis are pierced to receive glass. As a result the entire upper wall surface seems to dissolve into a wall of glass and all solid areas of masonry are eliminated.

87

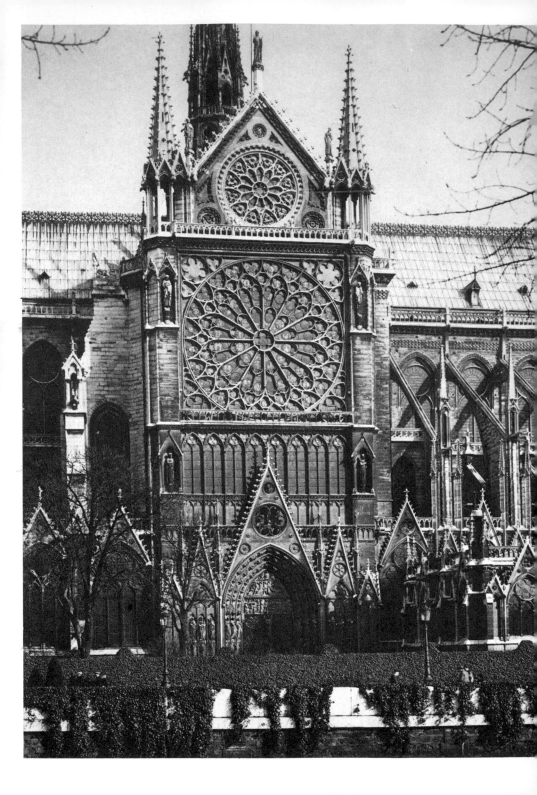

Of the many imitations and derivatives of the St Denis style, the transept fronts of Notre Dame in Paris are among the most magnificent and important. It was noted above that originally these transepts were not intended to project beyond the outer aisles. In about 1250, however, it was decided to enlarge the extremities so that they projected, as did the transepts of most thirteenth-century great churches. This presented an opportunity to construct two enormous façades, that on the north belonging probably to the 1250s, that on the south (*Ill. 61*) being begun in 1258. The striking feature about these façades, from both inside and out, is their apparent slender proportions and the flatness of their relief. The sense of weight and mass found in earlier façades has sensibly diminished. These are presented rather as surface on to which, inside and out, the architect has projected patterns. The patterns exist partly in the form of the traceried windows. But they are continued across the blank wall surfaces in the form of blind traceried panels; and they also exist in the form of subsidiary skins of unglazed openwork tracery in the arcades and gables. Many of these ideas are already found in St Denis and in other churches of the rayonnant style. The effect of the subsidiary skins of tracery, for instance, is already to be found in glazed *triforia*. The importance of large designs like those of the Parisian façades lies in the extent to which they pull together current ideas into a definitive statement which may then serve as a point of departure for subsequent projects.

Within the development of this style, one building deserves special mention in spite of its comparatively small scale. This is the royal chapel on the Île de la Cité, generally called the Sainte Chapelle (*Ills. 62–3*). It was built during the 1240s, consecrated in 1248 and intended as a house for a number of very special relics which Louis IX had acquired – relics which included among their number the Crown of Thorns. It has for this reason frequently been likened to an enormous reliquary, and the considerable amount of decoration both inside and out confirm the impression that one is looking at something influenced by goldsmith's work. On the exterior, the main decorative features are the large gables over the windows and the pinnacled buttresses – both features found also on the choir of Amiens and other northern cathedrals. On the inside the decorative effect is

89

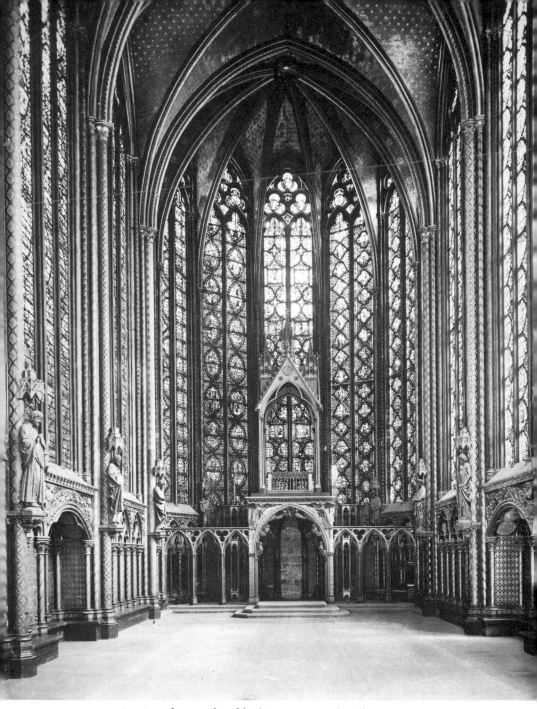

62 Interior of upper chapel looking east, Ste Chapelle, Paris, 1243–8

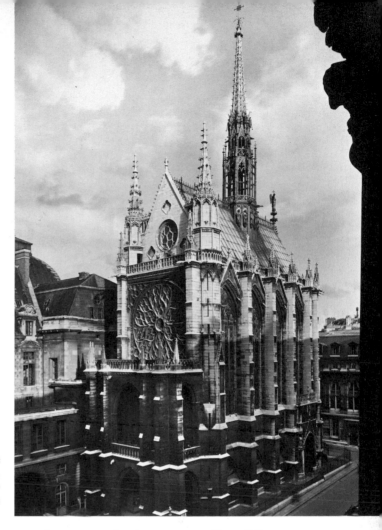

63 Exterior of the Ste Chapelle, Paris, 1243–8. The original rose window was replaced in the late fifteenth century

very dense, for there is scarcely any part that is not covered by gilding or decorative patterns. The arcading and the figures of the Apostles on pedestals are very similar to the sort of decoration found on metal reliquaries. But the main impact of the Ste Chapelle is made by the glass of the enormous windows. The west end was originally surmounted by a rayonnant rose window (replaced in the late fifteenth century), and the lateral windows occupy a large part of the remaining wall space. Being filled with stained glass, they create a glowing, jewel-like effect which is characteristic of the interior. The Ste Chapelle set a new standard in sumptuous decoration.

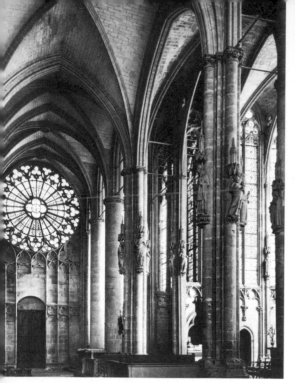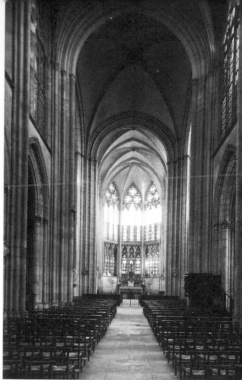

Three other monuments in the rayonnant style may be selected since they show the application of Parisian ideas in varied contexts. One, the new east end of the cathedral of Carcassonne (built after 1269; *Ill. 64*) has many obvious Parisian features. The transept wall is composed of a large rose window surmounting panels of tracery; the other walls contain large traceried windows also surrounding panels of tracery; and the partitions between the chapels are pierced with traceried lights and have the appearance of unglazed windows.

Another important rayonnant building is the church of St Urbain at Troyes (founded 1262; *Ills. 65–6*). Only the choir and transepts were completed in the Middle Ages, but the whole east end with its delicate pierced gables and unglazed tracery-work is clearly related to the shrine-like appearance of the Ste Chapelle. (St Urbain was actually a family commemorative chapel rather than a shrine.) It is unusual in not possessing a rose window in the transepts, but inside it has all the other rayonnant features – large traceried windows, a glazed triforium, secondary 'skins' of openwork tracery and panels of blind tracery.

64 (*far left*) North transept, Cathedral of St Nazaire, Carcassonne; after 1269

67 (*right*) Interior of presbytery, St Thibault-en-Auxois, *c*. 1300

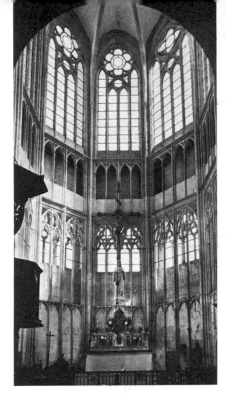

65 (*left*) Interior of St Urbain, Troyes, looking east. Founded 1262

66 (*below*) Exterior of St Urbain, Troyes, from the south-east

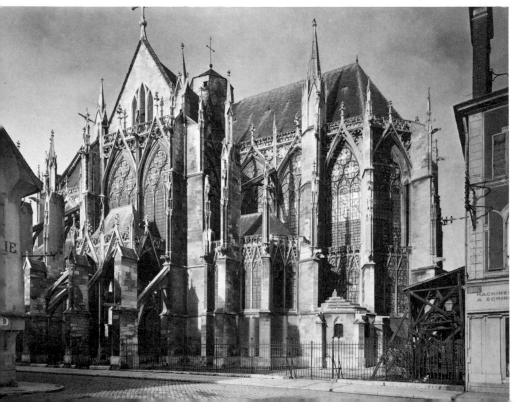

One last example of the style may be noted at St Thibault in Burgundy (*Ill. 67*). The choir of this church was rebuilt in about 1300 and housed the relics of St Theobald. Here the principle of applying to a building similar panels of tracery glazed, unglazed (openwork) and blind (across opaque wall surfaces) is worked out in an almost monotonously repetitious way: but the total effect of the surviving fragment of the building is extremely fine.

This whole development had a debit as well as a credit side. Briefly, it represents the triumph of grandiose general effects over detailed interest. This change is connected with the alteration in the status of the architect and represents the triumph of what in the thirteenth century would have been called science (or the intellect) over art (or craft). Architects ceased to be masons, in the sense that these men were artisan hewers of stone; instead they became masters of geometry – for the whole art of devising tracery patterns was grounded in a sound knowledge of the way in which basic geometrical figures might be manipulated. Such features as mouldings and capitals tended in this process to get whittled down in size and interest until they almost ceased to exist. Few French churches after 1260 tempt one to linger over their details.

It seems to be true that French architectural invention tended to stagnate after *c.* 1300. This may reflect the oppressive influence of Paris. Certainly French ecclesiastical architects played around with a very limited range of ideas during the fourteenth century. A church such as St Ouen at Rouen (begun 1318) merely restates with variations in tracery and considerable refinement in mouldings, the mid-thirteenth-century conception of what a large three-storey church should look like.

The rayonnant style was transplanted quickly to the Rhineland. Cologne Cathedral (begun 1248; *Ill. 68*) is French in almost everything except scale, since it exceeds in almost every direction anything built in France. However, the choir, the only part completed in the Middle Ages, has the by now familiar repertoire of ideas, deriving ultimately mainly from Paris. The architect is, nevertheless, known to have been German, and he was in particular strongly influenced by the new choirs of Amiens and Beauvais Cathedrals.

Another rayonnant building is the nave of Strasbourg Cathedral

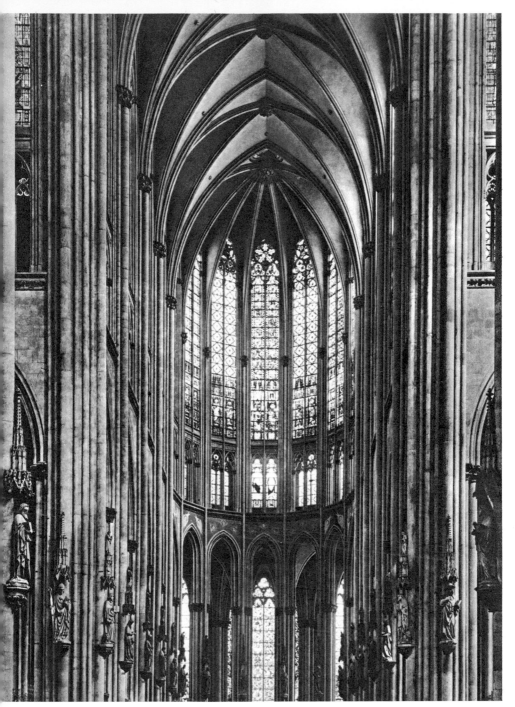

68 Interior of choir, Cologne Cathedral; begun 1248, consecrated 1322

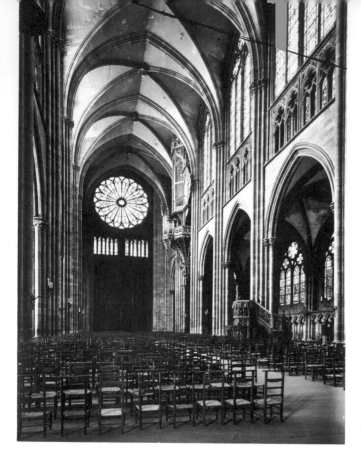

69 Interior of nave looking
west, Strasbourg Cathedral;
building begun *c.* 1245

(after 1240; *Ill. 69*). For technical reasons, connected with the re-use
of existing foundations this is unusually wide; but the elevation is,
in effect, a reworking of the elevation of St Denis in Paris. However,
a most original development of rayonnant ideas is to be found in the
Strasbourg west façade (*Ill. 70*). The present façade was begun in
1277 by a German architect called Erwin who had probably studied
façades in Paris and Rheims. It also seems likely that he knew the
church of St Urbain at Troyes. The main effect is made by the pat-
terns of the free-standing tracery which are extended with great
freedom in front of the main structure of the façade. The whole
design was intended to be crowned by slender open lantern towers
surmounted by spires. They were never built and the existing tower
is part of a series of changes made towards the end of the fourteenth

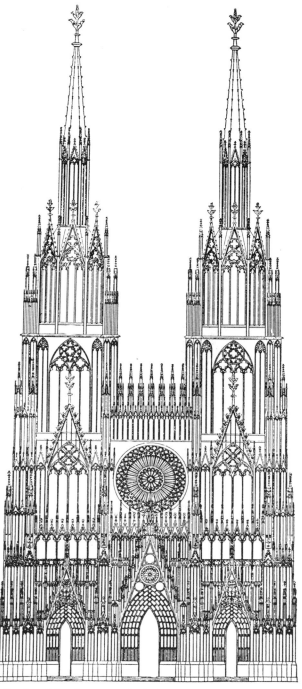

70 The façade of Strasbourg Cathedral as planned in 1277. This elevation
is based on thirteenth-century architect's drawings still at Strasbourg

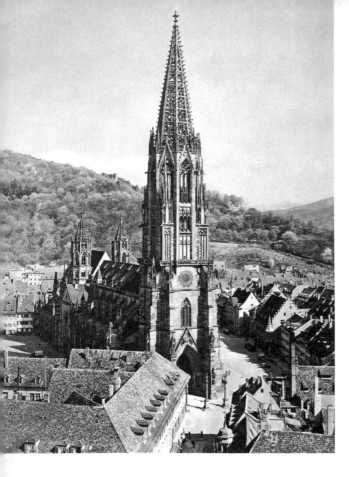

71 Western tower and spire, cathedral of Freiburg-im-Breisgau, c. 1330

century. But the designs were known; and they formed the basis both for the final design of the west façade of Cologne Cathedral (completed in the nineteenth century) and of the tower and spire at Freiburg-im-Breisgau (*c.* 1330; incidentally the only openwork tower and spire actually to be completed in the fourteenth century; *Ill. 71*).

Both Cologne and Strasbourg were built after the fashion of the basilicas with the nave taller than the side aisles. The popularity of the hall-church in Germany has already been mentioned, and there is a long series following on the church of St Elizabeth at Marburg (see above, p. 37). In the treatment of detail, these followed a reasonably predictable course if one bears the developments in France in mind. Mouldings became thinner, windows became larger,

tracery patterns more complicated (see for instance the church of St Katharine, Oppenheim); in the Wiesenkirche at Soest (begun 1331; *Ill. 72*) it will be seen that capitals have vanished entirely, the main vault-ribs now descending in an unbroken line to the floor of the church. The unique feature of a hall-church was the fact that the main vaults were all at the same height. In a large church, this presented an immense unbroken area of vault to any architect anxious to experiment in vault design. However, it was not until the second half of the fourteenth century that German architects began to develop these potentialities, and it is one of the curious features of the history of the period that some of the ideas which they developed seem to have been derived from England. The most spectacular German vaults belong to the fifteenth century and lie outside the scope of this book.

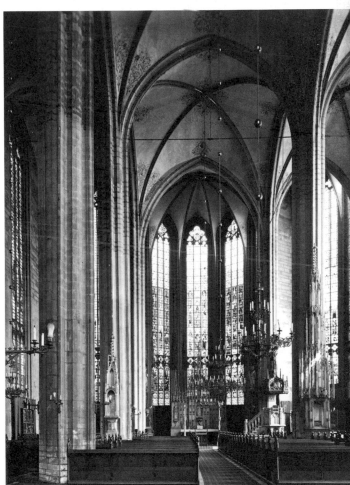

72 Interior looking east, Wiesenkirche, Soest; begun 1331

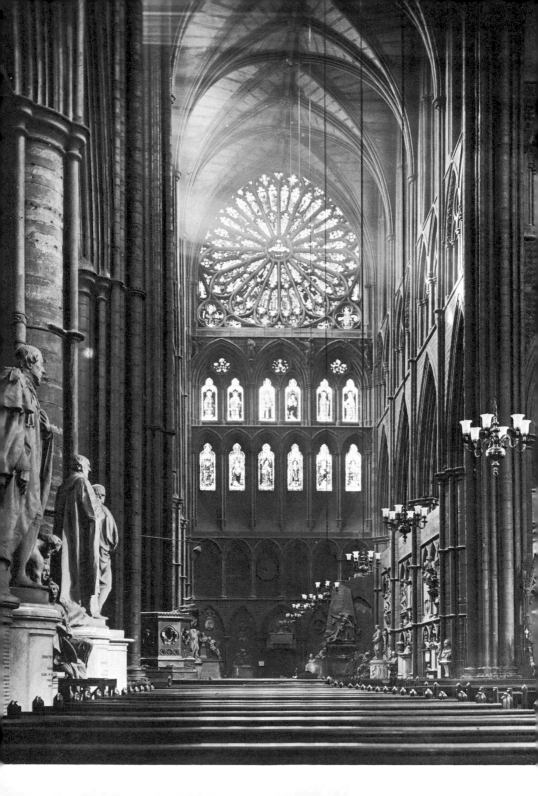

The course of events in England was less straightforward than it was in Germany. The only great church with serious pretensions to a rayonnant style is Westminster Abbey (*Ill. 73*). Henry III assumed responsibility for its rebuilding in 1245, and the existing thirteenth-century parts probably date from this period. The church was incomplete at Henry's death in 1272, much of the nave being a skilful imitation of the thirteenth-century style, put up in the late fourteenth and fifteenth centuries. Many of the features of Westminster Abbey are obviously un-French. The shape of the piers is reminiscent of Salisbury and the inclusion of a tribune gallery was out of step with Parisian standards. Yet it is certain that the architect had a close knowledge of the Parisian achievements. The clerestory is unusually tall and slender by English standards and is supported externally by flying buttresses. This is the first really large English church in which the clerestory passage was abandoned. The tribune gallery, notwithstanding the gallery behind it, reproduces the double layer of tracery commonly found in the glazed triforia of France. The plan of the east end stands alone among English church plans in reproducing a fairly authentic French *chevet*; and the transept fronts with their great rose windows are heavily influenced by the rayonnant transept façades of St Denis.

Another important influence at Westminster was the Ste Chapelle in Paris. Westminster Abbey is covered with an unusual amount of surface ornament. Most of the painting is now lost; but there is a great deal of carved diaper ornament and many arch spandrels are carved with figures (see below, pp. 116–7) and foliage. Some of these innovations in Westminster found little response among English masons. Exposed flying buttresses, for instance, never became popular. In one feature, however, Westminster had a profound effect, namely in the popularization of bar tracery. In this respect, the chapter house, which has extremely large traceried windows, has a chronological importance, since it was virtually complete by 1253.

The influence of the rayonnant façades of Westminster was not enormous, but one immediate emulation is to be found in the east end of Old St Paul's, London (*Ill. 74*), the rebuilding of which was begun in 1258. The design included a large rose window with traceried spandrels, and beneath it, a series of lancets, an elongated

73 South transept, Westminster Abbey, London, after 1245. Just visible is the double tracery of the tribune gallery

equivalent of the glazed triforium. Moreover, apparently to give the front an authentic French flavour, the centre is abutted by a double bank of flying buttresses on either side, regardless of the fact that in the absence of double aisles, the intermediate supports sit uncomfortably over the centre of the aisle windows.

In two particular features, Westminster was out of line with developments elsewhere in England. It was sparing in its use both of attached shafts and of vaulting ribs. This can be seen by comparing it to the nave of Lincoln Cathedral, and it is interesting to find that in the Angel Choir at Lincoln (begun 1256) the architect combined the tradition of the nave with the main decorative features of Westminster. For this reason, one finds here not only the full repertoire

74 East elevation of medieval St Paul's Cathedral, London; begun 1258

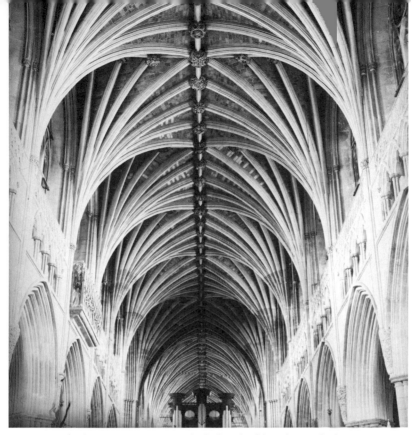

75 Interior looking east, Exeter Cathedral; rebuilding begun before 1280, nave fourteenth century

of shafts and ribs but also traceried or carved spandrels, double skins of tracery both in the tribune gallery and clerestory, and large windows filled with bar tracery. It is perhaps of interest that he made no attempt to follow the architect of St Paul's and to produce a rayonnant east façade.

In the West of England, the decorative possibilities of mouldings, shafts and ribs were pushed to their utmost, regardless of what was happening in London. Exeter Cathedral (begun before 1280; *Ill. 75*), Wells Cathedral retrochoir (begun 1285), and Wells Chapter House (early fourteenth century) all make their visual impact through these features. The main influence of Westminster is to be seen in the immediate popularity of bar tracery, mainly on account of the patterns which could be devised with it. It is true that the cathedral of

Exeter was designed without a tribune gallery, but this is the only point at which it may be said to be up to date by international standards. Otherwise, the details are thick, the vault gives an impression of overwhelming weight and, above all, there is a lack of continuity in the patterning itself. There are no continuous vertical shafts, the triforium is divorced from the clerestory, and the clerestory windows, recessed under the vault, contribute comparatively little to one's general impression of the interior.

It is at this point in English architectural history that one enters what is called, with some understatement, the Decorated Period. The years c. 1280–1350 were ones of great experiment. In this short survey, such extraordinary achievements as the choir of Bristol Cathedral or the octagon of Ely Cathedral must be ignored in order to examine what we know, with historical hindsight, to have been the mainstream of development. In doing so, we are in effect watching the process whereby the traditions still visible in Lincoln and Exeter yielded gradually to the distinctively English version of the rayonnant style called 'Perpendicular'.

This development is, predictably, centred on London, but there is one notable outlying building which must be considered first: the new nave of York Minster, founded in 1291 (*Ill. 76*). York is an enormous building and its very width makes it hard to compare to anything in France. However, if it is compared to a building such as the nave of Strasbourg, it will immediately be apparent how much closer it is to the rayonnant style. There is little of the heaviness of Exeter, the vaulting ribs rest on shafts which run unbroken to the floor of the church. There is no tribune gallery, but it is especially important that the tracery of the clerestory windows forms a continuous pattern with the arcade of the triforium although the triforium is not glazed. The nearest French pattern for York in this respect is probably the cathedral of Clermont-Ferrand, begun 1248, or Narbonne, begun 1272.

In its vault, York differs from all French or Continental buildings. Like most Continental vaults, it has transverse and diagonal ribs; and like most English vaults, it has a ridge rib. Slung between these main ribs are short subsidiary ribs called 'liernes' which form the basis of a completely new idea for vault patterning. At York, the

104

76 Nave, south arcade, York Minster; founded 1291

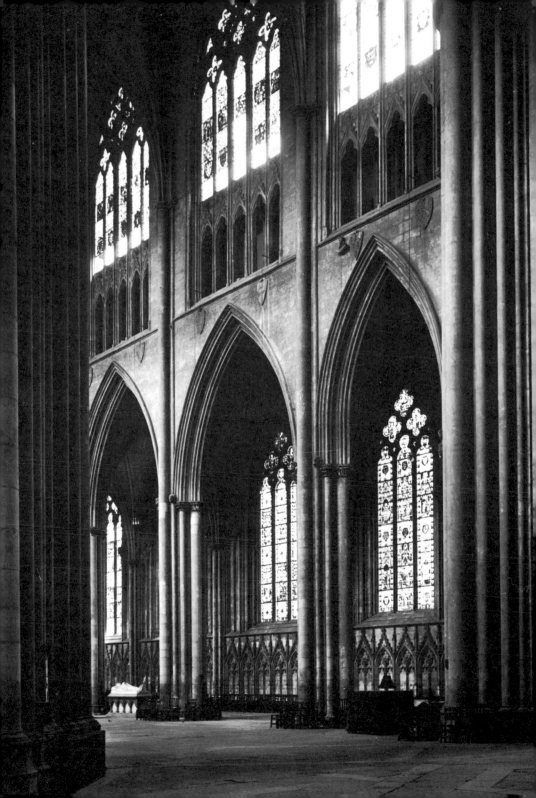

pattern is created not by increasing the number of main ribs (as at Exeter), but by reducing their number and filling in the spaces between.

The invention of the lierne ribs may have occurred in London. They are used in the lower part of St Stephen's Chapel, Westminster, the only part to survive the fire of 1834. This royal chapel was begun in 1292 and sufficient is known about it to see that the architect combined with this new idea for vaulting a newly imported idea for wall decoration, the traceried panel. Both outside and in, blind panels of tracery were used to cover exposed wall surfaces.

The first major building in which one can measure the combined effects of these innovations is the choir of Gloucester Cathedral (begun shortly after 1330; *Ill. 77*). The intention here was to create a suitable setting for the tomb of Edward II, and even without detailed analysis it will be seen that its effect depends on the use of traceried panels, either blind or pierced or glazed. This tracery embraces not merely the clerestory and intermediate storey (as at York), but descends right down to the ground. Combined with this is a lierne vault of far greater complexity than anything so far seen.

One final development followed logically from this, but it is unfortunately impossible to know for certain where it occurred first. This was the abandonment of the accepted system of vault decoration and its replacement by a system of tracery panels similar to those used on vertical surfaces. However, from such evidence as survives this development must be referred to the final chapter.

The history of the rayonnant style in Spain in terms of major building operations is confined to two cathedrals, Leon and Toledo. Leon Cathedral (*Ill. 78*) was begun in 1255 – a near contemporary of Cologne. Like Cologne, it is both in plan and elevation much influenced by the French example. Certain features, such as the form of the windows and the design of the piers, suggest Rheims, although Leon has also a large clerestory linked to a glazed triforium.

The rebuilding of the nave and transepts of Toledo Cathedral was begun in about 1300. The design, apart from the vaulting, is strangely similar to the nave of York, since both have a triforium arcade (that at Toledo is now transformed into a plain window) composed of narrow arches, each of which corresponds to one light of the window

106

77 Choir looking east, Gloucester Cathedral; begun soon after 1330

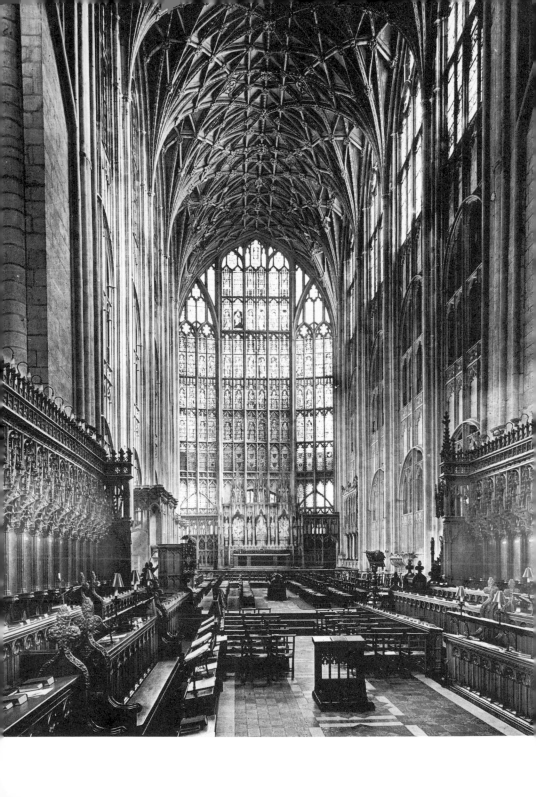

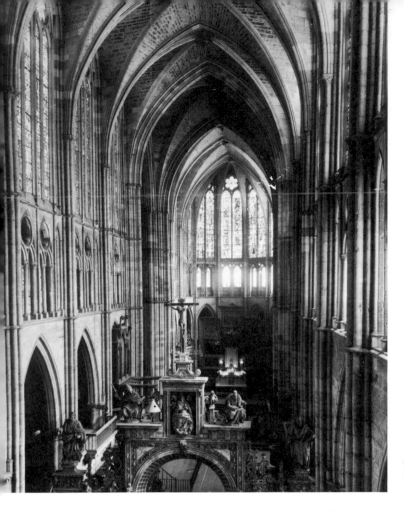

78 Interior looking east, Leon Cathedral; rebuilding begun 1255

above. Toledo may also have been influenced by Clermont-Ferrand and Narbonne, but it should be added that the triforium when it existed was glazed. Nevertheless, the vault supports of Toledo, with the large vertical attached columns and heavy capitals, are extremely old-fashioned for the date.

The three great undertakings of the early fourteenth century were Gerona (begun *c.* 1292), Barcelona (begun 1298), and Palma de Mallorca (begun *c.* 1300). The design of none of these has any obvious connection with the rayonnant style. In plan, they form part of a group of churches which includes the cathedral of Albi (begun 1281), and they are distinguished by a continuous line of tall

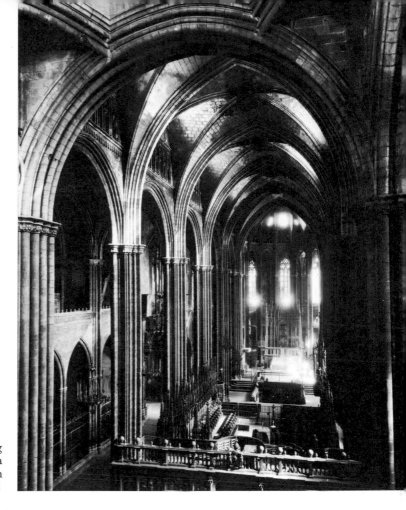

79 Interior looking east, Barcelona Cathedral; begun 1298

peripheral chapels sandwiched between the main buttresses (Palma has a different east end). Unlike Albi, however, these churches have inserted into the plan aisles with inner arcades of immense height, surmounted by a comparatively small upper storey lodged within the curve of the vault. It has already been observed that this idea, already used at the east end of Toledo, derives ultimately from Bourges. Yet these churches do not look like Bourges, or Toledo, or indeed like each other. Barcelona (*Ill. 79*) was probably the most influential, since the architect introduced a strongly horizontal triforium gallery, which recurs as a feature in later Spanish churches (as at Seville or Astorga).

It has already been remarked that the reign of St Louis marks the beginning of serious consistent secular court patronage in the history of European art. Isolated kings and emperors had, before this date, built chapels and palaces and patronized artists. From the time of St Louis, however, the French court remains almost consistently at the centre of northern European artistic developments; art in the rest of Europe will frequently to be found on examination to be a reflection, perhaps in distant and local terms, of something that had already happened in Paris.

We have already seen how St Louis set a new fashion in sumptuous palace chapels. He appears, as will be shown, to have been the first bibliophile to have his library custom-made specially for himself. One might expect to find therefore indications of a court-style of sculpture; and, in view of the general elegance and daintiness of the manuscripts, the sculptural style of the Joseph Master at Rheims (*Ill. 31*) would seem a likely candidate for the role. The major sculpture surviving from the Ste Chapelle suggests that the development is not quite so straightforward. The most exceptional Ste Chapelle Apostles (? before 1248; *Ill. 81*) can be related stylistically to the *Vierge Dorée* of Amiens (after 1236), and it will be seen that they do have a certain rather dainty, modish demeanour. But the drapery is much heavier than that of the Joseph Master, falling in great baggy folds. In this, however, they are exceptional, and most French sculpture for the next century appears to oscillate between the Rheims and Ste Chapelle styles.

The details of this period are still very obscure, but it does appear to be one of stylistic stagnation. For instance, if one examines the differences between the sculpture of 1140 and 1240, one is left in no doubt that a great deal had happened; and bearing this degree of change in mind, one might be pardoned for supposing that the Virgin of Jeanne d'Evreux (*Ill. 80*) was executed not long after the Rheims sculpture, although it is known to have been made in or shortly before 1339.

It is true that sculpture exists which cannot entirely be reconciled to this picture. Such is the Virgin from St Aignan (now in Notre Dame in Paris). She is clothed in drapery drawn out in very narrow

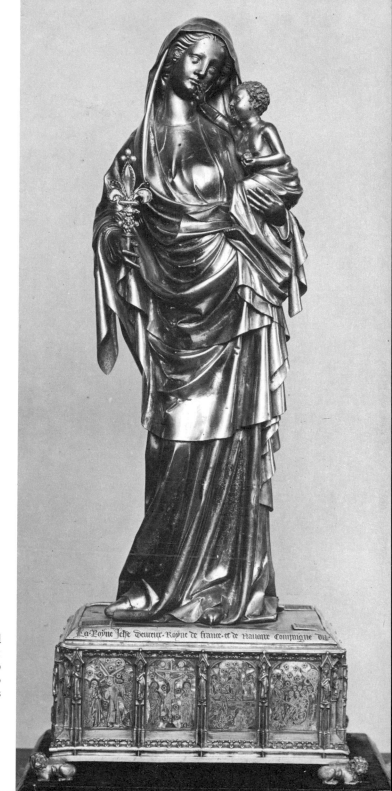

80 The Virgin and Child. A silver-gilt statuette given in 1339 by Jeanne d'Evreux to the Abbey of St Denis

folds with sharp ridges (*Ill. 82*). She is usually dated to *c.* 1330, but in the present state of knowledge one can hardly do more than present her as a deviation from an assumed norm. As a general rule this was not a great period for architectural sculpture. There are a number of great portals which date from the second half of the thirteenth century (for instance at Bourges and Poitiers) but they merely repeat ideas already formulated in Paris, Amiens and Rheims in what may be described as this mid-Gothic style of no great distinction.

One innovation made an appearance but failed to become popular, although it would seem to be an obvious extension of the rayonnant style. This was the division of the tympanum, not by horizontal lintels, but by tracery patterns. This feature was to be found on the (destroyed) church of St Nicaise, Rheims (founded 1231). Rheims Cathedral has glazed traceried tympana. Later, unglazed traceried tympana were installed elsewhere, as at Sens (after 1268) and at St Urbain, Troyes (founded 1261), but the idea never became wide-

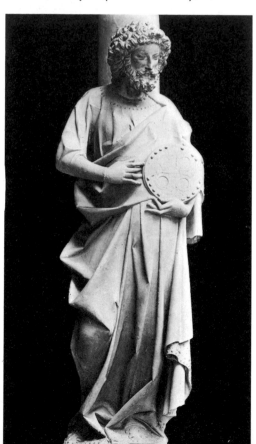

81 Apostle, Ste Chapelle, Paris, 1243–8

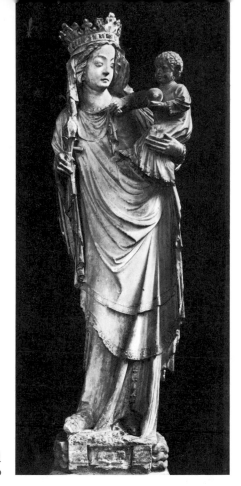

82 Virgin and Child
from St Aignan, *c.* 1330

spread. Other detailed ideas also enjoyed a brief popularity – for
instance, the extensive use of carved quatrefoils on the lower parts
of portal jambs (as on the transept portals of Rouen Cathedral, after
1281).

The field of sculpture which really expanded in this period was
that commanded by the private patron and concerned with his
immediate private interests – sculpture connected with family
palaces and family chapels and mausolea. Of all this so-to-speak
private sculpture, the most substantial remains are on the tombs,
although even these have come down to us in a sadly fragmentary
condition. Louis IX had a strong sense of family history, and the
remains exist of a long series of monuments commissioned by him to

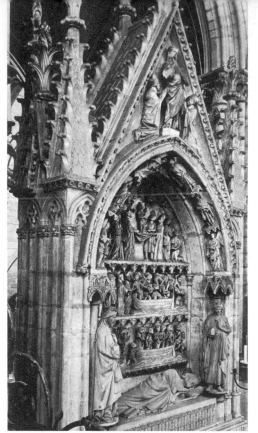

83 Tomb of Dagobert I (died 638,) St Denis, Paris, *c.* 1260. One of the many monuments remade at the order of St Louis. The detail is heavily restored but the main outlines of the monument are medieval

84 Tomb of Louis de France (died 1260), eldest son of St Louis; St Denis, Paris; *c.* 1260. Originally in the abbey church of Royaumont

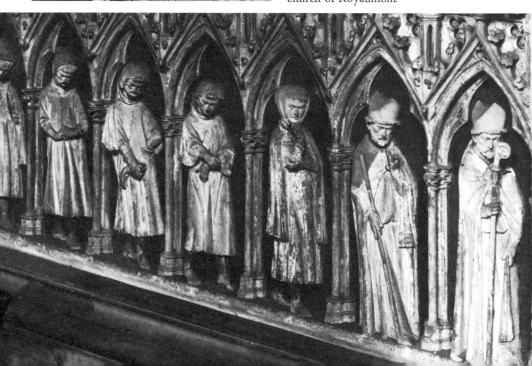

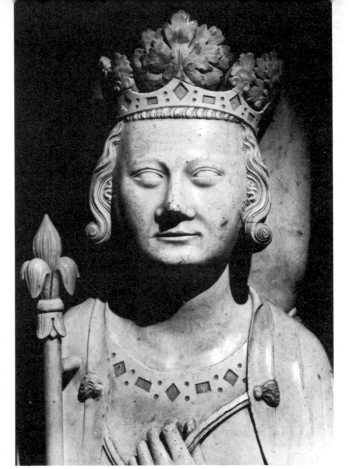

85 Effigy of Philippe IV le Bel (died 1314), St Denis, Paris. Ordered in 1327. Although not as individual as the more celebrated effigy of Philippe III le Hardi, this head with its long thin lips and broadly splayed nose has a definite character of its own

mark the re-interment of members of the Carolingian and Capetian houses of the distant and not-so-distant past. They were executed mainly in the years immediately following 1260. That to Dagobert (in St Denis), although much restored, has an interest in that it preserves its original canopy (*Ill. 83*). No other canopies survive, but many of the monuments preserve the tomb-chests. The sides of these were now decorated with small figures set in arcades and generally representing relatives, called 'weeper-figures'. Sometimes they are depicted as grief-stricken. Another motif was the funeral procession of the deceased (*Ill. 84*). One important development took place in the effigy: more attention was now paid to giving the face the features of the person it was supposed to represent. This appears to mark the beginnings of serious portraiture (*Ill. 85*).

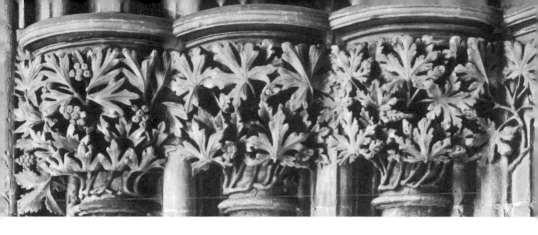

Westminster Abbey, so important as a monument to French influence on English architecture, has in this connection a reduced importance for sculpture. Certain ideas concerning the use and arrangement of sculpture were obviously French. The main north

86 (*left*) Capitals with naturalistic foliage decoration, entrance to the chapter house, Southwell Minster, *c.* 1295

88 (*right*) Virgin of the Annunciation, chapter house, Westminster Abbey, London; probably 1253

87 (*opposite*) Censing Angel, south transept of Westminster Abbey, London; probably 1250s

portal possessed column figures and the tympanum was divided something after the manner of that of St Nicaise, Rheims. There is copious spandrel carving which reflects the influence of Ste Chapelle. Yet the *style* of the sculptures which survive is not that of contemporary France. It seems instead to be a compound of the Chartres-Amiens-Wells style of *c.* 1220–5 (*Ills. 87, 88*). One looks in vain for the heavy drapery folds of the Ste Chapelle sculpture and the later figures at Rheims. It is only with the sculpture of the Angel Choir of Lincoln (after 1256) that these make their appearance.

During the second half of the century, the fashion for naturalistic foliage carving, already noted at Rheims and Naumburg, spread to England. Such foliage is found carved on the bosses of the Angel Choir at Lincoln. It then appears, more famously perhaps than anywhere else in Europe, in the chapter house at Southwell (1290s; *Ill. 86*). This brief phase is interesting since it was perhaps the last time in the history of medieval architecture that capitals were treated as independent centres of interest. The current tendency was towards subordinating the individual parts of a building to the total effect.

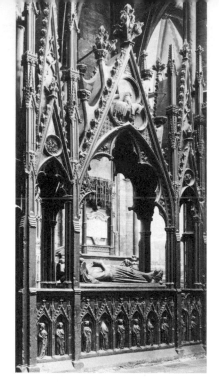

89 Tomb of Edmund 'Crouchback', Earl of Lancaster (died 1296). Westminster Abbey, London, *c.* 1296

As in France, much of the most individual sculptural work from now on went into private family enterprises like tombs. The English royal family commissioned some splendid tombs, many of which still survive in Westminster Abbey, in the hemicycle surrounding the shrine of Edward the Confessor. That of Edmund Crouchback (executed *c.* 1295–1300; *Ill. 89*) survives virtually intact, even retaining some of its original colouring. Like the monument to Dagobert (see above, p. 115) it has a large canopy, and, like other contemporary French monuments, the sides are ornamented with family 'weepers'. Occasionally important monuments depart from this general pattern, and none more strikingly than that of Edward II (after 1330; *Ill. 90*). Imitating a current French court fashion, the effigy is not of bronze or painted stone but white alabaster. The canopy, however, departs radically from all that we know about French or English court monuments in its tiers of elaborate arcading. The nearest parallels outside the West of England (although later) are to be found in the papal tombs at Avignon (especially that of John XXII, 1345). The nature of this connection is far from clear.

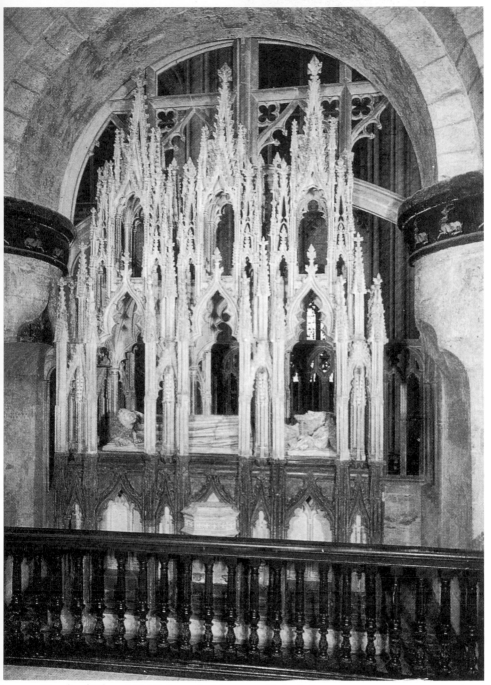

90 Tomb of Edward II (died 1327), Gloucester Cathedral, *c.* 1330–5

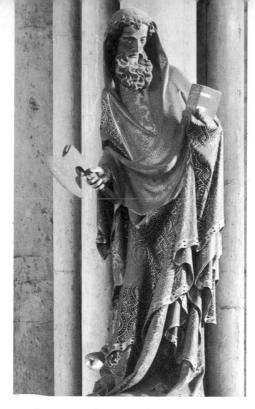

91 (*left*) St Matthew from the choir of Cologne Cathedral; probably shortly before 1322

92 (*opposite*) Three Prophets from the west front of Strasbourg Cathedral, *c.* 1300

The west façade of Strasbourg (begun 1277) has already been mentioned (see p. 96). Much of the sculptural decoration of this façade survives, and part of it derives its dainty style from the Joseph Master of Rheims. The Wise and Foolish Virgins who reappear are far more restrained than their predecessors at Magdeburg, but there is nevertheless a great deal of mannered movement and gesture. The Apostles in the central porch (*Ill. 92*) are much harder to place stylistically. Many of their faces are engulfed in bushy beards with carefully contrived curls, after the manner of the Joseph Master, their bodies are masked by bulky drapery which descends in tumbling dramatic folds, and their whole expression has an intensity which is foreign to Rheims, but may have been inspired by the earlier Gothic sculpture of Strasbourg itself.

It is, however, the dainty, elegant style of Strasbourg which is more typical of this whole period. The west portal of Freiburg-im-Breisgau (*c.* 1300) is directly dependent on Strasbourg; and the sculpture in the choir of Cologne Cathedral (*Ill. 91*) is also very similar.

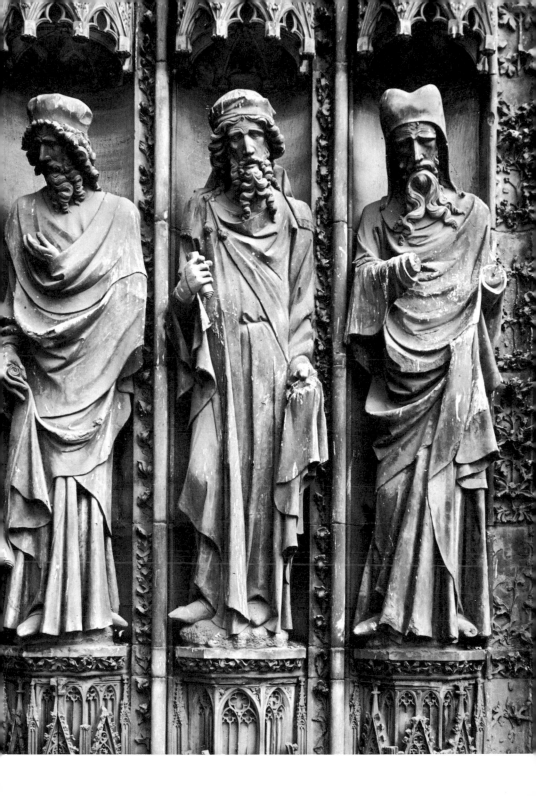

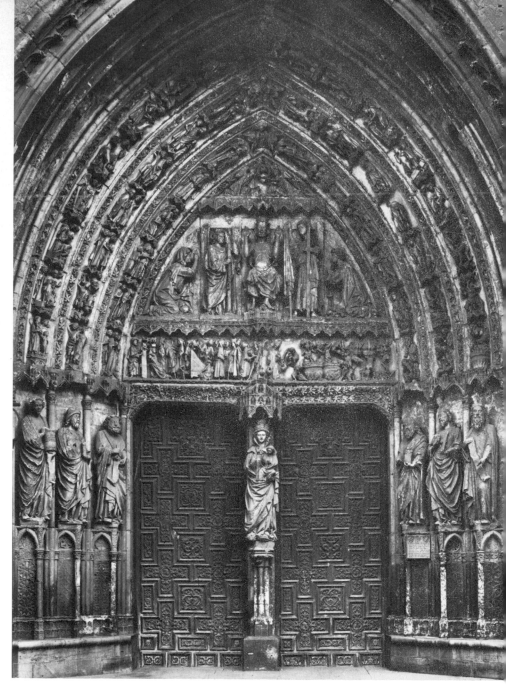

93 West portal (Portada del Virgen Blanca), Leon Cathedral, second half of thirteenth century

94 Tomb of Gonzalo de Hinojosa, Burgos Cathedral; probably *c.* 1327

The major portals of this period in Spain are attached to the cathedrals of Leon and Toledo. Those of Leon belong to the second half of the century (*Ill. 93*). The type of west porch appears to be derived from Chartres; but the sculpture itself relates first to Burgos and then back to France (probably to Amiens and Rheims). Following the current fashion, a certain amount of naturalistic foliage is carved over the doors. The portals of Toledo were added to the newly constructed nave and transepts during the first half of the fourteenth century, and the figure style conforms to the graceful type of Gothic that we have seen elsewhere at this time.

It is remarkable that Spain possesses a very considerable number of sepulchral monuments from this period which, as a group, illustrate well tendencies already noted elsewhere. The dramatization of the monument was particularly popular, and there is a long series that includes a funeral procession as part of the decoration. A fine example is the tomb of Bishop Gonzalo de Hinojosa (d. 1327; *Ill. 94*) at Burgos, since this combines what appears to be a portrait effigy with a tomb-chest of remarkably high quality.

123

It is known that Louis IX built up a library of manuscripts and himself commissioned a number of works. A few of these survive, and they mark the beginning of a new style. The chief examples are Louis' own psalter (Paris, Bib. Nat. Lat. 10515) executed between 1252 and his death in 1270; the psalter of his sister, Isabella of France (Cambridge, Fitzwilliam Ms 300), and the majority of an Evangeliary of the Ste Chapelle in two volumes (Paris, Bib. Nat. Lat. 8892 and 17326). The psalter of St Louis (*Ill. 95*) is a luxurious book, with a preliminary group of seventy-eight full-page illuminations of scenes from the Old Testament. These are remarkably uniform in their layout. Each page contains a row of figures surmounted by a handsome architectural canopy which is derived in style from the current rayonnant taste, with pinnacles, traceried windows, and two large gables each containing a rose window. It is worth noting that this type of decoration can equally well be found in the small reliquaries of goldsmiths. This is a reminder that the rayonnant style was primarily a decorator's style, concerned in architecture with the application of pattern rather than the manipulation of mass. Many of the motifs of rayonnant style could be transferred effectively from the architect's drawing board to the illuminator's vellum. Architectural motifs also figure prominently in the psalter of Isabella and the Ste Chapelle Evangeliary.

With these manuscripts, all trace of the damp-fold style finally vanishes. Drapery falls with reasonable naturalism over the figures. It hangs rather than clings; and is caught up into soft broad V-shaped folds of a kind already seen in sculpture. The figures are dainty in their proportions and actions and have long arms which they tend to gesticulate. But it is perhaps in the heads that the change is most obvious. They are tiny in proportion to the bodies and are scarcely coloured, much less modelled in colour. The main features are drawn in, each head representing a minute triumph in penmanship. In the formation of this style, the influence of sculpture seems likely. The general elegance of the style had been preceded by the elegance of the Joseph Master at Rheims, and the way in which the hair is stylized into minute spiralling curves recalls the Joseph Master's work (*Ill. 31*). Further, the undersized chinless faces of the women must

95 Balaam and his Ass, page from the Psalter of St Louis; between 1252 and 1270

be related to the smiling females and angels at Rheims. Thus the masons appear to have had an important hand in creating the stylistic *milieu* to which the St Louis Psalter belongs.

Of the other two books, one particular innovation should be mentioned although it does not occur in the St Louis Psalter. It concerns the illumination of text-pages. Normally, decoration of text-pages had been confined to the illumination of the main initial letters of the text, but it is during this period that the decoration begins to spread into the margins. Louis' illuminations were here following an existing fashion already established in England and the northern areas of France (see below, p. 140), but it is interesting to note how 'tastefully' the idea is managed in the Parisian books. There are almost no grotesques. Instead the initials sprout long spiky excrescences which extend up and down the margins of the pages.

The names of the illuminators of Louis IX are not known. However, the name of one of his grandson's artists was Master Honoré and he worked for the court of Philip the Fair (1285–1314). Little is known about his career. He lived in Paris on the south bank, and there are three documentary references to him, in 1288, 1293 and 1296 respectively. He appears to have died before 1318. A small group of manuscripts can be attributed to him and it is clear that by his time the style of Louis IX's painters had been significantly altered.

His illumination is still extremely graceful and elegant, but architectural motifs play a far smaller part in the decoration (*Ill. 96*). Faces and hands are extremely pallid and almost completely without colour, even more emphasis being laid on the drawing. By contrast, the drapery is fuller and the folds heavier. This is accomplished by a development in the modelling technique, for there is far more suggestion of light and shadow. The forward surfaces of folds are given the suggestion of a white highlight. This development is not without interest because it may represent the first impingement of Italian Gothic painting on the north. The main problem is one of dating. The earliest dated manuscript from Honoré's shop was produced sometime before 1288, but already before 1278 this modelling is found in a martyrology from the abbey of St Germain-des-Prés (Paris, Bib. Nat. Lat. 12834). The development of this type of

126

modelling in Italy is associated with the Roman master Cavallini and the so-called 'Isaac Master'. Although Cavallini's known career extends back to 1273, nothing survives that antedates the years around 1290 (see below, p. 183). The development should have been an Italian one transmitted to France, but its details are hard to piece together.

Honoré's work marks a further stage in evolution of Parisian page decoration. The long excrescences noted in the earlier manuscripts now grew leaves and the first examples appear of the spiky ivy-leaf which was to dominate the decoration of Parisian manuscripts for more than a century. Moreover, one manuscript, a Book of Hours now at Nuremberg (Stadtbibliothek, Solger in 4-to, 4; *Ill. 97*) has a text-page layout which came to be almost universally adopted for Books of Hours during the fourteenth and early fifteenth centuries. The Nuremberg manuscript is puzzling since its contents show that it was designed for use in England or by someone with English connections. It is, however, certainly a Parisian production. The page illustrated shows the opening of the Hours of the Virgin. The upper part of the page is occupied by an illustration, still at this stage connected to the initial letters of the text. From this illustration springs foliage decoration which branches down and round to enclose the text beneath. This scheme is satisfactory since the foliage sprays bind text and picture together to form a pleasing surface pattern, and it is not surprising that it was widely adopted.

The tradition of Honoré was probably continued by his son-in-law Richard of Verdun, who is known to have been employed by the Ste Chapelle in 1318. Unfortunately, no books have survived which can be attributed to Richard, and the next royal illuminator whose work is identifiable was Jean Pucelle. Pucelle first appears in an account-entry made between 1319 and 1324; and then in the colophon of a book dated 1327. We have no further documentary information, but his name features in some marginal notes in a Breviary datable to before 1326 (*Ill. 98*). Books attributable to him exist up to the middle years of the century; in all, there are more than a dozen such manuscripts.

Pucelle may possibly have worked under Honoré (*Ill. 96*), for their work is in some respects very close. The drapery has the same soft

96 Humility, Pride, the Sinner and the Hypocrite. Page from a text of *La Somme le Roy*, illuminated by Master Honoré; probably *c.* 1290

eus madutorium meum intende.

omine ad adiuuandum me festina.

loria patri et filio: et spiritui sancto.

icut erat inprincipio et nunc et semper: et in

secula seculorum amen. Alleluya. In Vitator.

ue maria gratia plena dominus tecum. ₱

Enite exultemus dño iubile

mus deo salutari nřo. preocu

97 Book of Hours from the workshop of Master Honoré. Opening page of the Hours of Virgin, probably *c*. 1290

modelling, and in Pucelle's presumed early work faces and hands are delicate and pallid. Nevertheless, a great many new features appear in the course of Pucelle's career. In a sense they were embellishments to an existing style. For instance, it was really under his guidance that grotesque *drôleries* and other forms of marginal embellishment became accepted in Parisian circles; and their acceptance was largely the result of Pucelle's own deft and polished application of them. A page from the Belleville Breviary (Paris, Bib. Nat. Ms Lat. 10488; *Ill. 98*) reveals a wide range of decorative invention embracing naturalistic flowers, insects, birds and animals and grotesque little men playing musical instruments. But the whole effect is extremely tightly controlled, associated as it is with a firm regular framework of narrow bars. The quality of this type of decoration is very high indeed.

The influence of Italian ideas becomes even more marked in Pucelle's work, and it has been suggested that early in his career he actually went to Italy. Italian iconographical schemes appear, as for instance in the Crucifixion scene of the Book of Hours done between 1325 and 1328 for the Queen Jeanne d'Evreux (New York, The Cloisters Museum, f. 68v). This represents the Crucifixion taking place in a gesticulating crowd, for which comparisons may be made with the Maesta of Duccio (1308–11; see below, p. 194). It is also noteworthy that Pucelle's range of facial types and expressions increased far beyond that of Honoré, and again it would appear to be Italian art that suggested these increased dramatic possibilities.

However, the most obvious influence of Italy is to be seen in the awakening of Pucelle's interest in pictorial space (*Ills. 98, 103*). This is possibly the most revolutionary feature of his work. The exploitation of various rudimentary forms of perspective was a completely new feature of late thirteenth-century Italian painting, and Pucelle incorporated something of these experiments into his manuscript illumination. The page illustrated from the Belleville Breviary shows David and Saul enclosed within a small doll's-house-like construction, painted erratically but clearly in three dimensions. There is, too, a specifically Roman feature included: the coffered ceiling inside the building. Many other examples exist of figures placed in three-dimensional settings.

These attempts of Pucelle to absorb the elements of Italian spatial construction and convert them to his own uses introduced an element of contradiction into manuscript painting from which, one might almost say, it never recovered. Was the page decorator trying to open into the page a tiny 'window on the world' through which the reader peeped at a vignette of three-dimensional existence? Or was he embellishing a two-dimensional text with a two-dimensional pattern? This conflict becomes clearer in the course of the century.

One further innovation made by Pucelle may be noted since this was widely imitated in the next half-century. This was the *grisaille* painting – executed in monochrome grey sometimes with very light tinting. The Hours of Jeanne d'Evreux, mentioned above, are all decorated in grisaille. Once again, this appears to be a transposition of an Italian idea, since Giotto, for instance, had executed part of the decoration of the Arena Chapel, Padua (*c.* 1310) in grisaille. The glaring dissimilarities, however, make the Italian connection obscure.

The influence of Italy becomes, from now on, a constant pre-occupation of the art historian, and it is most unfortunate that almost nothing is known of large-scale Parisian painting at this time. Following the break-up of Roman patronage when the papacy moved from Rome (1305), three Roman painters made their way to France, where they were employed by the court during the first two decades of the century. Nothing survives of this work, but it may be that Pucelle's interest in Italian art was stimulated by the presence of these foreigners. The type of innovation which he carried into manuscript painting may already have appeared in France in panel- and wall-painting.

To return to the thirteenth century: the influence of the new style found in the books of Louis IX shortly reached England. Henry III, while he commissioned a great many paintings for his palaces and chapels, was unfortunately not a bibliophile. Almost all the painting on a larger scale has vanished and we do not, by way of compensation, possess a nucleus of royal manuscripts such as is found in France. Two works survive, however, which, although not commissioned for Henry III, may nevertheless come within this category. The first is known as the Douce Apocalypse (Oxford, Bodleian Lib. Ms Douce 180). This manuscript, one of an extraordinary number

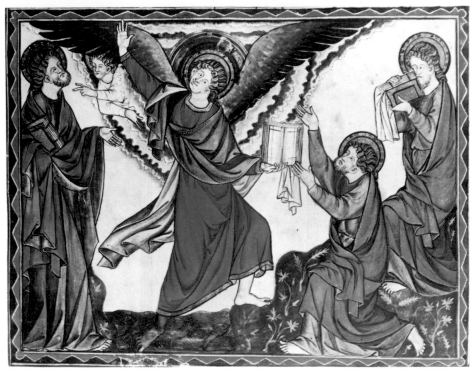

99 Illustration from the so-called Douce Apocalypse; probably *c.* 1270

of Apocalypse manuscripts produced during the thirteenth century, was made for Henry III's son, Edward, at some date before his accession to the throne in 1272. Thus it probably follows the St Louis manuscripts and antedates all the known work of Master Honoré.

In style, this manuscript (*Ill. 99*) appears to be somewhere between the two. In any case, it is by no means clear that it was illuminated by an artist trained in England. The general build of the figures is closer to those of Honoré, as is also the pallor of the faces. The stylization of the hair and beards is also similar; and the drapery is now shaped into large hanging folds which contrast sharply with the previous tradition of smaller looping tubular folds (compare *Ill. 95*). What the drapery lacks, however, is the soft modelling by light which is such an obvious feature of Honoré's style. By comparison, the painting of the Douce Apocalypse has a rather flat, matt appearance, most of the form being indicated by line.

98 Belleville Breviary from the workshop of Jean Pucelle; probably between 1323 and 1326

100 St Peter, detail of the Westminster Retable. Perhaps the last quarter of the thirteenth century

The second book is a psalter intended for Edward's son Alfonso. He died in 1284 and some of the decoration of his psalter (London, B. Mus. Add. 24686) belongs to a later date. Those parts of the manuscript, however, which belong to the earliest and best phase (before 1284; *Ill. 101*) again show strong French influence. Comparisons may

again be made with Master Honoré's style and the St Germain Martyrology and it seems that the careful modelling of the Parisian workshops is already in evidence here. The exact inter-relation of all these styles is obscure, but both these manuscripts show that, in taste, the court in London was following the court in Paris fairly closely.

This court style survives on a large scale in Westminster Abbey. Two wall-paintings in the south transept, a further wall-painting in the chapel of St Faith, and an altarpiece painted on panel are all in a style comparable to that of the Douce Apocalypse. The wall-paintings, although they would appear to be slightly inferior in quality to the altarpiece, are of interest since almost nothing else of this quality on this scale survives. They are proof that the style of the manuscripts could be transferred to work on an immensely larger scale. But the altarpiece, or retable (as it is normally called), is by far the most extraordinary object (*Ill. 100*). It is, again, a unique survival from the period in England and France, which makes all comparison difficult. It also has the bizarre quality of meticulously executed ersatz production. In its original state, it would have had the appearance of a sumptuous painted gold work adorned with enamels, precious stones and antique cameos. But the frame is of wood and the adornments are all counterfeit objects of one sort or another. Their quality, however, is very high and that of the painting is first rate. It has never been at all clear in what circumstances a rich abbey like Westminster would have commissioned something which was so good and yet so bogus. Nor has the date been settled. The standing figures are extremely elongated, with minutely painted features, and the drapery has the by now familiar hang and modelling. The style might belong to any time in the last quarter of the thirteenth century, and it is perhaps worth mentioning that the King's chief painter, Walter of Durham, who presumably was intimately connected with the development of this style in England, was active during the whole of this period and only died in 1308.

It is not difficult to follow this general figure style into the fourteenth century. In doing so, however, one moves away from London to a group of manuscripts of which many are associated by their contents with East Anglia. This geographical displacement is a puzzle and is not made easier by the heterogeneous nature of the group.

102 Marriage at Cana, page from the Queen Mary Psalter, *c.* 1310

There is indeed one book which has no indication of its provenance and which from its persistently high quality and prolific but re-strained illustration ought to be a royal book. This is the so-called 'Queen Mary Psalter' (London, B. Mus. Ms Royal 2 B VII; *Ill. 102*) which contains a large number of introductory pictures, pictures set in the text, and small drawings at the foot of the pages. The illustrations are executed in a drawing technique. The *bas-de-page* scenes are lightly tinted; the main pictures are more heavily coloured but still rely on line rather than modelling. This type of painting comes close to the style of a psalter (Cambridge, Corpus Christi

101 Four female saints, page from the Alfonso Psalter; probably shortly before 1284

College Ms 53) which, from its contents, was intended for use either in Peterborough or Norwich, and written in about 1310. Both manuscripts may have been executed in this area. The Queen Mary Psalter nevertheless has a number of interesting features. The presentation of most of the illuminations is uniform in that the scenes are enacted within a modest architectural framework. They are, moreover, included within the text of the psalter as illustrations independent of the initial decoration. This marks a break with tradition, since English psalters up to this time usually have the larger pictures at the front of the book and are confined for text decoration to little scenes framed within the initials. If, however, one looks across the Channel and compares the Queen Mary Psalter to the Hours of Jeanne d'Evreux of Pucelle (*Ill. 103*), one can see that it does follow Parisian decorative trends. The main picture in an architectural setting occupies a large area at the top of the page; the initial and text come next, to be followed by a *bas-de-page* decoration. One might even see the resurgence of the delicate tinted drawing as an English equivalent to the French *grisaille* painting. One ingredient which is very sparingly used in the Queen Mary Psalter is the spiky ivy-leaf decoration.

103 Annunciation. Opening page of Hours of Virgin from the Hours of Jeanne d'Evreux, from the workshop of Jean Pucelle. Between 1325 and 1328

104 The opening of Psalm 1 from the Peterborough Psalter, early fourteenth century

The profuse *bas-de-page* illustrations of the Queen Mary Psalter bring it into line with a common feature of the so-called East Anglian School – a penchant for extravagant border decoration. In particular, the initial of Psalm I, B(eatus Vir), became a focal point for lavish displays of foliage and other decoration incorporating biblical scenes and grotesques. A well-organized example of this is to be found in another Peterborough psalter executed before 1321 (Brussels, Bib. Royale Ms 9961–2; *Ill. 104*). Here the grotesques, animals and foliage are contained within a regular rectangular border.

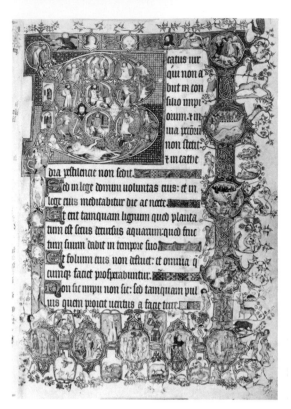

105 The opening of Psalm 1 from the
St Omer Psalter; probably *c.* 1330

In spite of the great richness of invention, which well repays study,
the confining frame gives the whole page a controlled and orderly
appearance. Usually, however, the decoration is more lavish and far
less regular. One of the most elaborate of these pages is that of the St
Omer Psalter (London, B. Mus. Ms Add. 39810; *Ill. 105*) which has
numerous medallions containing heads and Old Testament scenes
bound together by a fantastic sphagetti-like interlace.

The origin of this passion for elaborate marginalia lies well back
in the thirteenth century. Already by the mid-thirteenth century,
illuminators were designing initials whose extremities extended well
into the margin of the book. Men and grotesques also invaded the
lower parts of the pages. A notable example is the Rutland Psalter
(Belvoir Castle), executed probably before 1258, in which almost
every page has figures of men or beasts along the lower margin. This
type of decoration is also to be found in the work of William de
Brailes; and the artist of the Alfonso Psalter, while imitating Parisian

140

foliage, included more incidental details of a *genre* nature than would probably have been acceptable in Paris. But although this sort of extravagance was unpopular in Paris, it nevertheless became popular in northern France and Flanders during the second half of the thirteenth century. It has already been remarked that *drôleries* were only gradually admitted to Parisian manuscripts and were then kept under strict control. A comparison of the St Omer Psalter Beatus page with the page from the Belleville Breviary (*Ill. 98*) will give some idea of the contrasts in aesthetic approach which are involved.

In spite of the great differences between this type of English painting and that of Paris, Italianate features appear in English illuminations at about the same date that they appear in Parisian. Both the Ormesby and the St Omer Psalters contain instances of Italianate nude figures and somewhat rudimentary suggestions of space. A Crucifixion Leaf added to the Gorleston Psalter (*Ill. 106*; London,

106 The Crucifixion, a leaf added to the Gorleston Psalter; probably *c.* 1330

B. Mus. Ms Add. f F) goes much farther than this. Iconographically, one can find quite close parallels in Italian painting, and the scene is played out on a stage of formalized rocks similar to the convention used by both Duccio and Simone Martini.

Already by 1300, the court of Paris was affecting German painting, and the zigzag style had been abandoned. In the succeeding period some manuscripts (produced probably in the area of Cologne) came very close to Parisian work. Notable is the work of an artist in a Gradual now at Aarau (MS. Bibl. Wett fol. max. 3), whose style is very near indeed to that of the workshop of Jean Pucelle. Germany is remarkable for the survival from the fourteenth century of a large number of panel paintings. Many of these were painted in Cologne;

107 *Noli me Tangere*. Part of the painting added 1324–9 to the enamels of Nicolas of Verdun to form the present Klosterneuberg altarpiece

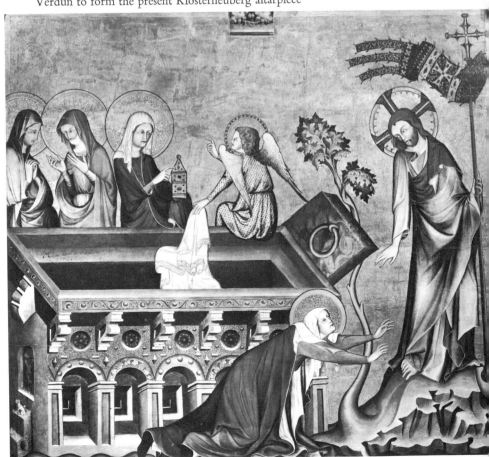

108 Virgin and Child and Crucifixion. Diptych from Cologne, perhaps *c.* 1325–50

and although very few are dated, it would appear that almost at once the rounded, modelled style of Master Honoré's circle was imitated. Painters were much influenced by the refinement of Parisian art, but there are also evident connections with Italy. The Virgin in a diptych from the church of St George, Cologne (*Ill. 108*), is drawn in a type of perspective used in Italy, and she sits on a throne decorated with painted cosmatesque marble mosaic. However, it is not clear in Germany, either, to what extent artists had access to Italian originals.

The Italian influence comes out particularly strongly in a group of Austrian paintings added to the enamels of Nicolas of Verdun between 1324 and 1329, to form as a whole the Klosterneuburg altarpiece (*Ill. 107*). In these there is clear evidence of a knowledge of the iconography used by Giotto, an iconography doubtless transmitted by pattern books since the total effect is far from Giottesque.

109 FERRER BASSA
Paintings in S. Miguel
de Pedralbes, 1346

The increasing importance of Italian painting emerges at the end of this period in Spanish art. Between 1320 and 1350 there are various documented activities of a painter from Barcelona called Ferrer Bassa. In 1343 he was commissioned to paint a series of fresco paintings in a chapel near Barcelona, S. Miguel de Pedralbes (*Ill. 109*). These were apparently executed between March and November 1346, and might almost be mistaken for the work of an itinerant Italian. All Ferrer Bassa's known activity is in Spain and we have little idea about his travels. But these must have included a study of the major Italian masterpieces available at that time; for the types used, the decorative details and the way in which the scenes are marshalled on the walls all suggest a far more thorough knowledge of Italian art than was to be found in any other country beyond the Alps at this date. This Italian orientation persists in Spanish painting throughout the fourteenth century.

Italian Art of the Mid-thirteenth to Mid-fourteenth Century

A possible approach to Gothic art is to treat it as something largely created by the French, and then to examine the impact of this creation on the countries surrounding France. Some attempt has been made to do this in the previous two chapters, with regard to the Empire, England and Spain. In the case of Italy, however, it is almost impossible to adopt this approach. For the resistance to French ideas in general and Parisian ideas in particular appears to have been exceptionally strong; and local traditions flourished to such an extent that Italian artists, while frequently borrowing detailed motifs from north of the Alps, seldom produced anything which would readily be confused with northern work. There were almost always fundamental differences of approach which make the distinction relatively simple.

Nothing illustrates this better than the history of Gothic architecture in Italy. All the countries so far studied came to terms with the rayonnant style by the mid-thirteenth century. Whether one takes Westminster Abbey, Cologne Cathedral or Leon Cathedral, the ultimate sources for these buildings are relatively clear. The masons (and probably the patrons too) had certainly been greatly impressed by the achievements of French architects in the northern parts of France; and, with a number of judicious emendations made to suit local prejudices, these churches can be understood as rayonnant buildings. Here is evidence that somebody at some stage made some effort to understand what French architecture was all about. It is precisely this that one misses in Italy.

This resistance to northern ideas was probably sustained by the traditional competence of Italian masons. There are a large number of imposing Romanesque buildings dating from the eleventh and twelfth centuries which demonstrate this competence. Pisa Cathedral (founded 1063) is faced with marble worked with a precision which

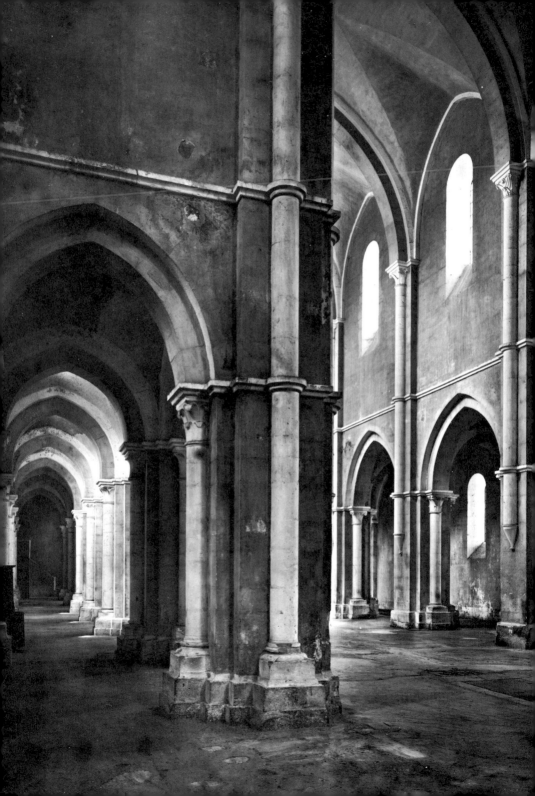

can have had no northern rivals at the time of its inception. North of the Apennines, there is a long series of enormous buildings characteristically of brick (for instance, St Abbondio, Como or Piacenza Cathedral) which is managed with considerable technical ability. It was in this area that ribbed vaults began to appear at about the same period at which they appeared in the north. Nor, of course, is the south of Italy devoid of large Romanesque churches.

There are various regional differences which might have made it technically difficult for Italians to imitate French buildings. Tuscan masons had large supplies of accessible marble which they liked to use; Lombard masons had little accessible stone and built in brick. Material restrictions of this sort, however, cannot provide the whole answer. The churches on the Baltic shores prove that it is possible to build a church of northern Gothic proportions and detail in brick. In default of written testimony, one can only assume that Italian masons and patrons simply disliked what they knew or heard about Parisian buildings. Later in the period, when northerners were called in to advise on the stability of the proposed plans for the new cathedral of Milan (c. 1390–1400), it is apparent that the native Lombard masons were fairly certain that the experts from Cologne and Paris could teach them nothing about church building.

In countries north of the Alps, the Cistercians played an interesting but on the whole minor role in the diffusion of French architectural ideas. The spread of these ideas is to be traced mainly through the succession of larger churches such as Canterbury Cathedral, the Liebfrauenkirche at Trier or Burgos Cathedral. Since this type of imitation is almost completely lacking in Italy, the Cistercians assume an importance which they lack in other countries.

The Italian Cistercian community being founded from Burgundy, a number of Cistercian houses exist in central and southern Italy which translate the type of church already seen at Fontenay to Italian soil. Fossanova (consecrated 1208; *Ill. 110*) has a rectangular east end and a nave elevation which imitates very closely Cistercian architecture in Burgundy. Fossanova is roofed with a groined vault, but a slightly later Cistercian abbey church at Casamari (begun 1203, consecrated 1217) has a ribbed vault. Both churches display crocket capitals. One further Cistercian abbey in Tuscany at Monte S. Galgano

110 Nave from crossing, Abbey of Fossanova; church consecrated 1208

(begun 1224) should be noted since it imitates very closely the style of the two churches already mentioned. In south Italy, the type of Gothic represented by these buildings was continued in a steady stream of churches. Their ground plans varied considerably, but they all tended to be unambitious two-storeyed buildings employing pointed arches, crocket capitals and ribbed vaults. Such for example are the church of S. Giovanni, Matera (c. 1230) or the east end of the cathedral of Cosenza (after 1230).

A church such as Fossanova can claim to be a building in an unpretentious but authentic French Gothic style. In Italy this type of building had a very limited influence. Moreover, in Lombardy, the Cistercian architects might adhere to the traditional plan, but the buildings they put up adhered to the traditional masonic practices of the area. Morimondo (c. 1190), built of brick, has an arcade supported on large cylindrical piers. There are no continuous horizontal mouldings and, except for one bay, the vertical supports to the vault do not run down to the ground but stop at the level of the capital.

The persistence of Romanesque forms of Italian architecture is visible throughout the thirteenth century. None of the major undertakings imitated contemporary French buildings to any great extent in their structure. Siena Cathedral (begun before 1260) was originally planned as a hall-church, for reasons which are still obscure. The eastern termination, of uncertain plan, was arranged not round a square nor an octagon, but round a hexagon (which precluded any idea of regular transepts). The original nave arcade still stands with its high round-headed arches and heavy Corinthian capitals. This may seem surprising, but Orvieto Cathedral (begun in 1290; *Ill. 111*) also has large round-headed nave arcades.

A common feature of these two churches is the size of the arcade and this became an important feature in Gothic building in Italy. Italian great churches naturally vary considerably in plan. S. Francesco, Bologna (begun 1236), is one of a very small scattered group of churches to have an ambulatory round its east end. Sta Maria Novella, Florence (begun before 1246), and Sta Croce, Florence (begun 1294), adopted the rectangular termination of the Cistercians. S. Andrea, Vercelli (founded 1219, consecrated 1224), has transept chapels with polygonal terminations flanking a rectangular central

148

111 Nave looking east, Orvieto Cathedral; church begun 1290

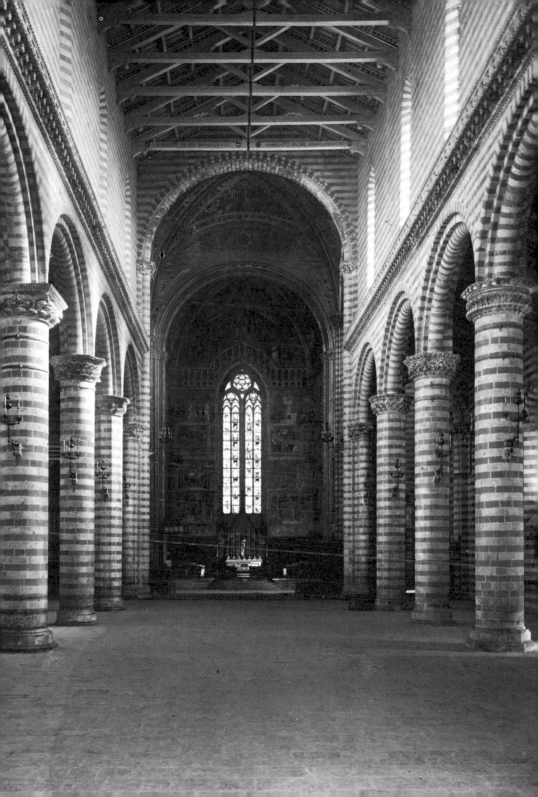

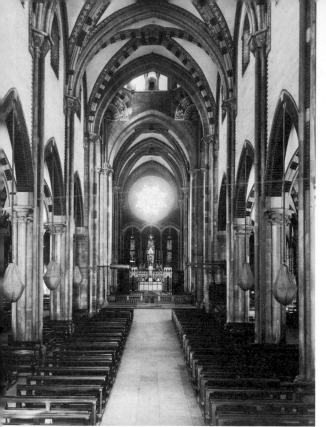 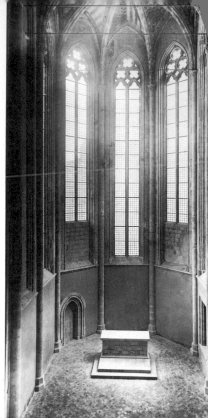

112 (*left*) Interior of nave, looking east, church of S. Andrea, Vercelli; founded 1219

113 (*right*) Interior showing apse, Sta Maria Donnaregina, Naples; founded 1307

chapel. The cathedral of Florence (begun 1294) was planned with polygonal ends to the three main arms of the church – an idea perhaps suggested by the apses in the plan of Pisa Cathedral.

But these churches are all two-storeyed, with a large arcade and a small clerestory (*Ill. 112*), and apart from a number of eccentric churches such as S. Francesco, Assisi (begun 1228) or S. Antonio, Padua (begun *c.* 1232) this represents the Italian ideal of what a great Gothic church should look like. Substantially the same impression was aimed at in the church of S. Petronio, Bologna, which was begun in 1388 : this is the Italian type to put alongside the rayonnant tradition of St Denis in Paris. The detail of these buildings is austere by French standards. There is no traceried panelling, no double skins

150

of tracery, no elaboration of the main mouldings, little refinement of the piers. Odd features make erratic appearances. The architect of S. Andrea, Vercelli, for instance, made extensive use of detached shafts and crocket capitals (*Ill. 112*). Various churches possess rose windows. One of the designs for the façade of Orvieto Cathedral (early fourteenth century) has a strong suggestion of French rayonnant influence (it should be added that it was rejected, see *Ill. 129*). The campanile of Florence Cathedral was apparently intended at one stage (*c.* 1335–40) to have a polygonal openwork tower with spire similar to Cologne and Freiburg (this, too, was never built. *Ill. 114*, compare *Ill. 71*). But such direct northern influence made little headway.

With the simplicity, however, went an impressive size. Italian masons made little or no use of flying buttresses, which were part of the repertoire of all ambitious French masons. This did not prevent Italians building extremely tall buildings. S. Petronio, Bologna, has a nave vault the height of which surpasses that of Bourges. This reinforces the general impression that the Italians saw little reason to suppose that either on technical or aesthetic grounds the French could teach them very much about building.

In one area French influence acquired a momentarily greater hold, namely the south of Italy. Here, under the Angevin royal house, French features persisted into the fourteenth century. One notable monument is the apse of Sta Maria Donnaregina, Naples (begun 1307; *Ill. 113*), built by Queen Mary of Hungary. This was intended to hold the tomb of the queen, and, as a personal chapel, was in form inspired ultimately by the Ste Chapelle, Paris.

114 Design for the Campanile of Florence Cathedral; probably 1334–7

Italian sculpture also shows considerable resistance to northern ideas. A large quantity of sculpture executed in 1140–1250 is hardly touched by the style of the early Gothic sculpture of the Île-de-France. The main French area of contact was the southern seaboard and Provence. The evidence for this is varied, but much of the major sculpture of northern Italy and Tuscany in the twelfth century evinces connections of some sort with this area. This applies particularly to the work of the mason Benedetto Antelami.

Antelami's earliest surviving work, a relief at Parma, is dated 1178. He may have worked up to c. 1220, although his last dated work is from 1196. His main surviving monument is the baptistery at Parma (*Ill. 115*). This is a massive octagonal building, not in the least Gothic in its general appearance, although the interior is roofed with a ribbed vault. Whether Antelami designed it is not certain, but he was certainly responsible for the portals, since it is on one of these that his name appears. These portals are for their date unique in Italy in that they describe an ambitious and coherent iconographic programme. This single feature alone prompts comparison with France, for it was only in France that such thought had been given to the programmatic content of the church portal.

Two of the three portals are devoted to subjects familiar from France – the Virgin (*Ill. 115*) and the Last Judgment. But whatever Antelami may have seen beyond the Alps hardly influenced his ideas about the structure of a portal. Most of the architectural layout can be derived from previous north Italian sources. The style of the sculpture is entirely that of the area, the figures being solid with rather large round heads. There are no column figures and the voussoirs are plain. Only occasionally in some of the subsidiary sculpture, inside and out, are there suggestions of a more graceful style with northern affinities.

Almost half a century later, a far more authentic Gothic style of sculpture appeared in Tuscany. The mason's name was Nicola Pisano and his known life extends from 1259 to 1278. Unlike Antelami, it is almost impossible to see his style growing naturally out of that of his predecessors. For comparison there is a pulpit at Pistoia, dated 1250 and signed by another mason who worked in the area,

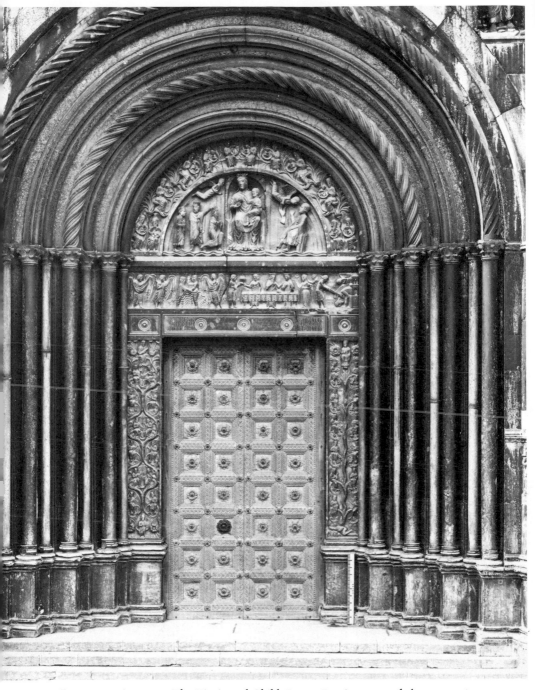

115 BENEDETTO ANTELAMI The Virgin and Child, Parma Baptistery portal; begun 1196

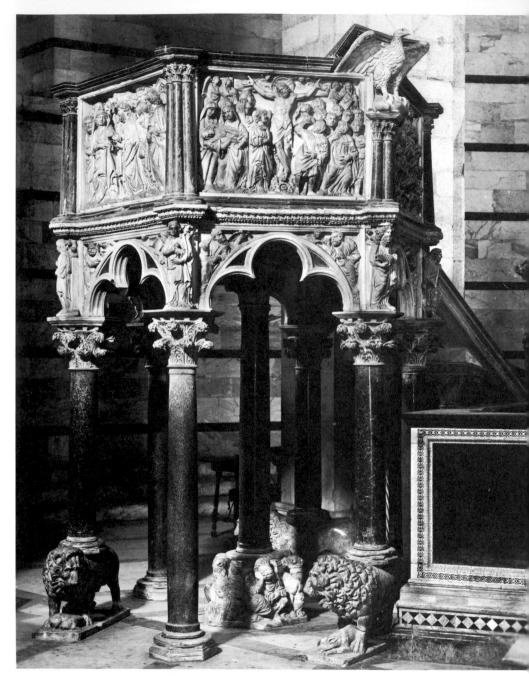

116 NICOLA PISANO Pulpit in the Baptistery, Pisa, 1259–60

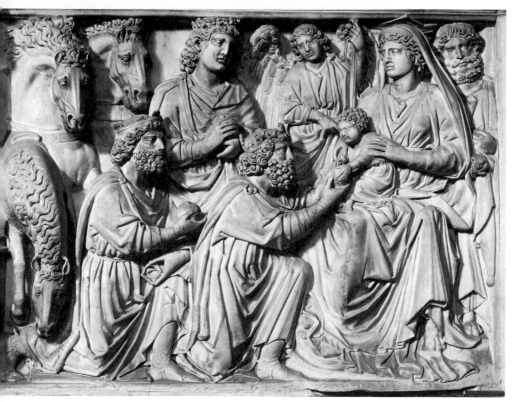

117 NICOLA PISANO Adoration of the Magi, relief from the Pisa Baptistery pulpit, 1259–60

Guido da Como. Guido was not a great artist, but his work serves fairly to represent the level of Tuscan sculpture in about 1240–60. The scenes executed are in rather narrow reliefs, with doll-like figures with somewhat wooden gestures arranged to form a single layer across a flat background. In almost every way Nicola's style is different and far more distinguished.

To begin with, the drapery of Nicola's figures is obviously Gothic (*Ill. 117*), falling in the angular V-shaped folds familiar, for instance, from the work of the Joseph Master at Rheims. But the relief style itself may be compared to works in northern Europe. The thirteenth century saw a considerable advance in the handling of relief. Unfortunately many of the main monuments, choir-screens, have been destroyed. But reliefs surviving on the Naumburg screen show considerable skill in the handling of groups and in the suggestion of

depth and space. The same may be said of the relief of the 'Finding of the True Cross' on the west front of Rheims. These masons in their approach to the problems raised by relief sculpture had advanced far beyond the single-layer-of-figures conception current in twelfth-century France.

It seems likely therefore that Nicola, just as he learnt his drapery style from the French, may also have learnt about the possibilities of relief from practising masons in the north, and it may also have been the experience of the striking realism of the north which aroused Nicola's interest in antique sculpture. Nicola's heads are certainly modelled on antique heads, as is the method of carving the hair. Moreover, his method of carving relief appears to have been influenced by the antique in that his scenes are quite shallow, but pretend to a greater depth than they actually possess. The means used are semi-pictorial and illusionistic (*Ill. 117*).

Unfortunately, there is no contemporary testimony which throws any light on his training, except for two references in which he was called Nicholas of Apulia. This had led to much speculation on a possible contact with a deliberate renaissance of antique motifs connected with the masons of the Emperor Frederick II (1220–50) in the Kingdom of Sicily. Military buildings ordered by Frederick do on occasion incorporate classical ideas into their ornament. Castel del Monte, in Apulia, built as a hunting residence in 1240, has a fine classicizing frontispiece erected round its main entrance. At Capua, one gateway (1230s) also had a considerable amount of classicizing architectural decoration and some very remarkable sculpture which was clearly intended to look classical. Nothing, however, survives in southern Italy which serves as a really convincing link with Nicola's style as revealed in the Pisa Baptistery pulpit (*Ills. 116, 117*) and the mystery remains unsolved.

It is interesting that the pulpit, itself a vehicle of complex iconography, was developed by Nicola and by his son Giovanni in a manner similar to the earlier expansion of French portals. The largest of these pulpits by Giovanni, dating between 1302 and 1310 (long after Nicola's death), has all the appearance of a *folie de grandeur*, being overloaded with iconographical ideas (*Ill. 118*). Visible are scenes from the life of the Baptist and the life of Christ, the Last Judgment,

156

118 Giovanni Pisano Pulpit in Pisa Cathedral, 1302–10

the Evangelists, Virtues, Liberal Arts, Sibyls, Ecclesia and others – all of which might equally be found on a portal.

The extraordinary solidity which Nicola imparted to his figures diminished in his later works, which veered sensibly towards the style of northern Europe (*Ill. 119*). The pictorial nature of his scenes increased with iconographical demands and, with this, the scale of the figures lessened. They acquired, too, a certain grace foreign to the first pulpit, and a decorative character through the lavish use of patterns on the drapery border.

Nicola's career gives rise to a number of interesting problems. The first concerns his development. Had the Pisa Baptistery pulpit been destroyed without trace, his career could be seen primarily as one of gradual absorption of French Gothic stylistic elements, for this is the tale that the Siena pulpit would suggest. In this development, the interposition of the strong classicism of the Pisa Baptistery pulpit might appear to be out of place. It can only be explained in terms of the artistic problems which, it appeared to Nicola, the classical sculptors had solved satisfactorily. Thus, while he was in the process of developing a more realistic style, classical art must have appeared as a means to an end. It is of some interest that classical art had also played an important transitional role in the sculpture of the north in about 1200–20.

A second problem concerns the career of Nicola's son Giovanni. He did not share his father's taste for decorative grace, as it emerges in the Siena pulpit. In fact, Giovanni appears to have reacted against this, and Tuscan sculpture entered a stylistic phase which was anything but graceful, finished and delicate. Giovanni's first major independent work was the façade of Siena Cathedral (mainly between 1285 and 1295; *Ill. 120*). He never completed this above the line of the gables over the doors (the upper part with the round window was added in the second half of the fourteenth century). Perhaps, in the Pisan tradition after the general pattern of the great prototype Pisa Cathedral, he planned for the upper part an arcaded screen façade. The lower part luckily preserves its original decoration, and here for the first time one finds an Italian mason incorporating a major amount of large-scale figure sculpture into a façade design. This idea can only have come from France, but it is nevertheless

119 NICOLA PISANO Apocalyptic Christ, from a pulpit in Siena Cathedral, 1265–8

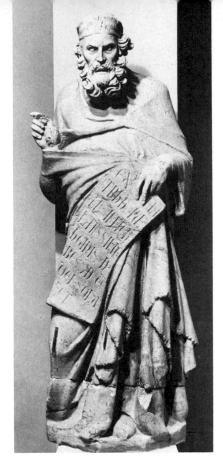

121 GIOVANNI PISANO Plato, from west façade of Siena Cathedral, *c.* 1290

120 (*opposite*) Siena Cathedral, west front. Lower half up to gallery probably designed by Giovanni Pisano, 1284–5. Façade completed from 1376

disconcerting to find the figures not in the embrasures of the portals but up above between the gables. It is not at all clear what prompted this idea. For Giovanni's figure style (*Ill. 121*) one can find parallels north of the Alps; not in France, but in the more emotionally conceived sculpture of the Empire. The Prophets at Strasbourg (*Ill. 92*), nearly contemporary, make an interesting comparison.

However, the dramatic emphasis which pervades Giovanni's style goes far beyond almost everything found in the north. The great figures on the façade of Siena Cathedral communicate with each other and with the spectator with an impressive seriousness and urgency. Communication as such was not new. What is unusual is the emphatic and awesome way in which it is done here. Moreover, this dramatic urgency was carried on into a work on a comparatively tiny scale: the pulpit in Sta Andrea Pistoia, finished by Giovanni in

161

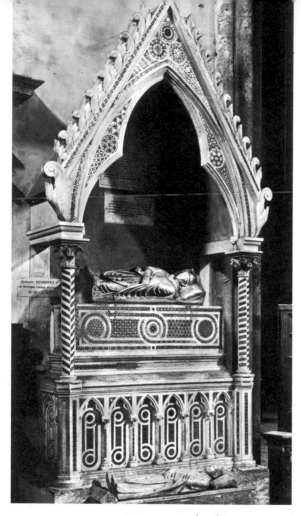

122 PIETRO ODERISI Tomb of Pope Clement IV (died 1268) in S. Francesco, Viterbo, c. 1271

1301. Here again the figures are agitated and the drapery is conceived in deep, bold, dramatic folds clearly derived from the style of the Siena façade. It is striking that the superb finish of Nicola's work is lacking in the Pistoia pulpit of his son. The surface carving is summary in its attention to detail and such things as drapery borders or hair and beards are not executed with Nicola's refinement. All this represents a very definite shift of interest on the part of his son and it is still difficult to reconstruct the circumstances in which it took place.

By the normal standards of medieval history, a considerable amount is known about Tuscan sculpture at this period, and this knowledge may well suggest caution in places and periods where

similar information is lacking. This is particularly the case where there is any question of a hypothetical workshop tradition. For Nicola's workshop harboured two sculptors of entirely contrasted styles. One was Giovanni, already mentioned; the other was a Florentine mason, Arnolfo di Cambio. After working under Nicola, his career took him to Rome (*c.* 1270–5), where he spent most of the remainder of his life working for the papal court.

Rome during the thirteenth century was a flourishing artistic centre. One characteristic type of decoration was a species of mosaic patterning made from marble chips and other pieces pillaged from the ancient ruins of the city. It consisted almost entirely of abstract patterns, and favourite objects to which it was applied were church fittings and church floors. One early thirteenth-century marble worker bore the name Cosmas, and from him the whole trade takes its name, 'the Cosmati'. The most striking works belong to the thirteenth century, when it would appear that almost every church in Rome and the surrounding countryside with any pretensions possessed some fitting inlaid with mosaic. One of the most impressive arrays is in the Roman basilica of S. Lorenzo fuori le Mura. The churches of S. Paolo fuori le Mura and S. Giovanni in Laterano both have cloisters (early thirteenth century) of exceptional magnificence.

The impression given by these mosaics is brilliant and opulent, and it is not surprising that the abbot of Westminster took home a team to decorate his new church (see above, p. 11). On the other hand, it must be admitted that as stone carvers, the Cosmati left much to be desired. Their art is largely non-figurative; but apart from the occasional lion, their showing on those occasions on which they tried to carve men and beasts is indifferent.

Perhaps on account of this lack of a flourishing sculptural tradition, the Gothic style from France was slow to make any impact. But during the second half of the thirteenth century, as a result of increasing French influence in the Roman *curia*, French ideas and fashions began to make some headway. An early instance of this is the tomb of the French pope Clement IV at Viterbo (S. Francesco; *Ill. 122*). He died in 1268, and the monument was executed in about 1271. The decoration of this monument is in many ways typically Roman, and similar marble mosaic patterns can be found elsewhere. The main

constructional outlines are also Roman; but they are given a Gothic character. The canopy has Gothic crockets and a trefoiled arch. The podium on which the whole erection is raised has a Gothic arcade along its exposed faces. The most unusual feature of the tomb is the effigy. As things survive, it appears to be the first sepulchral effigy in Italy, and certainly reflects French fashion. It may be rash to speak of portraiture; but the heavy characterization of the face is also in line with latest Parisian developments (see above, p. 115).

The Cosmati, as we have mentioned, were not great sculptors, and Arnolfo, trained as a sculptor in a first-class workshop, filled a need. He was to some extent absorbed by his Roman environment, since he himself employed cosmatesque craftsmen and worked on types of commission traditional to these artists. We have two handsome ciboria by him from 1285 and 1293. But presumably on account of his expertise as a figure sculptor, one of his main occupations concerned the construction of tombs and monuments. In the tombs, he developed many ideas already found in France. In his major monuments, there is generally some element of dramatization to be found. For instance, on the monument to the Cardinal Annibaldi (d. 1276) he carved a row of figures representing the funeral service of the dead man. The Annibaldi effigy shows the dead man with his eyes closed. The element of successful portraiture may be slight, but the attempt

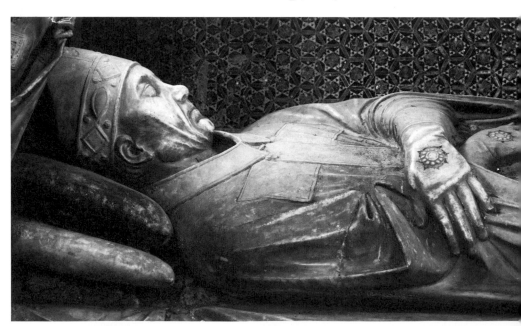

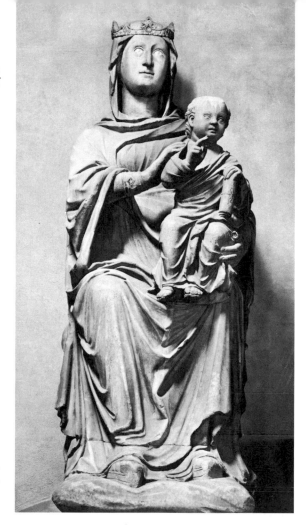

124 ARNOLFO DI CAMBIO Madonna and Child from first façade of Florence Cathedral, c. 1300

123 (opposite) ARNOLFO DI CAMBIO Tomb effigy of Cardinal Guillaume de Braye, 1282 or after

at characterization is obvious. Another monument made for the executors of the French Cardinal de Braye (d. 1281, monument in S. Domenico, Orvieto) possesses two images of the dead man, each of which produces a similar type of characterization (*Ill. 123*).

There are many problems about Arnolfo's career, not least those of attribution. In the last years of his life he was given command of the building of the new cathedral of Florence (1296). As a result, he had to maintain a shop in each city, and his latest Roman work, the monument to Boniface VIII which should be his greatest tomb (1295–1301), is as far as the fragments go the most disappointing in

165

quality. But even in the earlier monuments the range of variations in quality and style is considerable.

Almost nothing is left of Arnolfo's cathedral of Florence, apart from a certain amount of marble decoration on the aisle walls, since the existing church is the result of a general enlargement of the four-teenth century. It was begun at the west end, and Arnolfo's first task was to design a façade. Very little is known about this, for it was never finished, and was ultimately entirely replaced in the nineteenth century by the present façade. Parts of the sculptural programme at least survive, and from these it may be said that the façade was 'Gothic' in that it had a coherent iconographic programme. The theme was the glorification of the Virgin. Two carved stone tympana in the lateral portals represented the Nativity of Christ and the Death of the Virgin; but there were no column figures and no figures in the voussoirs. The main subsidiary sculpture was between and above the gables. The centre portal did not possess a tympanum. Instead, there was a free-standing figure of the Madonna and Child (*Ill. 124*). It shows how Arnolfo's style retained the impressive (and indeed impassive) solidity of Nicola Pisano's earlier work. The strong clas-sicism has dwindled but the unemotional character and the broken drapery folds remain, to provide the strongest possible contrast to the style of Giovanni Pisano.

With the departure of the papal court to Avignon, Rome ceased to be an important centre of art patronage. Its place was to some extent filled by Naples under the rule of Robert the Wise (1309–43). A number of eminent artists worked at his court, and of this court art a considerable number of royal tombs survive, though not very much else. Some of the ideas incorporated into these tombs origi-nated in the Roman work of Arnolfo. But the sculptor whose style had the greatest influence in Naples was the Sienese, Tino da Camaino. Trained in Pisa, he worked in Siena and Florence before moving, in c. 1323, to the Angevin court. There he remained until his death in 1337. He was an extremely accomplished decorator, and his work well represents one Italian version of the generalized mid-Gothic style of fourteenth-century Europe. It is unusually graceful for Italy, but its origins are almost always proclaimed by the full, rather heavy female faces (*Ill. 125*), which are totally unlike the dainty

166

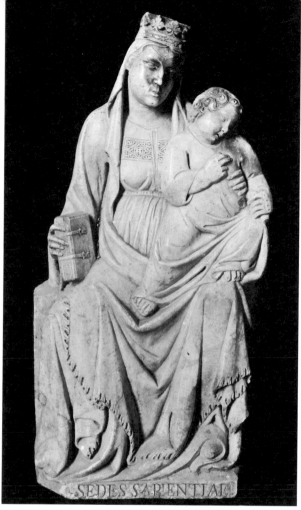

125 TINO DA CAMAINO Madonna
and Child from the monument to
Antonio Orso (died 1320/1), 1321

Parisian convention and are probably an aftermath of the Roman
matrons carved on Nicola Pisano's Pisa Baptistery pulpit.

Had Tino survived, he would undoubtedly have received the com-
mission for the tomb of King Robert (d. 1343). As it was, this was
made by two Florentine brothers, Giovanni and Paccio (*Ill. 126*). It is
a competent work, but its interest lies mainly in its content; for it is
a summing-up of much Italian sepulchral design during the previous
half-century. Particular elements to be noted are the sarcophagus
with the dead man surrounded by his relatives (almost all of them
dead by 1343); the effigy in an enclosed chamber backed by figures
(in this instance the liberal arts); the dead man being presented to the

167

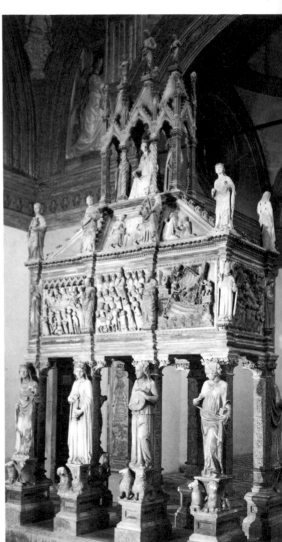

126 GIOVANNI and PACCIO DA FIRENZE Monument to Robert of Anjou, King of Sicily (died 1343), 1343–after 1345

127 GIOVANNI DI BALDUCCIO Shrine of St Peter Matyr, 1335–9

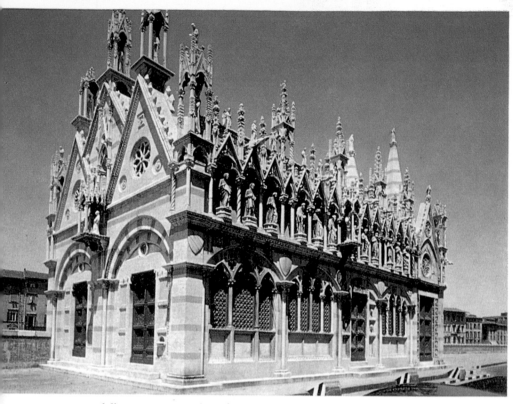

128 Sta Maria della Spina, Pisa. Enlarged after 1323

Virgin (compare for instance the de Braye monument of Arnolfo);
and the dead King seated in state.

Tino was an expatriate Tuscan who carried the Tuscan Gothic
style south. Another Tuscan, Giovanni di Balduccio, carried it north
to Bologna and Milan. His main work in Milan is the shrine of St
Peter Martyr (1335–9, S. Eustorgio). It was modelled on the shrine
of St Dominic made at Bologna by the workshop of Nicola Pisano
(c. 1260–5). Giovanni di Balduccio, however, made a number of
Gothic improvements including the addition to the lid of a fine
Gothic tabernacle (*Ill. 127*). This type of embellishment was gaining
popularity. There is a good Tuscan example above the entrance to
the Campo Santo at Pisa; and the church of Sta Maria della Spina at
Pisa (c. 1330) shows how this new architectural style might be used
to transform the traditional Pisan arcading (*Ill. 128*).

In this whole development, one mason stands apart – Lorenzo Maitani. He appears to have been Sienese, born perhaps *c.* 1275 and therefore reared in the shadow of the Pisani, father and son. His major work was the façade of Orvieto Cathedral, of which he had charge from 1308 to his death in 1330. For this, two parchment drawings still exist, one of which is far closer to the French rayonnant style than the second, which approximates to the façade as it was actually executed. If Maitani was responsible for the first (*Ill. 129*), then he was, for an Italian, remarkably receptive to French ideas. This also emerges in his sculptural style. From the Virgin and Child (*Ill. 130*) over the centre portal for which he is generally assumed to be responsible, it is clear that he had moved right away from the heritage of the Pisani. Here is poise and grace, a delicacy and refinement which at this time could only have been imitated from France. Yet if, as seems likely, Maitani did visit France, his models are not at all clear. The

129 Parchment elevation of a façade for Orvieto Cathedral, never executed; probably shortly before 1310

130 LORENZO MAITANI Madonna and Child with attendant angels, from the west front of Orvieto Cathedral, probably 1325–30

style of the Madonna seems to reflect the influence not of contemporary work but of the most elegant and reticent sculpture of the period 1230–40.

Whatever may be counted among Maitani's experiences, nothing prevented him from producing a final façade which was emphatically Italian (*Ill. 131*). The vertical emphasis was diminished and many of the surfaces covered with mosaics (at least in intention; the existing mosaic is all much later). The idea of mosaics is imitated from the great basilicas in Rome. As one might expect, there are no column figures, and no figures in the voussoirs. Indeed, the embrasures of the door are lined with decorative colonnettes inlaid with glittering cosmatesque mosaic; and the forward surfaces of the dividing buttresses are covered with relief sculpture. The whole effect is

overwhelmingly splendid, and although it would have been anathema to any orthodox Parisian mason, one cannot help feeling that at least the Abbot Suger would have approved wholeheartedly.

To round off this account of the early phases of Italian Gothic sculpture, mention must be made of Andrea Pisano. Nothing is known about his career until 1330 when he had already taken charge of the first pair of bronze doors of the baptistery of Florence. These were the first Gothic historiated bronze doors to be created in Europe. This may seem surprising, but the latest historiated bronze doors before this date are those of Pisa Cathedral, of the late twelfth century. North of the Alps the last historiated bronze doors were even earlier, being those commissioned by Suger (c. 1140) for the west front of St Denis. Doors had since then increased in size and fashions had changed. The doors of the Ste Chapelle were wooden, and were decorated with heraldic shields. Andrea Pisano's problem, therefore, was to reinstate a form of art which had been out of use for about 130 years.

The bronze doors of Pisa Cathedral contains rectangular relief panels. The motif used by Andrea Pisano to bring this scheme up-to-date was the quatrefoil pierced at the angles by the points of an inscribed square (*Ills. 132–3*). This motif was imported from France where it already had a long history. Figured quatrefoils appear in sculpture on the west front of Amiens Cathedral (c. 1220). But the earliest pierced by a square, and perhaps the closest to those of Andrea, are on the south transept buttresses of Notre Dame in Paris (c. 1260). Other later examples exist on Notre Dame in Paris, and at Lyons, Auxerre and Rouen. The use of pierced quatrefoils also became popular with glaziers and, later, with manuscript painters. They are used, for instance, in the Billyng Bible produced by the Pucelle workshop in 1327. Thus, in producing the first Gothic bronze door, Andrea Pisano had recourse to an important French decorative motif.

His figure style (*Ill. 133*), however, while based on that of Pisa of the first quarter of the century was much influenced by the art of Giotto. There is a clarity and bulk about much of his figure carving and a deft sense of drama in the scenes, both of which are absent from the more relaxed and decorative style of Tino da Camaino whose

173

131 Orvieto Cathedral, west façade; begun 1310

132 ANDREA PISANO Bronze doors of Florence Baptistery, 1330–6

work probably set the stylistic fashion during Andrea's youth. Where necessary the dramatic continuity of the story is stressed by the repetition of a particular 'set' – as will be seen, an idea derived from fresco paintings. Underlying all this is the pervasive influence of Giotto, and it is therefore perhaps the moment to examine the development of Italian painting.

133 ANDREA PISANO Burial of St John Baptist, from the bronze doors of Florence Baptistery, 1330–6

It may seem strange that the work of Giotto appears in a book about Gothic art, so firmly is he fixed by tradition as a founder of the Italian Renaissance. This interpretation of Giotto's position is an early one. It was already a commonplace when Ghiberti wrote in the mid-fifteenth century. Later the idea was taken up by Vasari and from that point on it has been usual to treat Giotto as a forerunner of Masaccio and a prologue to the whole Renaissance movement. Nevertheless, it is possible to treat Giotto as a 'Gothic' painter and to examine his relationship to his own time. It has already been seen that Italian sculpture and architecture diverged significantly in style from work produced north of the Alps; and that there were, moreover, considerable differences in style within Italy itself. The question is whether similar variations of 'Gothic' are visible in painting, and how Giotto fits into the historical setting which chance assigned to him.

Giotto's career may be considered in chronological terms as a bridge between the known activity of Master Honoré and that of Jean Pucelle. The juxtaposition is incongruous, but serves to bring out one dominating factor in differentiating between north and south. Throughout the period there was a strong and persistent tradition in Italy of large-scale mural-painting. Italian churches, if they received decoration, were as a matter of course coated with frescoes (excessively rich patrons might substitute mosaic for fresco). By the end of the twelfth century large paintings of this kind were rare in major northern churches. Architects made little or no provision for them (at least in the form of large areas of flat wall space); and religious narrative was now to be found in stained glass windows. To a large extent the mural painter had been superseded by the painter-glazier. It is necessary to be a little cautious at this point. A certain amount of religious mural-painting survives; and records exist of secular wall-painting in castles and palaces – painting which has subsequently vanished almost entirely. It is pointless to speculate on what has been lost; but where fragments of wall-painting do survive in important buildings such as Windsor Castle or Westminster Abbey, their style seems faithfully to reflect the far more copious remains on the smaller scale of manuscript-painting. If this

134 Institution of the Crib at Greccio by the St Francis Master, Upper Church of
S. Francesco, Assisi, *c.* 1295

general impression is correct the differences dividing the two traditions would only have become more striking had this mural-painting of the thirteenth and fourteenth centuries survived north of the Alps.

To say that northern mural-painting looked like northern manuscript-painting at this period is to brand it in general terms as two-dimensional and decorative. The lack of interest in illusion and in the projection of a third dimension may well be connected with a particular deficiency in the mural-painting tradition. Painters working on this large scale showed little desire to relate their work at all closely to the building in which it was painted. It is true that much surviving northern mural-painting is of a second-rate quality (or worse) and has, in keeping with this, a haphazard or random air in the manner in which it is placed on the wall. From knowledge of important monuments such as the Painted Chamber of Henry III in Westminster Palace or the chapel of the Virgin in the palace of Karlstein, it is clear that this 'random air' was not the concomitant of bad painting but a normal feature of Gothic monumental art. Narrative sequences were related by painters after the manner of modern strip-cartoons, one 'strip' superimposed on another according to the length of the narrative. The design of one length was not necessarily related to those above and below it. More important, the size of the scenes was not uniform and there was therefore no vertical continuity of design. Finally, there was little idea of linking a total scheme to the building in which it was placed. Exceptions to this rule were usually the result of direct contact with Italian ideas – the example of Ferrer Bassa has already been mentioned (see above, p. 144). Italian artists would appear to have thought of their work as an extension of the work of the mason; on the whole, this does not appear to have been the case in northern Europe. But this sense of extending the work of the mason must certainly have had some influence in the development of pictorial space and illusion which took place at this time in Italy.

The continuing persistence of Byzantine influence in Italy was an important factor contributing to the differences of style between north and south. At the time at which the St Louis style was being evolved and during the period of Matthew Paris' activity, Italian

135 Last Judgment and scenes from life of St Sylvester, Chapel of S. Sylvestro, SS. Quattro Coronati, Rome; chapel consecrated 1246

painting was still firmly influenced by the conventions of Byzantine art. It is a continual surprise to find in the middle of the thirteenth century in the area around the city of Rome a resurgence of linear damp-fold painting which in almost any other country would confidently be dated to about a century earlier. There are two particular monuments to this art. One is a small chapel attached to the Roman church of the Quattro Coronati (*Ill. 135*). It was dedicated to St Silvester in 1246 and the decoration is usually taken to be related to this date. It includes a representation of Christ in glory seated between the twelve Apostles; and a frieze of pictures telling the history of St Silvester and the Emperor Constantine. The painting is executed with great conviction and, as a decorative work, is very successful. This decorative quality is to be seen particularly in the details of flowers and other blossoms, yet the pictorial style has a

136 Sacrifice of Isaac, Upper Church of S. Francesco, Assisi, 1280s

harsh linearity and a wayward disregard for any considerations of realism. Further painting in the same style is in the crypt of the cathedral of Anagni (consecrated 1255).

It is possible that the Eastern Empire continued to play an important part in the early stages of the ensuing development, for there are indications that already in the mid-thirteenth century Byzantine artists were moving towards a more heavily modelled drapery style and greater realism in the arrangement of the surrounding space. The only remaining relevant monument in Constantinople is the church of the Chora, whose mosaics were made in the early fourteenth

180

century. Earlier dated monuments exist on the fringes of the Byzantine Empire, notably the frescoes in the monastery of Sopoćani in Serbia (1263–5).

Similar developments are to be found in the important church of S. Francesco, at Assisi. This church was built at two levels. Eventually both the upper and the lower churches were decorated with wall-paintings, but those in the upper church were completed first. They were executed over a period of time, probably c. 1280 to 1305; and as a whole they demonstrate, in microcosm, much of the change in Italian art during this crucial period of transition. The earliest frescoes in the choir and transepts are still fairly close to the style of the mid-century. The architecture is box-like and unconvincing but the drapery is softer, running in small ridges and troughs rather than lines. The total scheme is conceived on a grand scale. Composition is balanced by composition and the whole bound together by a scheme of illusionistically-painted decorative motifs. As the decoration proceeded down the nave, these developments become more marked. The artist who painted 'Noah' and 'Abraham' scenes adopted a softened and rounded drapery style very similar to the 'new' style of Constantinople (*Ill. 136*). At this point the transition to 'Gothic' painting in Italy may perhaps be merely a further manifestation of Byzantine influence.

The master who painted the two scenes of Isaac (usually called simply the 'Isaac Master') was perhaps the greatest painter in the upper church (*Ill. 137*). His work is remarkable for the solidity of its construction, the consistency of the lighting and also the element of dramatic tension to be found in it. The figures are enclosed in a defined space and have extremely solid heads and bodies.

The final addition to the upper church was the famous cycle of frescoes depicting the legend of St Francis himself. This was a large undertaking and at least three separate masters worked on it. The styles are to some extent contrasted but all show a strong realistic streak in the settings and in the action of the figures (*Ill. 134*). An early tradition of the fourteenth century recorded that Giotto himself worked at Assisi, and it has frequently been suggested that he was responsible for a large part of the St Francis cycle. There is, however, no unanimity on this point.

137 ISSAC MASTER Isaac and Esau, Upper Church of S. Francesco, Assisi, *c.* 1290

It is indeed tempting to try to enlarge the *œuvre* of the Assisi masters by attributing the different parts to specific artists. It has been suggested above that the greatest of the painters in the nave at Assisi was the 'Isaac Master'. He was certainly one of the foremost painters of his time, but neither in Rome nor anywhere else has anything survived from his hand (unless, as has also recently been argued *he* is identical with Giotto). From Rome, three particular names may be cited. One of these, Cimabue, probably decorated the altar end of the upper church at Assisi. Although he was a Tuscan, he is first mentioned in Rome in 1272. No work survives here, although he is traditionally supposed to have painted a series of frescoes in the *atrium* of Old St Peter's. He last appears at Pisa in 1301. His other main attributed work is now the enormous enthroned Madonna from the church of Sta Trinita, Florence (Uffizi), a painting still recognizably Byzantine in appearance but with the softened drapery style.

A second artist, Jacopo Torriti, is known only through mosaics, although in inscriptions he called himself 'painter'. His work includes two important apse mosaics in the Roman churches of S. Giovanni in Laterano (1292) and Sta Maria Maggiore (1296). Beneath the main mosaic in this last church runs a series of scenes illustrating the life of the Virgin (*Ill. 138*). From these, there appears to be a similarity between Torriti's work and the frescoes at Assisi which represent the stories of Noah and Abraham. He clearly belongs to the same stage of development, and it is sometimes suggested that he actually worked at Assisi.

The third great Roman master known both by name and work is Pietro Cavallini. He is first documented in Rome in 1273, but his surviving work is all later. Having worked in the church of S. Paolo fuori le Mura (work destroyed in the last century) he was by *c.* 1290 working both in Sta Cecilia and in Sta Maria in Trastevere (mosaic

138 JACOPO TORRITI Presentation in the Temple, Sta Maria Maggiore, Rome, 1296

139 PIETRO CAVALLINI
Apostles from Last
Judgement, Sta Cecilia,
Rome, *c.* 1290

decoration). When the papacy left Rome for Avignon, he sought
work in Naples (1308), where frescoes in his general style still survive
both in the cathedral and in Sta Maria Donnaregina. Cavallini's
narrative style, as it is revealed in the mosaics of Sta Maria in Traste-
vere, was a lively one. His settings have greater variety than those of
Torriti and he appears to have been more experimental in his treat-
ment of space. The scene of the 'Adoration of the Magi' has a small
landscape background to it. His painting technique, to be seen in the
fragmentary 'Last Judgment' of Sta Cecilia (*Ill. 139*), shows great
softness and roundness in the painting of drapery. In addition the
light source is consistently indicated – a piece of natural observation
unusual up to this date but found also in the Isaac Master's work. In
all these features he seems to have developed beyond the style of
Cimabue and Torriti and he has sometimes been identified with the
elusive Isaac Master. This, however, is unlikely. In spite of similari-
ties, the Isaac Master displays in almost every respect a firmer, more

three-dimensionally certain style than is ever to be found in Cavallini's work.

About this art, which forms the background to Giotto's work, certain general observations should be made. The first is that the 'damp-fold' style left an ineradicable impression on Roman art and its derivatives. The garments always tend to cling rather than to hang. This is true even of the work of Giotto. Whereas northern painters used the human body as a framework round which to arrange drapery, the Roman-trained painter, in moulding the drapery round the body gave a firm account of the form beneath it. This form may often be anatomically odd, but it is there – hence the extraordinarily impressive forms and silhouettes of Giotto. They are never interrupted or obscured by thick clusters or cascades of hanging, baggy folds.

Fresh experiments in imitating the natural world were also made during these last years of the thirteenth century. It has already been noted that the Isaac Master and Cavallini were more consistent in their use of light. As the damp-fold style softened, the drapery gradually ceased to consist of areas of line dividing areas of plane surface and became areas of light and dark. This can already be seen in the Assisi painting of the sacrifice of Isaac. It is far more obvious in the 'Last Judgment' of Cavallini where the lighting is that assumed to come from the windows of the church. Thus half the Apostles around Christ are lit from one side and half from the other. The course of this development is not clear, but the technique of modelling in light had by this date already made its way north, as has already been seen in the previous chapter.

The third observation concerns the apparent interest in the mastery of space in painting and the creation of illusion, obviously part and parcel of the development which produced the interest in light effects. It has already been observed that attempts at illusionistic realism are perhaps more easily imagined in the context of large-scale wall-painting than in manuscript-painting. For with wall-painting the artist's work is constantly juxtaposed to the three-dimensional building in which it is painted. The artists at Assisi painted a considerable amount of fictive architecture around the scenes which they executed, and this type of decoration forms a visual transition to the real architecture of the church. In their

awareness of the possibilities of illusionism, the Serbian painters at Sopoćani had been more advanced than the painters in the church of the Quattro Coronati. But the subsequent Roman painters pursued this interest still farther than the Byzantine artists.

Although Giotto is first mentioned in Florence in 1301, he was traditionally held to have been in Rome for the Jubilee of 1300. Any work at this period has been either destroyed or restored virtually out of existence. Since the leading fresco painters seem to have been based on Rome at this time, the above account will give some idea of the circumstances and conditions in which he was almost certainly trained. His first surviving work is not in Rome but Padua. Here he decorated a private chapel for the Scrovegni family, which is now called the Arena Chapel. The decoration was completed *c.* 1304–13, and it is immediately obvious that there is a considerable difference between this work and the work by the Roman masters already mentioned. Compared even with Cavallini, Giotto already in the Arena Chapel possessed a strikingly more vivid style. His figures communicated with each other more convincingly and with greater psychological *rapport*. There is a great variety of expression, a feature especially noted later by Alberti in one of Giotto's works in the Vatican, the so-called 'Navicella' (a mosaic in the atrium of Old St Peter's representing the storm during which Christ and St Peter walked upon the water). Giotto's spatial constructions are more ambitious and varied and relate more happily to the size of the figures. There was, in fact, only one master of the previous period, the so-called 'Isaac Master', who can be considered as a candidate to bridge the gap between surviving Roman art and Giotto. In the lost identity of this master probably resides part of the answer to the problem of Giotto's immediate origins. The sudden appearance of great artists is a constant reminder that nothing in history is inevitable until it has actually happened. But Giotto's appearance as a leading figure is, as things survive, unusually abrupt.

The Arena Chapel (*Ill. 140*) was an ambitious undertaking for a comparatively young artist. It is a small building, but the whole wall surface is covered with painting. Those in the little chancel are admittedly by Giotto's followers; but those in the nave appear to be almost entirely autograph works of Giotto himself. The scheme

140 Interior of the Arena Chapel, Padua, looking east. Founded 1303, decorated probably by 1313

141 GIOTTO The Marriage at Cana, from the Arena Chapel, Padua, probably between 1305 and 1313

comprises a life of the Virgin (the latest scenes are in the chancel), a life of Christ, a Last Judgment (on the west wall) and a series of Virtues and Vices painted in *grisaille* on the dado. One ingenious piece of illusionism may be noted at once. On each side of the chancel arch, Giotto painted *trompe l'œil* views into imaginary chambers.

One scene must suffice to give some indication of the character of this work. The 'Marriage at Cana' (*Ill. 141*) contains a complete narrative telescoped into one moment of time. On the left sits Christ

188

142 GIOTTO Raising of Drusiana, detail (*see Ill. 144*). Florence, Sta Croce, *c.* 1320

giving the order to the serving girl which led to the miracle. St Mary on the right encourages the servants to pour water into some huge pots, which accordingly they do. The steward, however, is already tasting the water changed into wine. This convention of placing separate episodes within a single theme is, of course, an old one; but the extent to which the scene is unified by intercommunication and gesture is remarkable. This unity is, of course, helped by the firm architectural framework. The whole story is told with directness and economy, but this does not exclude the artist from depicting markedly different characters. There is a splendid fat steward.

One of the striking features of the Arena Chapel is its variety. The decorative elements are, it is true, fairly uniform. The dado is painted to look like marble; the scenes are separated by painted cosmatesque bands set with quatrefoils. This fictive marble and mosaic were clearly intended to give the interior an opulent appearance without the consequent expense. The settings of the fresco scenes are, however, very varied, unless the artist found that the dramatic sequences required the 'stage-set' to be repeated. Thus the different scenes of the Last Supper take place in a similar building.

Only two fresco cycles survive from Giotto's later life, both in the church of Sta Croce, Florence. His career during this period is only partially known. While he was working at Padua, the papal court left Rome and he therefore settled in his native town of Florence. In 1328 he left for the Angevin court at Naples and remained there until c. 1334, at which time he returned to Florence. He was placed, rather unexpectedly, in charge of the building works of the cathedral, and during his period of office a start appears to have been made on the campanile. Giotto died in 1337.

One can be certain that the Sta Croce frescoes were painted before 1328. They were painted in chapels belonging respectively to the Bardi and Peruzzi banking families, and are the only works which provide an account of Giotto's late style. In this style much of the rich detail has now vanished and the settings are larger in relation to the figures. The figures themselves appear to be more massive, particularly in the Peruzzi Chapel (*Ills. 142, 144*). This follows from the diminished scale of the heads. The drapery falls in heavier and sometimes broken folds.

143 GIOTTO Presentation of the Virgin, from Arena Chapel, Padua, probably between 1305 and 1313

One can see how to some extent the developments in Giotto's later work mark a synthesis of the new style with that of the chapel of St Silvester. The decorative quality of that chapel has already been mentioned. One of the recurring problems of any artist concerned with realism is the way in which three-dimensional space and two-dimensional surface pattern conflict (this conflict has already been noted in the context of manuscript-painting). It is illustrated by the earliest scenes in the Arena Chapel. In the scene of the 'Presentation of

the Virgin' the architectural structure thrusts uncompromisingly forwards and backwards in space (*Ill. 143*). It has a far more complete presence than anything found in surviving work of previous artists and indeed almost anything else in the Arena Chapel itself. It might seem surprising that there is little else in Giotto's work to compare with this essay in three-dimensional projection. One can only conclude that however bold it may seem, it was also in some way unsatisfactory. The spatial definition was perhaps too explicit and conflicted with the surface composition. In subsequent painting in the Arena Chapel, where any form of depth was required by the structure of the scenes, Giotto almost always avoided stating it explicitly and proceeded more by way of suggestion. The perspective lines never plunge fiercely back into the picture and are frequently masked by figures and objects at crucial points at which they intersect.

This process becomes more marked in the Sta Croce figures. It appears at its most extreme perhaps in the 'Raising of Drusiana' (*Ill. 144*). There is no doubt about the weight and the volume of the figures in this scene. Nor is there any doubt about the presence of the buildings behind. On the other hand, there is a great deal of ambiguity about the spatial relationships between figures and buildings. In fact, the important function of the buildings behind is not to delimit a precise spatial platform on which the figures may stand. Rather, they echo, at a higher zone in the picture, the massing of the figures in the foreground. There are obviously dramatic as well as decorative reasons for this, but the total result is to suggest surface continuity as well as spatial depth. It is in this that the synthesis between the new realism and the old Byzantinism consists.

In conclusion, one can hardly avoid returning to the question, in what sense was Giotto a Gothic artist? The question is not to be answered in abstract terms but by the yardstick of French art. It can be seen that Giotto was very much less Gothic than the sculptors. This is not surprising, in view of the whole background of Italian painting which has already been described. Giotto can never be accused of painting with the dainty finesse of the St Louis style; indeed, if one seeks northern parallels, then they are to be found in sculpture rather than painting – sculpture of the early thirteenth century rather than the early fourteenth. The only comparisons which

144 GIOTTO Raising of Drusiana, from Peruzzi Chapel, Sta Croce, Florence, *c.* 1320

appear to carry weight are with the sculpture associated with Amiens (*c.* 1220). Even this comparison will not necessarily take one very far. For this sculpture, it will be remembered, is derived from one particular Parisian style which seems to be closely connected with the style of Byzantine ivories. Here then one may have two forms of art with comparable Byzantine backgrounds. It is true that Giotto uses a repertoire of Gothic motifs. His painted buildings sometimes have Gothic detail, learnt apparently from the Roman architects. His decorative painting generally includes quatrefoils. The folds of his drapery, although fine, generally fall in V-shapes. The whole style marks an increased naturalism. But all these features hardly amount to 'Gothic' as practised in Paris. Once again an Italian had put an assemblage of French ideas to his own special use and had emerged with a type of art which was triumphantly different.

Like sculpture, however, Italian 'early Gothic' painting was not a single unified phenomenon, but was made up of a succession of styles. If the main centre of mural painting in thirteenth-century Italy was Rome, the main centre of panel painting was Tuscany – in

particular the towns of Pisa, Lucca and Siena. The history of panel painting has many similarities to that of mural painting. Here too Byzantine damp-fold drapery style survived into the second half of the century. Here too around 1270 there are indications of an alteration in pictorial convention. But the real change of style came only with the career of the Sienese artist Duccio di Buoninsegna. About his life a number of scattered references survive. He first appears in 1278, at which date he was painting the covers of certain account books for the Sienese town council. Similar commissions followed and, indeed, all Duccio's known activity was in Siena, with one notable exception. This is the large painting known as the 'Rucellai Madonna' which was commissioned in 1285 by a Florentine confraternity for the church of Sta Maria Novella. The available information, however, does not lead to a securely documented and dated *œuvre*. Indeed, there is only one work for which the authentication and date are unquestionable. This is the signed altarpiece known as the 'Maesta', originally on the high altar of Siena Cathedral and now, for the most part, in the Museo of the Opera del Duomo. This was painted between 1308 and 1311. It must count as a late work in Duccio's career and in fact it is known that Duccio died a few years later (by 1318–19).

In its original form, the Maesta was a large two-sided altarpiece designed for a high altar which stood almost in the centre of Siena Cathedral and could thus be seen from both sides. The main face displays the Virgin seated in state surrounded by a court of saints and angels (*Ill. 145*). To this central scene were added along the base a predella with scenes from the infancy of Christ and along the top a series of scenes showing the last episodes of the Life of the Virgin. On the other face (*Ills. 146–7*) were represented scenes from the Ministry of Christ (on the predella), from the Passion, Resurrection and post-Resurrection. Parts of the reconstruction of its original form are still obscure but the whole altar would appear to have been terminated across the top by gables and, possibly, pinnacles.

The Maesta forms the basis of all deductions about Duccio's style. In order to gauge the size of Duccio's achievement, it is necessary to look back to the work associated with the painter Guido da Siena (*c.* 1260–70). In many ways, Guido's style forms an equivalent in

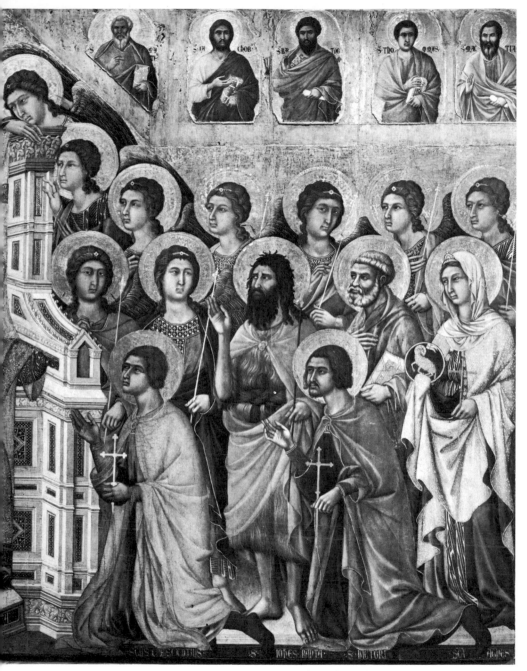

145 DUCCIO Group of Saints and Angels from the front face of the Maesta, 1308–11

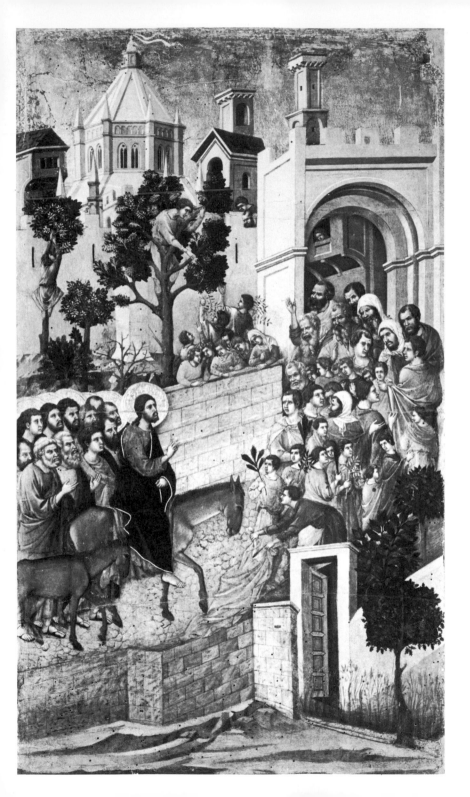

147 Duccio Maesta, rear face, 1308–11

panel painting to the mural painting at Assisi representing the stories of Noah and Abraham. A softening of the damp-fold tradition is visible, and also some awareness of the demands of realistic space representation. Nevertheless, the differences between this and the late work of Duccio are almost as striking as those between the styles of Torriti and Giotto.

Many of the features of the narrative scenes of the Maesta are probably derived from large-scale painting. In the space construction the painter developed ideas already to be found for instance at Assisi. The repetition of a particular stage-set to emphasize dramatic continuity is to be found there in the work of the Isaac Master. Duccio's method of modelling forms in light, the fall of which is more or less consistently and evenly observed, probably also follows the example of fresco painters. This lighting gives his drapery a quality similar to the painted drapery of Cavallini, and is something which he learnt between the time of the Rucellai Madonna (1285) and 1308. The idea of enlarging the Crucifixion scene to fill two horizontal registers of the rear face may also be derived from mural painting, for a similar device occurred in the decoration of Old St Peter's at Rome. In spite of all these possible borrowings, however, Duccio was essentially a miniaturist, and it is worth noting that he is not at any point recorded as a fresco painter. His work has an

146 Duccio 'Entry into Jerusalem' from the Maesta (detail of *Ill. 147*)

elegance and refinement without immediate precedent in Italian art; and his dense crowds of animated figures with their small gesturing hands and tiny nimble feet have something in common with earlier French court painters such as the Master of the St Louis Psalter (*Ill. 95*). It has indeed been suggested that he may have been influenced by French miniature art, but, attractive as this idea may seem, it has little definite evidence to support it. Certain mannerisms such as the meandering decorative drapery borders should indicate northern connections. This feature in, for instance, the 'Madonna of the Franciscans' (*Ill. 148*) may be compared with the style of the figures from the Westminster Retable (*Ill. 100*). But this idea had already been taken up by the Pisani family. The same is true of the diaper background to the Madonna of the Franciscans, a further detail of northern origin. The idea appears already in the coloured backgrounds to the reliefs on the Arca di S. Domenico, a shrine from the Pisani workshop of 1265 (Bologna, S. Domenico). Duccio may therefore have received these ideas not directly from the north but at second hand. In the end there remains only a general but persistent impression that by the date of the Maesta Duccio had moved closer to the style of northern painting than any of his Italian contemporaries. This impression is particularly strong on the front of the Maesta where, in drapery and stance, the female saints (*Ill. 145*) surely come close to the work of Master Honoré or the Master of the Alphonso Psalter (*Ill. 101*).

Duccio was a reinterpreter of the Italo–Byzantine tradition represented by Guido of Siena, achieving in panel painting results comparable to those of other masters such as Cavallini who worked on a large scale. But his work is effectively distinguished from these by an elegance, grace and a deft handling of detail which in turn are reminiscent of northern art. These elements in Duccio's work were of considerable importance in the immediate development of Italian Gothic painting.

It is convenient to think of Simone Martini as a pupil of Duccio, although nothing is known of Simone's life before 1315. From this point on, however, its main outlines are reasonably clear. He spent much of his life in Siena and Tuscany. He may have visited Naples *c.* 1317 and he certainly visited Avignon *c.* 1340, staying there until

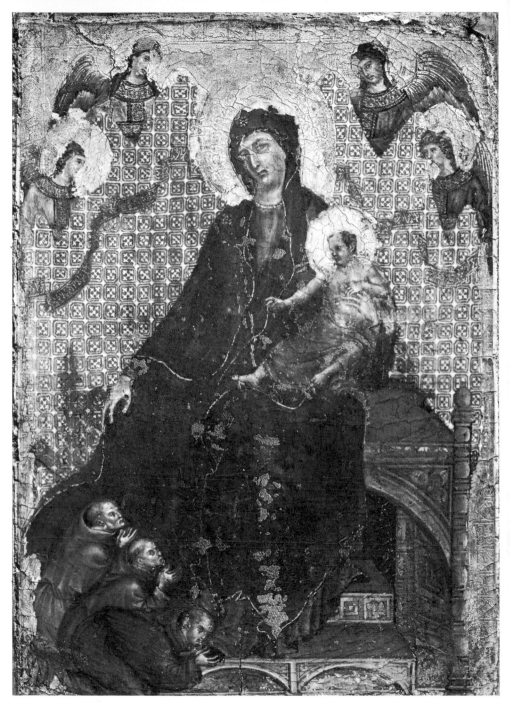

148 Duccio Madonna of the Franciscans, perhaps *c.* 1295

his death in 1344. At least one other visit to Avignon had probably already taken place. His work was certainly popular outside Tuscany, and it may be safely assumed that, for its grace and elegance, it would have been acceptable in Paris. Simone pressed the northern tendencies of Duccio very much farther than his presumed master, and he brought to the developing Gothic style in Italy an appreciation of the obvious features associated with court art – finesse, dexterity in the handling of detail, an appreciation of secular pomp and grandeur, an eye for costume and fashion, and, on occasion, ability as a painter of heraldry and portraits. Whence he derived his taste for this type of art is not at all clear – although all these features are visible in his work by 1320. Simone, who spent most of his working life in republican Siena, was in a curious way a court artist *par excellence*.

A sense of international fashion was certainly present in Italy at this time. It found one obvious expression in Simone's first commission, the Maesta of 1315, which he painted in the Sala del Mappamondo in the Palazzo Pubblico, Siena (*Ill. 149*). The Virgin is here seen seated in state, surrounded by a court and protected by a large canopy. This fresco is always referred back to the Maesta of Duccio in the cathedral. Stylistically this is correct, but iconographically the work probably belongs as much to another tradition, already found in the north. This was the tradition of depicting in a public place a representative of Authority seated in state. The appearance of one of these is known – namely the image of Edward the Confessor surrounded by ecclesiastical persons painted on a wall of the Painted Chamber at Westminster. The desire of the Sienese to possess such a work must indicate an awareness of court fashion north of the Alps; although it was only their recent election of the Queen of Heaven as *podestà* (chief executive official) that made this imitation possible.

Although Simone learnt much from Duccio, his range as a painter was far greater. It is, indeed, so extensive that it automatically illustrates many of the features of Italian painting of the first half of the fourteenth century and most of the types of commission available. From his hand, three large altarpieces survive, with fragments of at least three others. One of these, painted probably in 1319 for the church of Sta Caterina in Pisa (*Ill. 150*), is the first large Italian Gothic polyptych to survive virtually intact. Its splendid silhouette com-

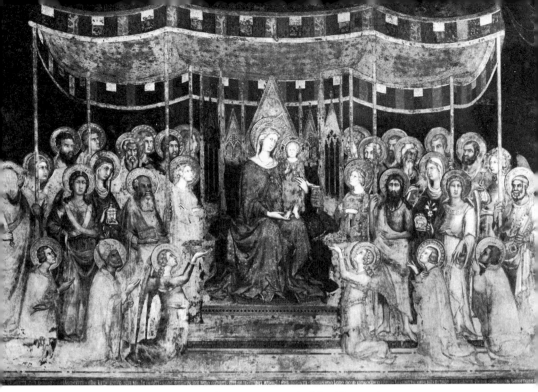

149 SIMONE MARTINI Virgin in Majesty, 1315, repaired by Simone in 1321

plete with the upper tier of gables must give some idea of the final appearance of Duccio's Maesta. The elegance of the painting is self-evident, as is also the skilful variety of each figure. The whole altar contains over forty figures, and in the hands of a lesser artist such an undertaking might well have become monotonous.

Another large altar is of a different kind (*Ill. 151*). This is the St Louis altar painted *c.* 1317 for the Angevin, Robert the Wise, King of Sicily. It represents St Louis of Toulouse seated, with his brother, Robert the Wise, kneeling before him. This direct family relationship is not a cause for surprise. Many royal dynasties in medieval Europe possessed family saints. The English kings possessed St Edward the Confessor (canonized 1161); the French kings possessed by the fourteenth century St Louis of France (canonized 1297); and it was generally felt that saints added lustre to the dynasties concerned. The St Louis altar is important for its format. It consists of a large

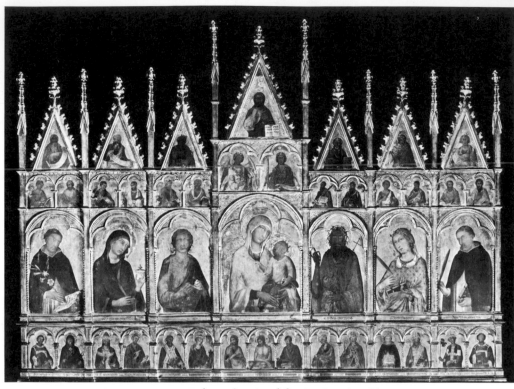

150 SIMONE MARTINI Polyptych painted for Sta Caterina, Pisa, 1319

upper panel containing the image of the saint; and a predella beneath containing five small scenes showing episodes taken from his *vita*. This is the first altarpiece to survive intact with an historiated predella. It was certainly not the first to exist, since Duccio's Maesta contained such a predella: and Duccio himself is known to have painted a (lost) altarpiece with a predella in 1302. Simone's altar marks the beginning of a process whereby this format for an altarpiece gradually became the normal one. Simone himself added one refinement to the scheme. It will be noticed that the receding lines of the architecture of the lateral scenes vanish towards the centre of the predella. In this way, a space-creating device is used also to unify the whole design.

The St Louis altar, being a family monument, is also a good example of court art. The comparatively new demands for facial

202

151 SIMONE MARTINI St Louis Altar, *c.* 1317

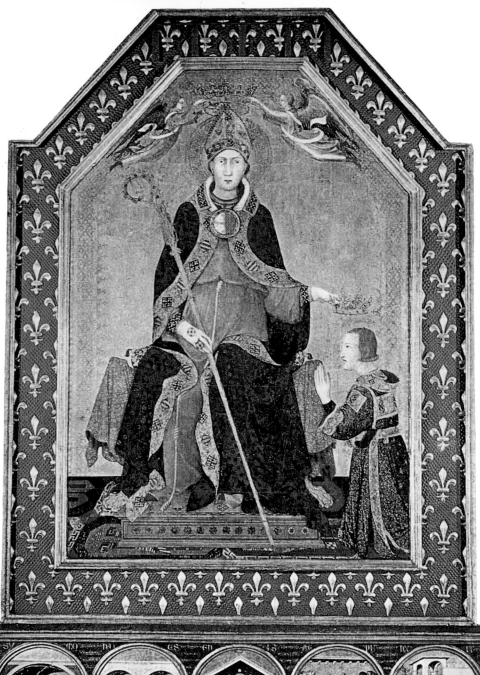

characterization, up to now associated mainly with sculpture, are here extended to painting in the kneeling figure of Robert the Wise. This type of characterization is also to be found in the image of Giotto's patron Enrico Scrovegni on the west wall of the Arena Chapel, Padua. Profile portraits of this type must underlie the famous profile portrait of John the Good of France (now in the Louvre; *Ill. 172*). There is a considerable emphasis on costume, Robert kneeling in what are presumably his coronation robes. Both these and St Louis' cope are liberally covered with family heraldry. This extends to the frame, for the border of the whole panel is carved with fleur-de-lis. Finally, the whole work was given an added sparkle and glitter by the addition of goldsmith's work to parts of the St Louis figure; and also by the addition of stones (probably semi-precious) to such objects as the crowns. These are now lost, but such additions were regularly made to royal tomb effigies in the north.

The third great altarpiece was intended for an altar in Siena Cathedral. Painted in 1333 it shows the 'Annunciation' flanked by the figures of SS. Ansano and Giustina (*Ill. 152*). It represents at its most extreme the best known aspects of Simone's style – his insubstantial elongated figures of immense elegance and decorative quality. One of the striking features of the 'Annunciation' is the small amount of 'stage scenery', compared to Giotto's 'Annunciation' in the Arena Chapel and the small 'Annunciation' on Pietro Lorenzetti's Arezzo polyptych of 1320. There is almost nothing here to suggest a physical *ambience*: even the marble throne of the Virgin is largely concealed by voluminous drapery.

However, to imagine that Simone's painting invariably followed the style found in these works would be seriously to underestimate his range. A number of other works survive, extending in size from a single manuscript leaf, through some smaller portable altar panels to the large scale of the fresco cycle in the lower church at Assisi depicting the Life of St Martin. These works vary so considerably in their treatment of dramatic subject-matter that their dating has always caused trouble. One small panel at Liverpool (*Ill. 153*), showing Joseph and Mary remonstrating with Christ for lingering in the Temple, is fortunately dated 1342, and represents an excursion into an unusual iconographic subject, painted at the end of Simone's life.

In some respects, it resembles the Uffizi Annunciation, for the decorative folds and edges of the drapery are used in a similar way in both. The Liverpool panel, however, represents an involved human situation, and what is obviously a difficult family problem apparently as yet unresolved. The subject is handled by the artist with consummate skill and restraint, and the balance between narrative and decoration is virtually perfect.

A glance at this little panel will confirm how far Simone had travelled away from the style of Duccio by the end of his life. All the figures, but especially that of Christ, have a heaviness and firmness not to be found in the Maesta. Duccio's drapery style from the stand-point of 1340 seems unduly fussy in its use of small rounded folds and has been exchanged for something broader in which the folds and borders describe larger and more sweeping patterns without necessarily concealing the form beneath. ·

A further facet of Simone's style is to be seen in the intense expression of emotion found in the so-called Antwerp polyptych. This tiny work has unfortunately been dismembered, four panels being in Antwerp, one in Paris and one in Berlin; but when complete it was exceptionally disquieting. Closed, it displayed an unhappy, troubled Annunciation, the Virgin recoiling more obviously before the impact of the angelic message than she does in the Uffizi altarpiece. When it was opened, the spectator was faced with the four Passion scenes of the Road to Calvary, the Crucifixion, the Deposition and the Entombment. In the evolving naturalism of Gothic art such intense emotion is to be found before this time only in sculpture – in certain mid-thirteenth-century German works already mentioned (see above, p. 58), and in the work of Giovanni Pisano. It was Simone who brought the skill of an exceptional painter to bear upon the problem of conveying extreme emotion, achieving results whose controlled intensity have no adequate parallel in painting before his time.

By contrast, the frescoes of the Life of St Martin at Assisi have a relaxed discursive atmosphere which might well lead to doubts about their attribution to the same painter (*Ill. 154*). These paintings are not documented but the type and drapery of certain of the female figures is so like other known work of Simone that the attribution

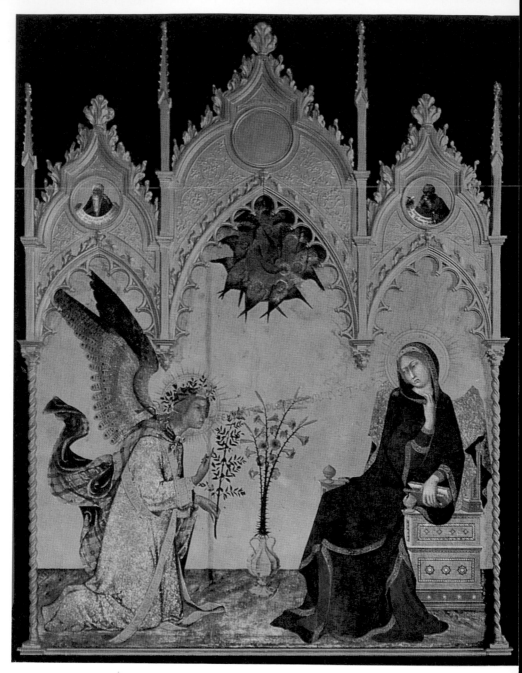

152 SIMONE MARTINI Annunciation, central part of an altarpiece painted for Siena
Cathedral, 1333

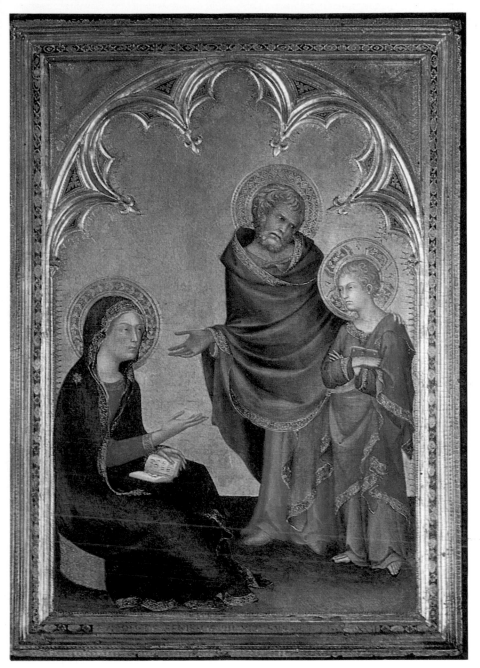

153 SIMONE MARTINI Christ with His parents, 1342

can hardly be doubted. The Assisi frescoes are reminders, therefore, that no great artist is necessarily a 'one-style' man, and also that the style of an artist may be expected to change and develop according to the problems and ideas currently interesting him. At Assisi, Simone was certainly influenced by the St Francis frescoes in the upper church, for some of the settings such as that of the 'Funeral of St Martin' seem to come from there. By contrast with the Antwerp polyptych, the figures are largely impassive in their expression and ambiguous in their feeling. The scenes contain, however, a wealth of detail in their settings and costumes. A scene such as the 'Knighting of St Martin' (*Ill. 154*) presumably contains some reflection of the sort of people Simone expected to find around a royal court, including attendants (one with a falcon on his wrist) and a group of minstrels.

Similarly, another scene in which St Martin renounces his profession as a knight must give a passable representation of an Army HQ *c.* 1330, with the king (here the Emperor Julian) seated outside his emblazoned tent surrounded by an extremely tough, rather ostentatiously dressed, group of senior officers, already armed and spurred, their horses waiting in the background. The chapel might well have been a palace chapel, for it is so splendidly decorated. There is a tall dado, faced with genuine marble decoration (contrast the Arena Chapel, Padua); the windows are filled with stained glass and the frescoes are embellished with gold leaf. It is possible that Simone himself was responsible for the total scheme. In any case, two architectural features point to further connections with the north. One is the pattern of pierced quatrefoils which clothes the lower part of the chapel. Used with this density and in this position, they must be derived from the quatrefoils which embellish the lower parts of the late thirteenth-century French portals (see above, p. 113). The second feature is to be seen in the painted architecture of the window embrasures. Here half-length figures of saints are shown beneath canopies, the pattern of whose trefoiled arches is repeated in a second painted arch immediately behind. This is the rayonnant idea of the double skin of tracery, adapted to a particular purpose but comparable to usage, found for instance at St Urbain at Troyes. It has already been noted that the rayonnant style made little impression on the Italian

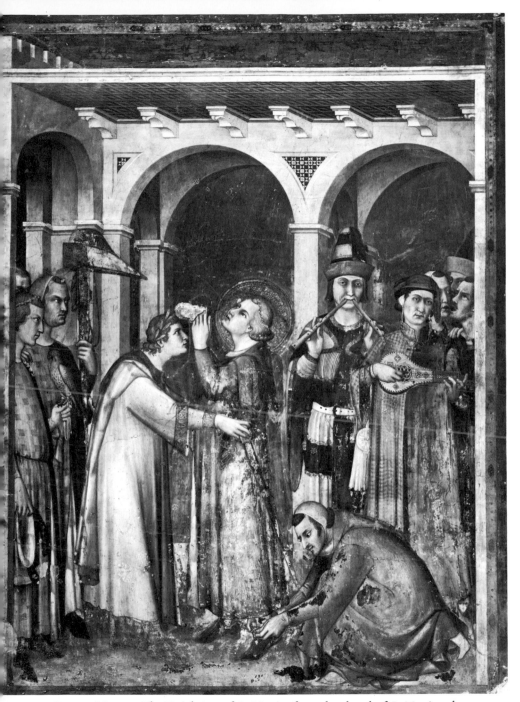

154 SIMONE MARTINI The Knighting of St Martin, from the chapel of S. Martino, lower church of S. Francesco, Assisi, perhaps *c.* 1330

masons, and it is therefore of some curiosity and interest to find a motif belonging to it taken up by a painter.

Simone's other great fresco faces the Maesta in the Sala del Mappamondo. This is the painting of the condottiere Guidoriccio da Fogliano on horseback (*Ill. 155*). Very little is known about equestrian representation in the Middle Ages, and as long as the identities of the thirteenth-century Rider figures at Bamberg and Magdeburg remain uncertain, the whole subject is hard to discuss. The figure of Guidoriccio is at least the first certain surviving equestrian portrait of a contemporary figure, painted in 1328, in the year in which this General beat the Florentines and captured the two towns of Montemassi and Sassoforte. Simone was clearly well qualified to paint this memorial, containing, as it does, elements of costume, heraldry and portraiture. His solution, however, contained a stroke of genius, since he excluded all other human elements from the scene. The background becomes in some sense symbolic of Guidoriccio's achievement with its representations of the two towns and the military encampments. But none of this effectively competes as a centre of interest with the single figure of the rider in the centre.

From all that has been said, it will be apparent that Simone was a painter of great ability and considerable range. It is not surprising that his services were in demand outside Siena and that he ended his life at Avignon. From that period little survives. In addition, however, to the Liverpool painting already discussed, a series of superb figures from his hand have recently been recovered inside the west porch of Avignon Cathedral. Here Simone painted the tympanum and gable of the west portal, and although the frescoes have almost vanished, the preparatory underpainting has survived intact. These magnificent monochrome sketches (*Ill. 157*) are a supreme example of a class of preparatory work becoming more common at this period. Painted usually in red ochre named after the city of Sinope in Asia Minor, these *Sinopia* paintings may provide valuable evidence about compositional methods, since they are the only preparatory evidence to survive from this early period. Simone's own work at Avignon shows many small alterations made to the scheme during the course of execution. At one stage, the figure of Christ was planned to hold an open book, but this was subsequently altered to

210

155 SIMONE MARTINI Equestrian effigy of Guidoriccio da Fogliano (detail), 1328

become an orb within which were painted on a minute scale water, mountains, trees and stars - symbols of the visible world of which the orb itself was a symbol. This detail is the more interesting because it is extremely rare. One other major work in which it appears is the Westminster Retable (see above, p. 134), providing a further tantalizing link between Simone and northern Gothic art.

Simone's painting has been dealt with at some length since in its range and variety it illustrates many aspects of Italian Gothic art of the first half of the fourteenth century. But, just as no other artist emulated the concentrated austerity of Giotto's work c. 1320, so few seriously imitated the grace and elegance of Simone's figure painting. Alongside both men there developed what may be seen as a series of intermediate styles, more robust than that of Simone, but also more extravagant in the treatment of detail and setting than the style of Giotto. In Florence, this type of painting is well exemplified by the work of Taddeo Gaddi. The frescoes painted in the Baroncelli chapel of Sta Croce in c. 1332–8 (and therefore for the most part within the life of Giotto) have great variety of setting and a striking illusionism in some of the painted architectural detail. The rather trivial anecdotal side to the scenes is notable, and the narrator is certainly not free from sentiment and feeling. Taddeo was a competent and interesting artist

211

but he is overshadowed by two Sienese artists, the brothers Pietro and Ambrogio Lorenzetti.

Pietro Lorenzetti's first certain work is of 1320; the first dated work of Ambrogio is 1319 (although this is only an attribution). Both artists were therefore older than Taddeo Gaddi of Florence, although younger than Simone Martini. Pietro's work of 1320 is an altarpiece in the Pieve of Arezzo (*Ill. 156*). It is of interest because it has a general similarity in its format to Simone's 1310 altar at Pisa. Pietro's figure style, however, is very different. The figures are more solid and appear to be larger, being in any case of almost three-quarter length. The Virgin has a broad solid face and looks intensely at the child (an idea probably derived from Giovanni Pisano) which

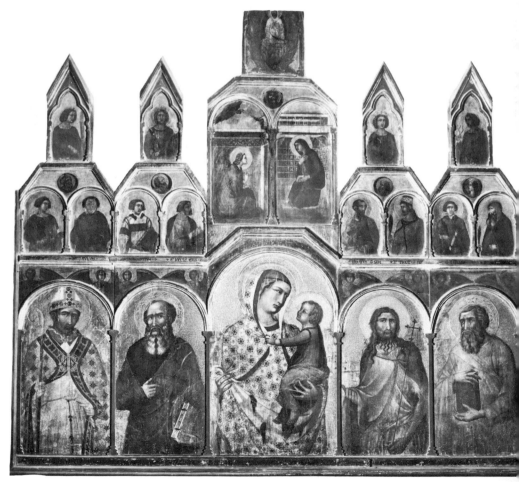

156 PIETRO LORENZETTI Altarpiece in Pieve, Arezzo, 1320

157 SIMONE MARTINI 'Salvator Mundi'. *Sinopia* painting for a fresco in the porch of Notre Dame des Doms, Avignon, *c.* 1340–4

she supports with a tense rigid hand. Simone's Pisa figures are expressionless but Pietro's Arezzo figures have a brooding seriousness. What is striking about Pietro's personal style as it is revealed in this altarpiece is the lack of any trace of the nascent Parisian elegance to be found before this date in the work of Duccio and Simone. In the history of altarpieces, the upper scene of the Annunciation provides a surprise. The action takes place in a defined setting which incorporates in its structure the frame of the altarpiece itself. The wooden pillars of the frame are to be understood as part of the house in which the Virgin sits. This type of confusion between the real and the painted world is found again in Pietro's 'Birth of the Virgin' of 1342 and was taken over from the repertoire of fresco painters.

Both the Lorenzetti brothers were important fresco painters. Both were indebted to Giotto, sometimes obviously. For instance, the scene

of 'St Louis of Toulouse before Boniface VIII' which Ambrogio Lorenzetti painted *c.* 1325 for the chapter house of S. Francesco, Siena, appears to develop a composition established in one of Giotto's scenes in the Bardi Chapel at Sta Croce, Florence. There is, however, a strong emphasis on the assembled court which overshadows the central action in a most un-Giottesque way. Ambrogio made use of the near-contemporary subject-matter to introduce a considerable variety of costume and facial type among the various spectators. This work has, indeed, many general similarities to the St Martin frescoes of Simone Martini already discussed.

A similar delight in descriptive detail, which must be understood as a characteristic of the period, emerges clearly in the mural paint-

158 PIETRO LORENZETTI Crucifixion in the lower church of S. Francesco, Assisi, *c.* 1330

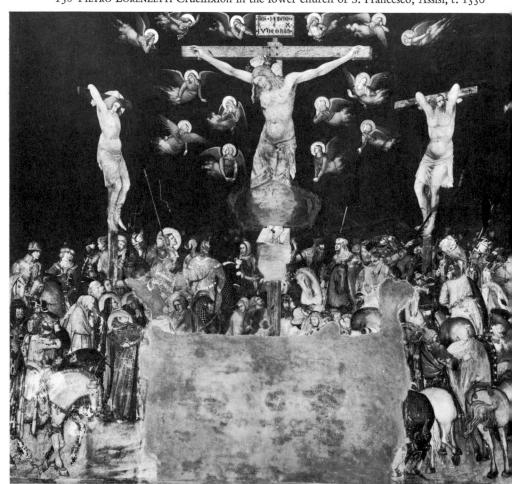

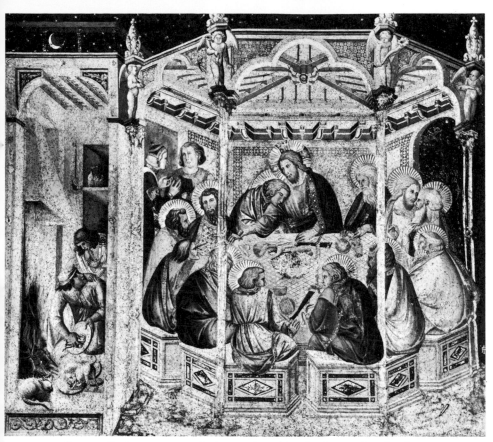

159 Follower of Pietro Lorenzetti: 'Last Supper' in the lower church of S. Francesco, Assisi, probably 1330s

ings coming from the workshop of Pietro Lorenzetti. There is a series of frescoes from this workshop, painted *c.* 1330 in the lower church of S. Francesco, Assisi, and representing the story of the Passion. As with the work of Ambrogio, some instances occur of indebtedness to Giotto. The Deposition scene is striking for the compactness of the grouping, the bulk of the figures and the control and restraint of the action and feeling. In other scenes, on the contrary, descriptive detail tends to run riot in a wholly un-Giottesque way. The Crucifixion scene (*Ill. 158*) is conceived on a panoramic scale, perhaps under the influence of Giovanni Pisano's Crucifixion relief on the Pisa Cathedral pulpit. The painter depicted a vast scene with jostling horsemen, and used the opportunity to insert all manner of

different costumes, uniforms, hats, helmets, and also types of reaction and types of face. The painting indeed makes its impact in the contrast between the heterogeneous mass of people and the still isolation of the crosses above.

Among the painters who finished off the Passion cycle at Assisi was one artist whose work is highly individual. The fresco of the 'Last Supper' is one of his scenes (*Ill. 159*), and it will be seen to what lengths he went to make his settings interesting. The action takes place in a somewhat bizarre hexagonal building, similar, as is often pointed out, to the lower part of a pulpit. It is night (there is a moon outside), and some attempt is made to suggest that the scene is artificially lit from within. The most surprising feature is the little annexe painted alongside where the servants are to be seen cleaning dishes beside a blazing fire accompanied by a cat and a small dog. The artist was certainly not Pietro, since his work has an unselective and confused narrative vein, far more pernickety in its devotion to irrelevant detail than anything to be found in Pietro's known work. This nameless master was nevertheless in his own way experimental and his observation of the servants' quarters mentioned above is a small masterpiece of great originality.

At some point during the 1330s Ambrogio Lorenzetti must have supplanted Simone Martini as the chief painter in Siena (perhaps as the result of a visit by the latter to Avignon); for in 1338–40 he undertook to fresco the walls of the Sala del Nove, a room immediately adjoining the room in which are Simone's Maesta and Guidoriccio frescoes. Since this room was the council chamber of Siena's chief magistrates and it is not surprising to find as the subject an allegory on the theme of Good and Bad Government. Nor is the personification of Virtue and Vice unusual: it has a long history in medieval art. Enthroned on one wall are Justice, the Common Good, Providence, Temperance and other Virtues, while adjacent is painted Tyranny enthroned, with corresponding Vices. However, accompanying these are two large town- and landscapes, illustrating the effects of the respective types of government (*Ill. 160–1*). These frescoes, the first great panoramic views of town and country since classical times, illustrate dramatically the extraordinary command of structure and the control of space and distance achieved in Italy

during the first half of the century. It is true that the elements of this juxtaposition of town and country are already present in Duccio's painting of the 'Entry into Jerusalem' (*Ill. 146*), and the delight in descriptive detail is a feature common to most artists of this period. Italian artists, however, were able to organize this wealth of detail on a large scale into a spatially convincing whole.

The genesis of the idea for these huge panoramic views is not at all clear, but it seems certain that the well-governed town is intended to be Siena. (The 'Ill-governed Town' is unfortunately almost ruined as a fresco.) This is indicated by the dome and campanile of the cathedral in the top left-hand corner; and although this part of the wall was repainted in the fourteenth century soon after the fresco was finished, there is no reason to suppose that these features did not exist from the start. These indications link this fresco to the genre of architectural portraiture which emerged probably in the late thirteenth century. Already by that date painters were beginning to specify a particular *milieu* by including a handful of recognizable objects. Thus, in the St Francis cycle at Assisi, the artist who worked the scene of 'St Francis and the Poor Man of Assisi' included in the background a not entirely accurate version of the small classical temple front still to be seen in the main street of Assisi – for this was where the scene took place. For Rome, artists soon developed a sort of shorthand which included such instantly recognizable monuments as the Pantheon, Trajan's Column, the Torre delle Milizie or the Pyramid of Sestus. The fresco of the city and countryside of Siena is really an extension of this idea, put to a novel use and executed with the enormously extended means now at the artist's disposal.

This account of Italian painting has so far made no mention of manuscript illuminations. These have their own distinctive appearance and development but they appear at all times to have been strongly influenced by the prevailing style of work on a larger scale; the most significant developments seem to occur in these larger works. This dependence of the smaller on the larger works has always given Italian manuscript-painting the status of a minor art. Comparatively little work has been done on it, in comparison to the immense amount of research that has been lavished on figures such as Giotto or Simone Martini; and there is no space here to attempt

to do justice to the ramifications of the subject. Bologna had always been a great centre of book production, and continued as such throughout this period. But in practice most large towns had of necessity *scriptoria*; and there would appear to have been a somewhat ill-defined 'court school' of manuscript production dependent on the Angevin court at Naples. Italian manuscripts are easily distinguishable by their pictorial style and script. In addition, they have, as a rule, a type of border decoration which is totally different from that of all areas in the north that fell under the influence of Paris. In contrast to the rather thin, wiry foliage decoration to be found in the north, Italian manuscripts are bordered normally by a species of florid acanthus leaf twisted into different patterns. The existence of this Italian convention was not without influence later on in the north.

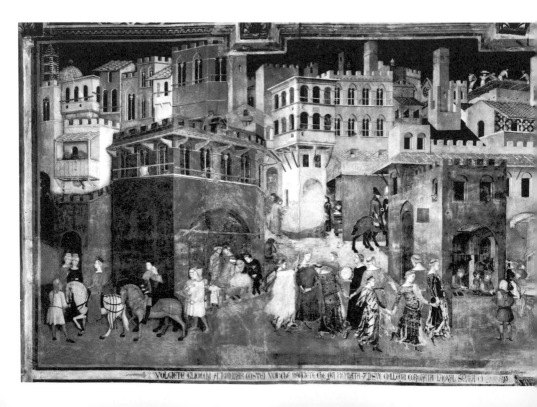

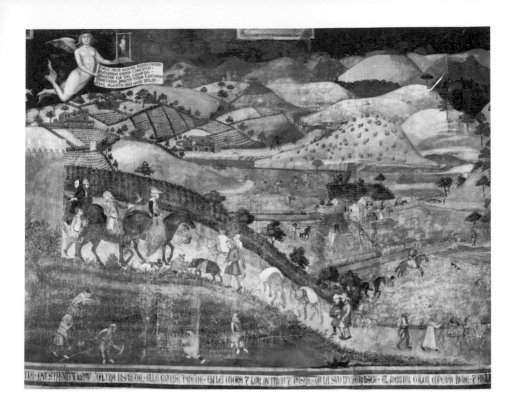

160–1 AMBROGIO LORENZETTI The Effects of Good Government, fresco for the Sala del Nove, Siena, 1338–40

219

162 South transept façade of Prague Cathedral, founded 1344

European Art 1350–1400

Poised midway between thirteenth-century Paris and sixteenth-century Italy, the years 1350–1400 are stylistically indecisive. During this period many ideas formulated in the mid-thirteenth to mid-fourteenth century were developed farther, but the impression is of existing traditions being embellished rather than changed.

Nevertheless, one virtually new artistic and cultural centre emerged during this period. This was Prague, the seat of the Imperial court for about half a century. Charles of Luxembourg was elected Emperor as Charles IV in 1346. He had since 1333 been ruling Bohemia as his father's regent, and when in 1346 his father died, he inherited the throne. Prague was already the centre of his power and influence and the visible elevation of its status had already begun. For in 1344 the bishopric had been raised to an archbishopric and almost at once a new cathedral was begun. Four years later a new university was founded and, turning to his own needs, Charles IV began a new palace-castle for himself at Karlstein outside the city.

The cathedral is probably the most striking monument to the new regime, and certainly one of the most important churches to be begun during the fourteenth century. It was designed on orthodox French lines by the master-mason of Narbonne Cathedral, Mathias of Arras. When he died in 1353, however, his place was taken by Peter Parler, member of a distinguished family of German masons (his father Heinrich had been responsible for the church of the Holy Cross at Schwäbisch Gmünd). Peter Parler controlled the building up to his death in 1399. By this time the choir and much of the south transept with its tower had been completed. The remainder of the building is of the nineteenth century.

Most of the unusual features of this building must be ascribed to Peter Parler – and there are many. What is of great interest is that

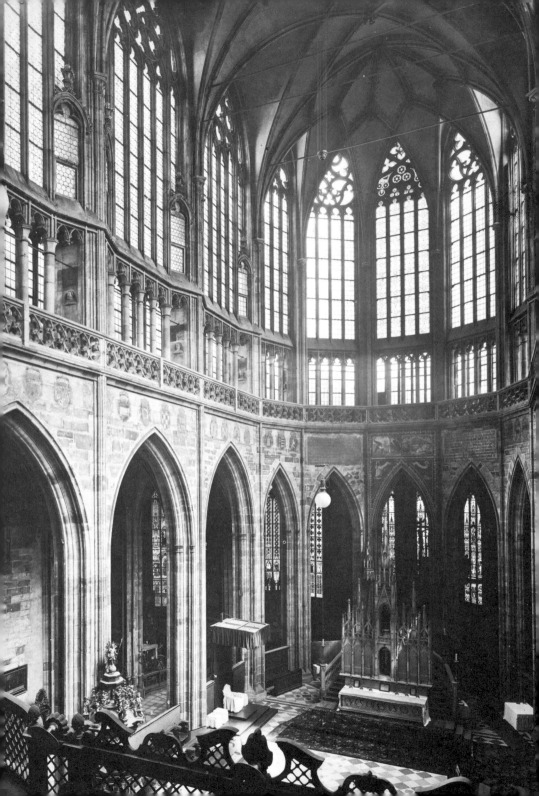

164 Vault of south transept porch, Prague Cathedral

cumulatively they suggest a knowledge of English architecture, although the means by which Parler could have acquired such knowledge are not at all clear. The upper part of the choir, begun 1374 (*Ill. 163*), is unusual as a rayonnant building in that the windows are set back behind the line of the arcade. The difference in the vertical surface is stressed both by a heavy balustrade which runs along in front of the triforium arcade; and also by diagonal arches set across the angles in each bay. The differentiation of level and the means of emphasis are all English in character, although of that part of English architecture not dealt with in any detail above (Chapter Two). Heavy balustrades occur at Exeter (*c.* 1300), and later at Winchester (nave from 1394). Diagonal arches used in a similar way occur in the choir at Wells (*c.* 1330). Moreover, the choir of Prague was the first major church to receive a type of vault, known from its pattern as a net-vault, which is closely linked to earlier English experiments in vault design.

Further, two smaller vaults in Prague Cathedral in the sacristy and (*Ill. 164*) the south porch suggest similar connections. These are small open-work skeleton vaults (that is, the ribs are exposed without any

163 Interior of choir of Prague Cathedral, founded 1344, upper parts after 1374

in-filling behind), and here again the immediate precedents are in England (for instance, Bristol Cathedral, ante-room of the Berkeley Chapel, *c.* 1305–10). These connections with England may be surprising but they act as a reminder that in the Europe *c.* 1300–50 many of the most interesting experiments in architecture were being carried out in England.

Some of the decorative features of Prague Cathedral may well have originated with the Emperor. The chapel of St Wenceslas has walls encrusted with large polished lumps of semi-precious stones – a feature which recurs in the imperial palace of Karlstein. The south transept façade (*Ill. 162*) is decorated with a large mosaic of the Last Judgment (1370–1), an idea undoubtedly derived from Italy (compare Suger, see above, p. 11). The influence of Italy is again to be seen in the unusual amount of narrative painting with which the church was decorated.

Charles IV undoubtedly saw the cathedral as a personal monument. In a manner reminiscent of St Louis, he re-interred many of his Bohemian ancestors, creating a family mausoleum in the eastern chapels; and he went to great lengths to stock the church with plate, jewels and relics. Not unexpectedly, he himself figured several times in the decoration, notably in a series of busts carved in the triforium of the choir. This gallery of personalities includes Charles' brothers, his heir Wenceslas, three archbishops of Prague and the two successive master-masons of the fabric. Thus the royal family and those immediately concerned with the building surround the Emperor (*Ill.* 165) and his wife, who took the place of honour on the central axis of the building.

Charles IV appears to have treated Prague Cathedral as if it were a Ste Chapelle, requiring of it a standard of brilliance commensurate with his imperial dignity. In fact, he also had his own palace chapel, or series of palace chapels, in the castle of Karlstein. This fortress was built and decorated mainly between 1348 and 1367. Except for one major loss (the painting in the Great Hall), virtually the whole of the decoration survives in varying states, both satisfactory and dilapidated. The layout of the decoration of the chapel of the Virgin has already been mentioned (see above, p. 178). Although there are points at which the decoration conforms to Western traditions, the

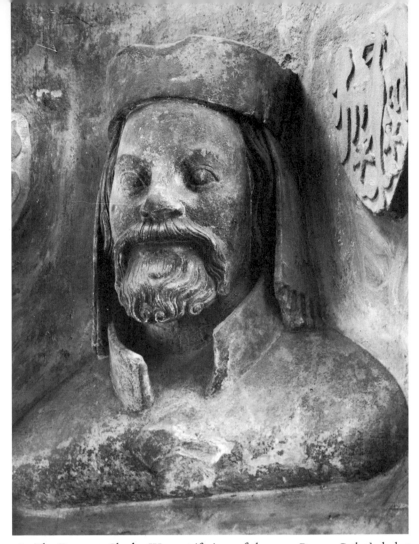

165 The Emperor Charles IV, on triforium of the apse, Prague Cathedral; last quarter of fourteenth century

Karlstein paintings have a curious individuality. In general, the main stylistic influence was Italy. Charles apparently liked Italian painting. He had also acted as his father's regent in Italy, and the altarpiece in his main chapel at Karlstein (the chapel of the Holy Cross) was by an Italian called Tomaso of Modena. His own painters had studied the illusionistic side of Italian painting fairly thoroughly and there are some examples of elaborate *trompe-l'œil* architectural effects (*Ill. 168*)

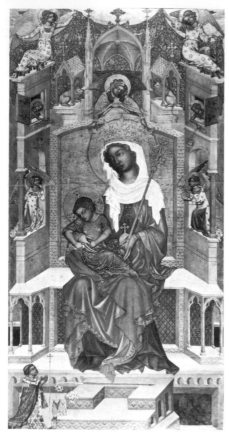

166 Glatz Madonna, *c.* 1350

Some of the settings are also convincingly three-dimensional, as in the famous scenes of Charles receiving and offering relics (*Ill. 167*). In addition the large heavily modelled faces are Italianate.

Earlier Bohemian painters had drawn directly and obviously on Sienese art. The so-called Glatz (Kladsko) Madonna (*Ill. 166*) has something of the splendour and elegance of Simone Martini's painting. It was painted *c.* 1350 for the Archbishop of Prague, Ernest von Pardubic, to be set on the altar of his new foundation in Glatz. Italian influence also pervades the incomplete cycle of nine panels from the Cistercian monastery of Hohenfurth (Vyssi Brod). However, it will be seen that what follows has lost much of the previous elegance. The figures are more massive. The heads tend to be larger and the drapery thicker, heavier and more rounded. It is the origins of this development which provide the problem.

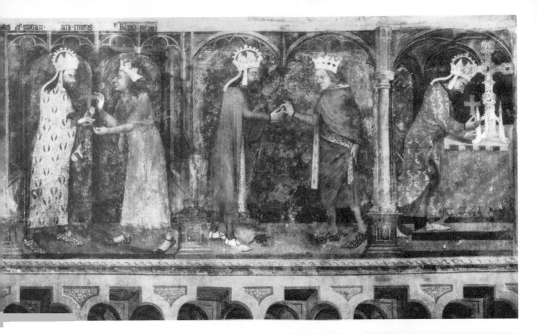

167–8 Scenes commemorating the donation of relics to the Emperor and part of the illusionistic painting beneath, Chapel of the Virgin, Karlstein Castle; probably 1357 or slightly before

All this can be seen at its most extreme in the chapel of the Holy Cross, the decoration of which was probably complete by the time of its second consecration in 1365 (*Ills. 169, 170*). The whole plan of this chapel is unusual. The lower part of the walls is encrusted with blocks of semi-precious stone – an idea also found in the cathedral and already mentioned. Above this, the walls are covered not with frescoes but with panel paintings, each panel containing the figure of a saint. Many of the frames of these panels once contained relics, and the general effect is of a chapel whose walls are covered with icons. Once again, the starting point for this idea is unclear, but it is worth remarking that, apart from the general impression of opulence, it owes nothing to the Ste Chapelle in Paris. In this it represents a very remarkable deviation in taste.

169 Chapel of the Holy Cross, Karlstein Castle. Decoration 1357–67

170 MASTER THEODORIC A Prophet. Chapel of the Holy Cross, Karlstein Castle, 1357–67

The name of the painter of the chapel was Theodoric. His origins
are now totally obscured. He left in these paintings a series of power-
ful but ungainly thick-set lumpish figures whose individuality has
never been questioned. No other European monarch could boast a
painter like Theodoric. What may seem surprising is that his style
should have been tolerated by a man brought up at the French court.
For Charles had spent his childhood in France and had been married
(until her death in 1348) to Blanche de Valois, sister of Philip VI of
France. He admired the Parisian Ste Chapelle sufficiently to sanction
the construction of a greatly enlarged edition of that building on the

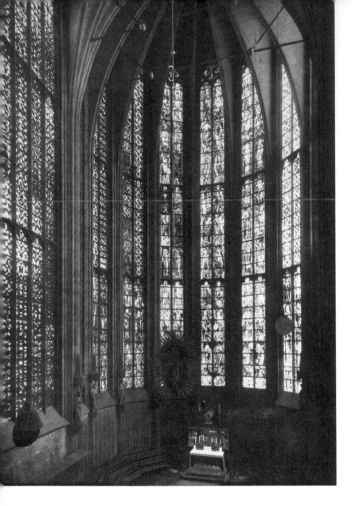

171 Interior of choir, Aachen Cathedral; begun 1355

east side of the palace chapel of Aachen (begun 1355; *Ill. 171*). He employed a French mason on Prague Cathedral. He must have known something of the delicacy and refinement of contemporary French miniature painting. His own sister, Bonne of Luxembourg, had taken easily enough to the manuscripts of the Pucelle workshop.

The delicate style of Pucelle, however, may not be entirely representative of Parisian art around 1360. It is possible that the style of Theodoric and his associates was acceptable because it imitated a style already current in Paris. Here art also came increasingly under the influence of Italy during the second half of the fourteenth century; and by the end of it (as in Bohemia) elaborate architectural perspec-

tives, illusionistic detail, and heavily modelled faces had all become stylistically acceptable and common.

As a result of the almost total loss of any art larger than manuscript illumination, much of the detail of this development is now lost. In any reckoning the profile portrait of John II must play an important part. If this painting (*Ill. 172*) was done during John's lifetime (he died in 1364), and if it was representative of a class of Parisian art on a scale larger than that of manuscripts, then there was a contemporary Parisian equivalent to the art of Prague.

172 John the Good, probably before 1364

Other surviving Parisian works in a comparable style are all later. They include the miniature of the presentation of the Bible of Jean Vaudetar (*Ill. 182*), dated 1372, in which a bulky and heavily modelled King Charles V of France sits in a clearly indicated space marked out by a tiled floor and, overhead, a circular baldacchino. The only considerable large-scale works to survive are two tapestries (*Ill. 173*) now at Angers and New York (The Cloisters Museum). The Angers Apocalypse tapestries are datable to 1375–81; those at New York showing the 'Nine Heroes' are probably a little later. Both rely for effect on elaborate architectural constructions contrived in a reasonably convincing perspective. The next datable monument in this style is the grisaille painted altar-hanging known as the 'Parement de Narbonne' (*Ill. 174*). This was executed for Charles V shortly before 1377. The figures are elegant and attenuated, but they have strongly modelled, expressive faces, and in the Flagellation scene are contained within an architectural framework. Derived directly from the style of the Parement are the opening miniatures of a Book of Hours

173 Scene from Apocalypse Tapestries, made for Louis I, Duke of Anjou, 1375–81

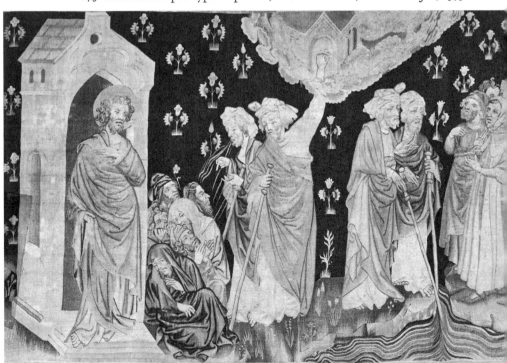

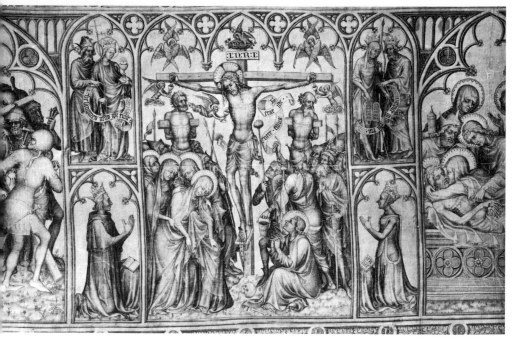

174 Crucifixion from the Parement de Narbonne, shortly before 1377

ultimately owned by the Duke of Berry, and now known as the *Très Belles Heures* (*Ill. 183*). Finally, to this tradition belongs the Broederlam paintings done during the 1390s for the Duke of Burgundy and still at Dijon. Here too are Italianate architecture, Italianate conventions for landscape and strongly characterized faces (see the next volume in this series: Peter and Linda Murray's *The Art of the Renaissance*).

Parisian fashion can be shown to have influenced the Emperor Charles in other contexts. The great hall of Karlstein was decorated with a fresco cycle representing figures from Charles' genealogy. The French kings already had a comparable cycle in the great Hall of the Louvre although it was carried out in sculpture and not as a wall-painting. It should be added that late in the fourteenth century (1393–8) Richard II of England ordered a similar sculptural cycle to decorate the interior of the redesigned Hall in the Palace of Westminster. Thus did decorative fashions spread.

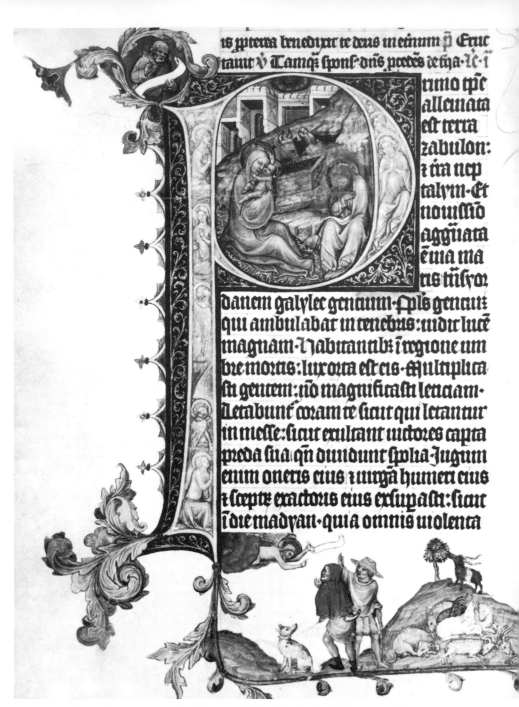

175 Page from the portable Breviary (*Liber Viaticus*) of Johann von Neumarkt, before 1364 (detail)

Parisian manuscript decoration also had initially a perceptible influence on Bohemian manuscripts. Many of these were executed for Charles' immediate *entourage*. The earliest is probably the portable Breviary (*Ill. 175*) known as the 'Liber Viaticus', executed before 1364 for Charles' own chancellor Johann von Neumarkt (Jan of Streda). The miniatures are closely allied to the style of the Glatz Madonna and the Hohenfurth panels, and like them are strongly influenced by Italian art. This is also true of the border decoration which, in contrast to the contemporary Parisian 'spiky ivy-leaf', is composed of acanthus foliage. Yet the book was certainly not written by an Italian-trained scribe; and what might be called the 'aesthetic of the page design' is far more Parisian than Italian. Italian manuscripts frequently have irregular page layouts. The text may be surrounded by a luxuriant but uneven wreath of acanthus foliage, and pictorial illustration, sometimes confined to initials, may equally spread unpredictably around the margins. Placed alongside almost any Italian manuscript, the Liber Viaticus is remarkable for the control and restraint of its decoration: so that in spite of the differences of detail, a comparison with the Belleville Breviary (*Ill. 98*) is not inappropriate.

It is necessary to add that in its restraint the Liber Viaticus is not at all typical of Bohemian manuscript-painting. Particularly in the books commissioned by Charles' son Wenceslas, acanthus foliage, armorial bearings, personal devices, animals, monsters and other decorative features tend to run riot around the text. Such conspicuous display of detail leaves the reader in no doubt about the *de luxe* and expensive nature of the manuscript; this and the feathery quality of the acanthus foliage makes most Bohemian court manuscripts easily recognizable (*Ill. 188*).

On a larger scale, too, Bohemian painting developed characteristics of its own. Parts of an altarpiece formerly at Wittingau (Trebon) belonging probably to the 1380s can obviously be classified alongside the decorations of Karlstein, or a major scheme such as the cycle of paintings in the Emmaus monastery at Prague. The Wittingau figures, however, while preserving the heavy modelling of what was by now the Bohemian tradition, are gracefully elongated. The drapery falls in ample folds and the female faces in particular have an unusually

soft appearance (*Ill. 176*). In the Wittingau altar and its associated paintings appear to lie the beginnings of the so-called 'soft-style', which spread thence to Hamburg, to Cologne and to the Rhineland (see *The Arts of the Renaissance*, Peter and Linda Murray, p. 65). In Bohemia itself, this tradition was elaborated around 1400 into the somewhat mannered style of the St Vitus Madonna. The style was also adopted by the sculptors, and is to be found in the Krumau (Krumlov) Madonna and similar works.

A part of the history of late fourteenth-century painting in France has been related above. The importance of Italian ideas is clear, and becomes even clearer in the opening years of the fifteenth century, with fresh experiments in landscape, with the introduction of architectural portraiture and occasionally (especially in the work of the Limbourg brothers) with the transposition to the manuscript page of compositions derived from Italian wall-painting. A significant innovation was the introduction of Italianate acanthus leaves into the borders of traditional spiky ivy-leaf. It would be of interest to know to what extent Italian artists travelled north. One Italian manuscript painter can certainly be traced to France. He was called Zebo da Firenze and worked probably in Paris during the opening years of the fifteenth century. At his most exuberant (*Ill. 189*) he tended to engulf the text in a mass of decorative acanthus liberally interspersed with *putti*. His narrative scenes were not always confined to a restricted area (compare *Ill. 183*) but sometimes spilled over into the border after the Italian manner.

Italian influence is also to be found in the firmly three-dimensional character of much secular interior decoration. Attention has already been drawn to the Angers Apocalypse tapestry for this reason. A further example has been seen at Karlstein (*Ills. 167–8*). Earlier major examples of interior painting still survive at Avignon (*c.* 1340) in the Papal Palace. Here rather flat scenic painting alternates with amusing and pleasant *trompe-l'œil* effects (*Ill. 177*). Nor, in this context, is it inappropriate to instance examples actually in Italy, for a house such as the Palazzo Davanzati in Florence contains much that would have been perfectly acceptable in a northern palace. One of the bedrooms (*c.* 1395; *Ill. 178*) has painted on to its upper walls an open garden loggia peopled by characters and scenes from a French romance. The

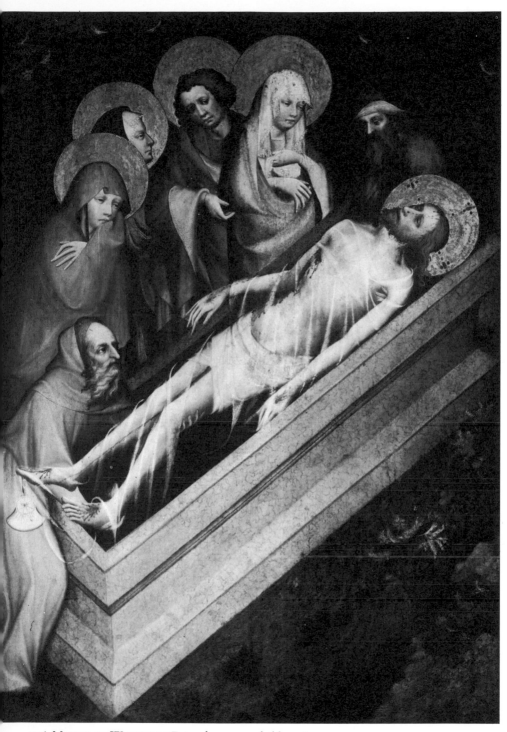

176 MASTER OF WITTINGAU Entombment, probably 1380s

rest of the area is copiously sprinkled with coats of arms and personal devices.

In England surviving large-scale work of the second half of the century also shows initially a strong Italian influence. The most important works of which parts still survive were those put in hand by King Edward III at Westminster. In the middle years of the century, a programme of redecoration was begun in St Stephen's Chapel, including a series of paintings on the east and lateral walls. Italian influence is obvious here in the treatment of space and in the modelled faces visible in the surviving fragments now in the British Museum. Drawings made before the final destruction of these paintings show that the altar wall included an impressive representation of Edward III and his family kneeling in line within a vaulted and tiled building. Moreover, the scenes on the side walls, although on a small scale, were marshalled in regular vertical and horizontal rows after the Italian manner, unlike those in the Painted Chamber near by.

177 (*left*) Living-room decoration in the Tour des Anges, Avignon Palace, *c.* 1340

178 (*right*) Bedroom decoration in the Palazzo Davanzati, Florence, *c.* 1395

179 Fragments of painted angels in the Chapter House, Westminster Abbey, London, *c.* 1370

Equally Italianate are the fragments, mainly of angels' heads, in the eastern bays of the chapter house of Westminster Abbey, executed probably *c.* 1370 (*Ill. 179*). However, this influence appears to have receded, since the later Apocalypse wall-paintings in the chapter house are much closer to art of the Empire and have been compared to painting in Hamburg of the last twenty years of the century.

In general, the influences at work in English painting during the later part of the century are far from clear. Since Richard II married a Bohemian wife, Anne, the daughter of Charles IV, it is an obvious question to ask whether any aspects of Bohemian art were transmitted to England. The great seated portrait of Richard II (perhaps *c.* 1395) now in Westminster Abbey (*Ill. 181*), may well reflect it. The modelling of the features has a similarity to some of the portrait figures at Karlstein; and the style of the drapery and the general stance are to be found also in the figure of Charles IV from the Karlstein genealogical cycle (known from engravings). Parallels can also be drawn with some of the seated figures painted in the cloisters of Emmaus Monastery. However, the unique character of this portrait has always made comparisons difficult.

239

180 (*left*) Page from Book of Hours made for the Bohun family, *c.* 1380

181 (*opposite*) Portrait of Richard II, *c.* 1395

English manuscript-painting of this period lacks above all the firm figure modelling of all these larger works. A number of important manuscripts exist, notably a group produced *c.* 1370–90, probably in London, for members of the Bohun family (*Ill. 180*), a missal produced for Abbot Lytlington of Westminster Abbey in 1383–4 and part of a missal produced for the Carmelite community (Whitefriars) in London *c.* 1395. These manuscripts (*Ills. 180, 184*) introduce various styles of border decoration, and derive some of the figure compositions from Italy. But the figures with their small beady black eyes tend to be rather awkward and shapeless in spite of the ambitious groupings which are sometimes attempted.

182 Frontispiece of the Bible
of Jean Vaudetar, 1372

The designer of the Carmelite missal made extensive use of acanthus foliage in the decoration of initials. This detail in itself marks a change of fashion. It will be seen (*Ill. 184*) that a type of feathery acanthus is used similar to that of the Bohemian manuscripts; frequently it is twisted into spiral patterns. A further feature already found in Bohemian painting is the idea of filling out the body of an initial with small figures or angels' heads. This is found in the work of one of the major artists of the missal who was also responsible for a distinct change in narrative and figure style. His figures are firm and rounded and set in clearly indicated spatial settings. It has been suggested that he was trained in Flanders or the Low Countries; and although this is not certain, the art of England does once again appear to make contact with the art of the Empire.

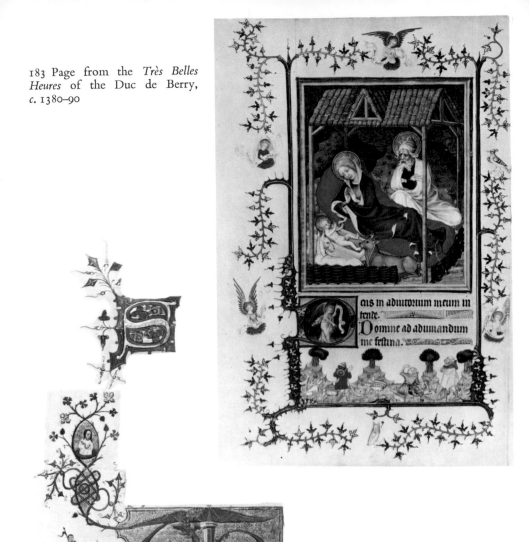

183 Page from the *Très Belles Heures* of the Duc de Berry, *c.* 1380–90

184 Initial from the Carmelite Missal, *c.* 1395

In sculpture, the story is far more fragmentary. It is generally agreed that the work of Claus Sluter for the Duke of Burgundy must in some sense mark a stylistic change from what had gone before.

Much surviving fourteenth-century sculpture is frankly decoration, and as such, does its job attractively. This may be seen in almost any royal monument where the subsidiary sculpture survives intact, and a work such as the altarpiece of Jacques de Baerze (*frontispiece*) carved, like Sluter's major creations, for the Chartreuse of Champmol, combines splendour with an intense prettiness which was certainly intended to delight. Sluter's main innovation lies in the degree of emotive power with which he instilled his figures, and his tendency to dramatize, yet it is worth pointing out that many of the ideas embodied in Sluter's work were part of an existing tradition. In the case of the tomb of Philip the Bold (the only French royal monument of the period to survive complete), the

185 CLAUS SLUTER Tomb of Philip the Bold, Duke of Burgundy (died 1404); begun *c*. 1390, unfinished at Sluter's death (1406)

186–7 Two fourteenth-century portrait heads. On the left is a detail of the wooden effigy made for the funeral of Edward III (died 1377), probably carved from a death-mask. The marble effigy, right, is of Philippa of Hainault by Jean de Liège (c. 1365–7). The rather pudgy face with its thick neck and double chins suggests a basis in a life-mask

elaborate arcading (*Ill. 185*) is already foreshadowed in the tomb of Philippa of Hainault in Westminster Abbey, the work of another sculptor from Flanders, Jean de Liège. The famous mourning Carthusian monks are foreshadowed in the cowled and grief-stricken figures which line the tombs of Simon de Gonçans (d. 1325) and Thomas de Savoie (d. 1332 or 1335–6) in Amiens Cathedral. The striking characterization of the effigy of Philip himself is already to be found in the effigy of the General du Guesclin, commissioned by Charles V, in Charles V's own effigy, and in the unprepossessing wooden funeral effigy of Edward III of England (d. 1377; *Ill. 186*). It has been suggested that this last was carved from a death-mask. Death-masks were certainly being taken for use by sculptors by the time of the death of Charles VI of France (1422), when the procedure is documented.

188 Opening of an official copy of the Imperial Golden Bull of 1356; executed in Prague *c.* 1390 for the Emperor Wenzel

189 Opening page of the Hours of the Virgin, from a Parisian Book of Hours, *c.* 1405–10. The artist has been identified as an Italian called Zebo da Firenze

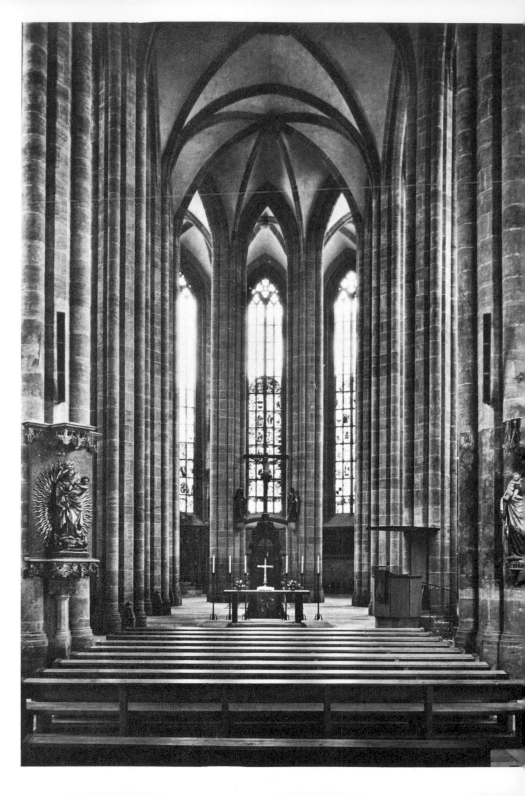

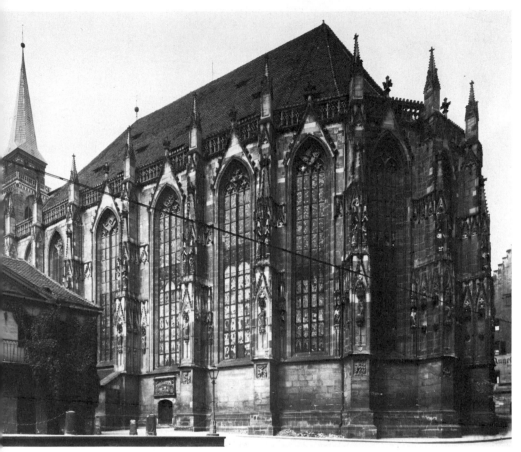

191 St Sebaldus, Nürnberg, exterior from south-east, 1361–79

The developments in northern architecture during this period were unimpressive. It is true that one major building, Prague Cathedral, was begun, and this has already been described. Another extremely imposing building, the choir of Aachen Cathedral (*Ill. 171*), mentioned above was really only a new edition of the Ste Chapelle in Paris.

Impressive churches on a smaller scale continued to be built in the Empire, a good example being the eastern choir of St Sebaldus at Nürnberg (1361–79; *Ill. 190*). This is also influenced by the Ste Chapelle, although it has three aisles. But in both the Empire and France, architectural design was at a low ebb, and the spectacular developments in vaulting tracery belong to the following century.

190 St Sebaldus, Nürnberg, interior of choir, looking east, 1361–79

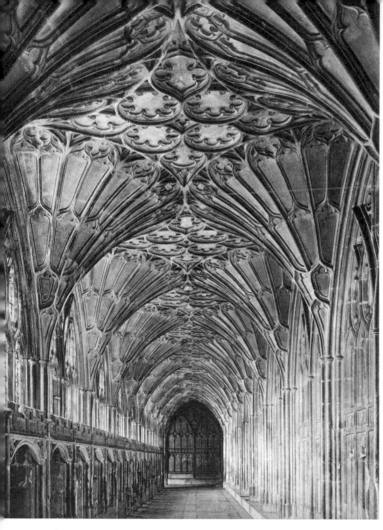

192 Gloucester Cathedral, cloisters, before 1377–1412

Only in England did a new design of vault materialize. This was the fan-vault already mentioned above (see p. 106). The first surviving example is in the cloisters of Gloucester Cathedral (begun before 1377; *Ill. 192*), although the chapter house at Hereford is known to have possessed such a vault (1360–70). This represents a logical extension of the decorative motif of the tracery panel, but nearly a century passed before fan-vaults were built on a large scale. The nave of Canterbury Cathedral, the last great building of the fourteenth century (rebuilding begun 1374) and a well-proportioned 'Perpendicular' construction, is still roofed with an elaborate lierne vault.

Perhaps more characteristic of this period is the use which secular patrons began to make of the decorative achievements of architects in ecclesiastical buildings. In effect, screens of tracery and features such as the open-work spires of Freiburg, and those planned for Cologne and Strasbourg, proved irresistible and were adapted to embellish secular palaces. Notable among these were the palaces of the Duke of Berry. His favourite residence was at Mehun-sur-Yèvre, now totally destroyed, its appearance preserved in an 'architectural portrait' by the Limbourg brothers (*Ill. 193*). It was begun soon after 1367, and its towers were topped by traceried polygonal turrets. The popularity of this idea becomes clear in the next century, and the single turret of the house of Jacques Cœur in Bourges helps to preserve something of the appearance of Mehun-sur-Yèvre. Here

193 The castle of Mehun-sur-Yèvre as shown in the *Très Riches Heures of the Duc de Berry*

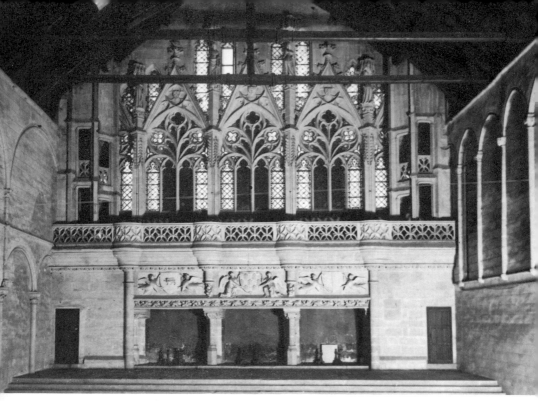

194 Fireplace of the Great Hall of the Castle of Poitiers, 1384–6

the fairy-tale quality of Chambord is already in existence. In the great hall of the Duke of Berry's palace at Poitiers is preserved another of these decorative embellishments in the form of an enormous fireplace, topped by an elaborate glazed screen of tracery with sculpture (1384–6; *Ills. 194–5*).

One major architectural feature has now irrevocably vanished, although, once more, its influence is to be seen in many fifteenth-century examples. This was the great staircase of the royal palace of the Louvre. It was a large circular staircase pierced with windows and decorated on the outside with statues of the royal family (1363–6). It has been suggested that the staircases of Henry V's chantry in Westminster Abbey reflect this celebrated work. Certainly a long tradition of large courtyard staircases in French châteaux stems from it, a tradition still alive in the staircase of the sixteenth-century château at Blois.

In Italy, the half-century produced few new buildings, and the continuation of a number of large churches already begun. The cathedral of Florence (*Ill. 196*) was continued according to an enlarged design in 1357, but there is no reason to suppose that its general outlines are not those of the church designed by Arnolfo di Cambio. In appearance, it belongs to the type of Italian great church already described – of two storeys with a large arcade. Its main regional peculiarity lies in the style of coloured marble external facing. The dome had already been planned by Arnolfo, probably in simulation of Pisa and Siena. It was, of course, completed by Brunelleschi in the next century.

The building of Siena Cathedral also continued throughout the half-century. A plan for a new enlargement on the south side was given up in 1357, and attention devoted to finishing off the existing

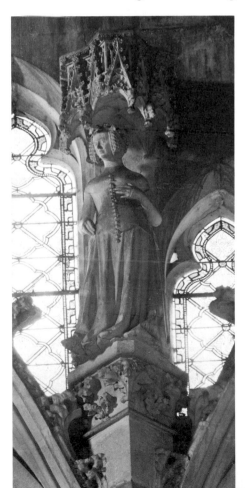

195 Figure representing Jeanne de Bourbon, detail from the fireplace shown opposite (*Ill. 194*), 1384–6

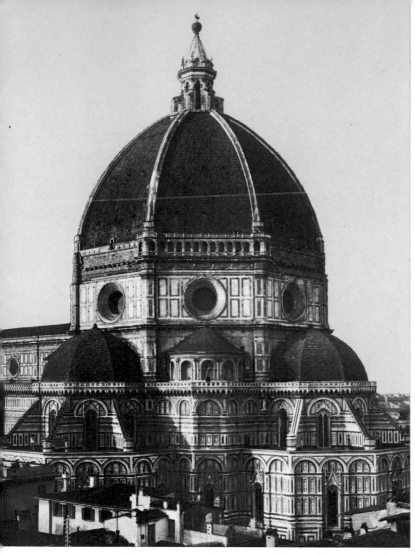

196 Florence Cathedral, the east end as finally redesigned in 1366–8. The completion of the dome belongs to the fifteenth century

building. Siena Cathedral has an east façade as well as a west façade, since the baptistery lies underneath the choir and its entrance is through the east end. This east façade was never finished, but an interesting drawing exists to show what it was intended to look like (*Ill. 197*). The influence of Orvieto is obvious: not only was the upper gable intended to have a mosaic, but there is a strong horizontal

254

197 Parchment drawing for the eastern elevation of Siena Cathedral, before 1382

emphasis in the arrangement of the decorative features. Some of the ideas, however, suggest a closer connection with the north. The scheme is dominated by its rose window, a simple design very similar to the original 'rose' of the Ste Chapelle in Paris. There are shafts, gables, pinnacles and arcading spread over the surface, and above the left aisle roof runs a cresting of pinnacles and gables very like that eventually used on Milan Cathedral. This façade has the appearance therefore of an intermediate step to the architecture of Milan, a somewhat tentative acceptance of some of the decorative ideas found, for instance, on the west end of Strasbourg.

The sculptural decoration of this façade, had it been executed, could have been interesting since the ideas here embodied are also found north of the Alps. On a level with the rose window and behind a balustrade stand the Angel and Virgin of the Annunciation. Here one is immediately reminded of the south transept of St Mary's Church, Mühlhausen (c. 1370), where an emperor and empress gravely gesture from behind a balustrade above the portal. Lower down the façade, a row of angels holding scrolls peep out from deep niches over traceried balustrades. Here one can only point to a similar but later usage in the north at the house of Jacques Cœur, Bourges (c. 1440).

The new cathedral in Milan was begun in 1387. It was undertaken at the instigation of Giangaleazzo Visconti, ruler of Milan and later created Duke. The building is famous for the trouble it caused during the early years, when northern advisers were summoned to help in the deliberations over the structure. There is much that is unusual about Milan in its Italian context. It belongs to the Bourges tradition of Gothic building, with double aisles and a very high arcade crowned by a diminutive clerestory. It has pier capitals which are hard to match anywhere else (*Ill. 198*), though clusters of figured niches appear around the nave piers of St Stephen's, Vienna (perhaps designed in 1359), and the piers of the Frauenkirche at Nürnberg (1355) have clusters of figures around the capitals but no niches. These Milanese capitals caused a certain amount of trouble, but it does not appear that the plans for the external decoration of Milan Cathedral were ever seriously questioned. This is of interest because most of the ingredients of this decoration are derived from northern rayonnant

198 Interior of nave, Milan Cathedral; begun 1387

architecture. Milan presents the nearest Italian approach to a rayonnant building (*Ill. 200*).

In painting and sculpture the most interesting developments seem to occur in the north of Italy. Plenty of art was produced in Tuscany, but although excellent in quality, it is almost without exception bound closely to the traditions of the preceding half-century. In Tuscan sculpture, the works of Nino Pisano may be noted not for any absolute superiority but for their style. He was the only Tuscan sculptor of the period who tried to imitate the rather cloying sweetness found in some French Gothic Madonnas (*c.* 1360; *Ill. 199*).

199 NINO PISANO Madonna and Child, *c.* 1360

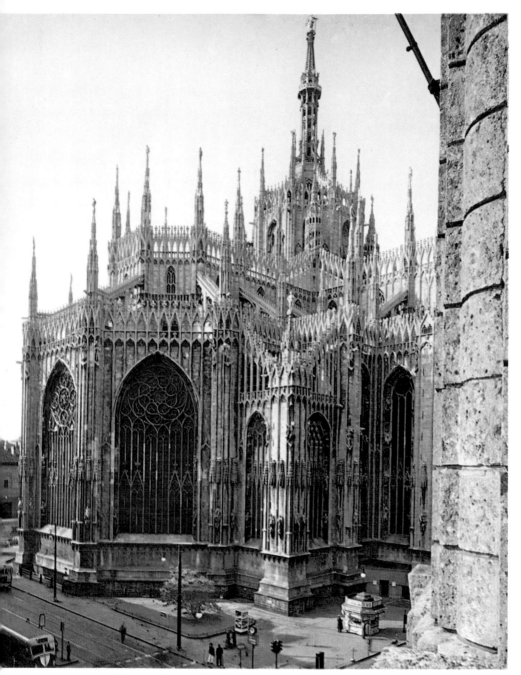

200 Exterior of choir, Milan Cathedral; begun 1387

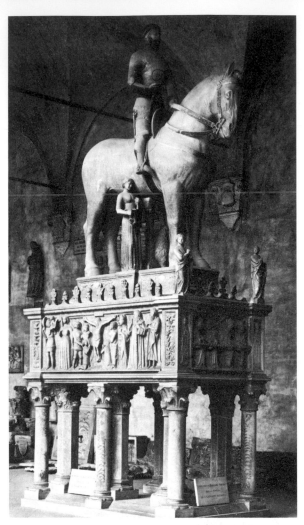

201 BONINO DA CAMPIONE Monument to Bernabo Visconti (died 1385); effigy before 1363, sarcophagus probably later

The sculptural history of northern Italy in the fourteenth century is punctuated by a series of magnificent tombs. The most impressive group was raised to members of the Scaliger family, lords of Verona. The tombs followed an existing tradition of external monuments, the idea being brought up-to-date by the addition of tall gables, *aediculæ* and pinnacles. The latest monument to Cansignorio della Scala is also the most complicated (before 1375; *Ill. 202*). Another interesting monument is the equestrian tomb of Bernarbo Visconti (before 1363; *Ill. 201*), lord of Milan. This formerly stood, apparently, on the high altar of S. Giovanni in Conca in that city. The

group is of marble, and the rider figure was at one stage covered in gold and silver and had golden spurs and shield. These trappings and attachments, familiar from northern monuments, are now lost. It is still a puzzle how the monument of Bernabo was allowed to occupy a position in the church usually reserved for the chief relics.

The building of Milan Cathedral certainly brought northern masons to the city, which might in itself have stimulated interest in northern styles. However, the Visconti lords of Milan were related to the French court by marriage; Galeazzo II Visconti married Blanche of Savoy, his son Giangaleazzo married Isabella de Valois

202 BONINO DA CAMPIONE
Monument to Cansignorio
della Scala (died 1375)

203 The Miracle at Cana, from the Hours of Blanche of Savoy, before 1378

(d. 1372), and his grand-daughter Valentina married Louis, Duke of Orleans. This connection shows interestingly in the books produced for the family. In the first place, Books of Hours, hitherto hardly to be found in Italy, became popular – clearly a fashion imported from Paris. One of these, produced before 1378 for Blanche of Savoy, shows an attempt by the Italian miniaturist Giovanni Benedetto da Como to produce an Italian version of a French book. The pages have a regularity and uniformity of layout unusual in an Italian book, and the artist produced his own rather meagre version of the Parisian spiky ivy-leaf (*Ill. 203*). The scenes, however, make no concessions to France, but adhere to the pictorial traditions of the area.

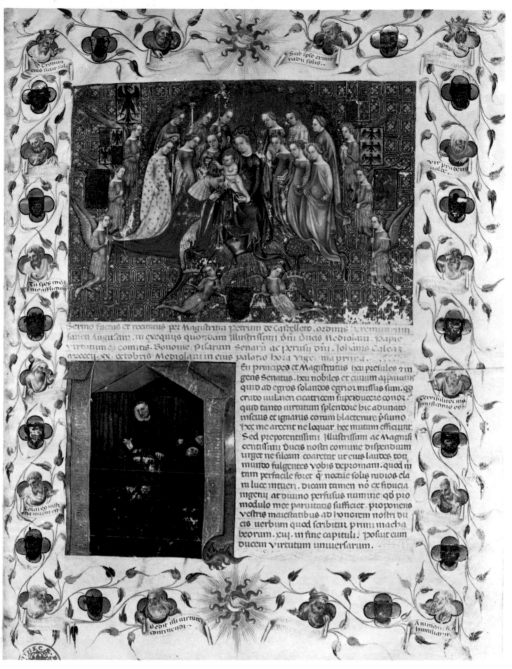

204 MICHELINO DA BESOZZO Illuminated copy of funeral oration pronounced over Giangaleazzo Visconti (died 1402), 1403

205 GIOVANNINO
DEI GRASSI Page
from the Book of
Hours of Gian-
galeazzo Visconti;
begun *c.* 1380

This restraint proved uncongenial – perhaps to patron and artist alike. For in the Book of Hours begun for Giangaleazzo Visconti himself around 1380 (*Ill. 205*), the artist adopted a different layout and programme of border decoration for almost all of the main illuminated pages, and the amount of sheer invention is very remarkable. Paradoxically, the artist Giovanni de Grassi, who is also found active as a sculptor and architectural designer, developed a figure style which was much closer to Parisian painting than that of any previous Italian manuscript-painter. The drapery style and facial types approach closely to the style of the *Parement de Narbonne* and the *Très Belles Heures* (*Ill. 183*).

Some of the pages of the Visconti Hours are bordered with naturalistic flowers, and this marks the beginning of one final development in manuscript illumination, when the border decoration itself ceased to be mainly a conventional pattern and came to depict a series of realistic objects. This development (which was taken up by the Limbourg brothers) can be followed in the work of a slightly later court artist, Michelino da Besozzo. Since he appears to have survived up to 1450, he belongs as much to the fifteenth century. However, already in 1403 he illuminated a *de luxe* copy of the funeral eulogy pronounced on Giangaleazzo Visconti (*Ill. 204*); and as things survive this is followed by a very small group of paintings and manuscripts. His highly individual figure-style has so far defied explanation, although the soft, rather pink little faces are easily recognizable. It is to be supposed that his painting is in some way connected with the 'soft-style' of the Empire; but convincing localization of this connection is still awaited.

Works of art from the years around 1400 are often described rather loosely as being in the 'International Gothic' style. The significance and limitations of this terminology will be clear from what has been described above. Many major centres of art, particularly those dominated by a court, shared similarities of taste and fashion. In general terms, there was a synthesis of a figure-style originating in Paris with a command of form and structure originating in Italy. It did not mean that art in one area became indistinguishable from the art of another – that, for instance, a Milanese manuscript would easily be confused with a Bohemian one. But it does mean that works produced during this short period frequently have a recognizable affinity. The most remarkable feature of the period was that the barrier of the Alps was at least partially breached. The moment passed swiftly, however, as under the impact of new forces north and south began to part company once more, only to re-unite in the sixteenth and seventeenth centuries under the unifying force of Italian Classicism.

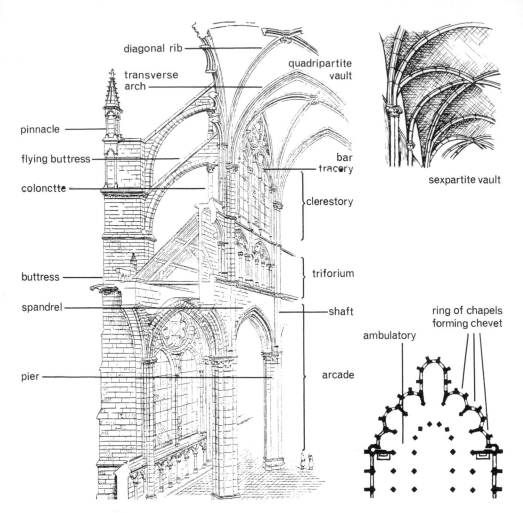

diagonal rib

transverse arch

quadripartite vault

pinnacle

flying buttress

colonctte

bar tracery

clerestory

buttress

triforium

spandrel

shaft

pier

arcade

sexpartite vault

ring of chapels forming chevet

ambulatory

Glossary

AMBO pulpit.

APSE part of a building semi-circular in plan.

COLUMN FIGURE sculptured figure placed against, or taking the place of, a shaft on a portal. See *Ill. 25*.

DAMP FOLD style of drapery-carving in which the creases are shallow and linear, and the material clings to the body as if it were damp. See p. 69.

DIAPER surface ornament of repeated straight-sided geometrical shapes, lozenge, triangle, etc.

EMBRASURE splayed opening in a battlement or rampart for shooting; also the splayed opening of a window.

FAN VAULT a vault in which ribs of the same length and curvature spring from the same point, forming an inverted half-cone. It is a feature of English Perpendicular. See *Ill. 192*.

HALL-CHURCH a church in which

268

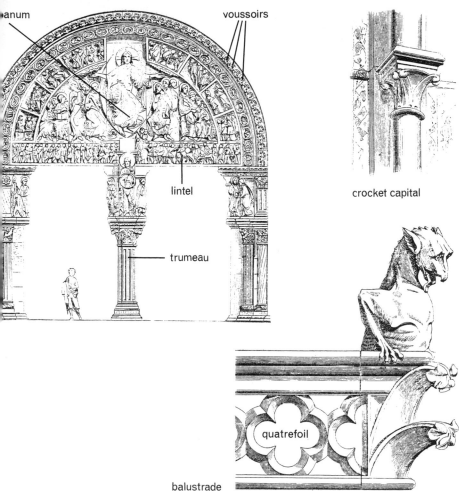

anum

voussoirs

lintel

trumeau

crocket capital

quatrefoil

balustrade

nave and aisles are of roughly the same height, i.e. having no triforium or clerestory.

LIERNE a short subsidiary rib connecting two main ones. See *Ill. 77*.

NET-VAULT a vault made up of intersecting ribs like a net. See *Ill. 163*.

OCULUS a round window.

PREDELLA row of small pictures at base of a large altarpiece. See *Ill. 150*.

PUTTO a cherubic naked boy.

RAYONNANT phase of French archi-

tecture corresponding to early bar-tracery. See Chapter II.

RETROCHOIR space behind the altar.

RIDGE-RIB longitudinal rib at the crown of a vault going the complete length of the vault. See *Ill. 17*.

TIERCERON a rib that is neither a transverse nor a diagonal rib but which springs from the same point and reaches to the crown of the vault. See *Ill. 75*.

TRIBUNE GALLERY a gallery above the aisles opening into the nave.

269

Chronology

History

1100		Henry I of England (1100–35)		Beginning of Cistercian Order
	Pope Callixtus II (1119–24)			
		Civil War in England		St Bernard's Apologia
	Conrad III, first Hohenstaufen emperor (1138–52)			
1150	Frederick I (Barbarossa) (1152–90)			Abbot Suger, Chancellor of France
	Pope Alexander III (1159–81)	Henry II of England (1154–89)		Second Crusade
				Murder of Thomas Becket
	Henry VI, emperor (1190–97)	Richard I of England (1189–99)		Third Crusade
1200	Pope Innocent III (1198–1216)	John of England (1199–1216)		Fourth Crusade
	Otto IV, emperor (1198–1215)		Magna Carta	Fifth Crusade
	Frederick II, stupor mundi (1215–50)	Henry III of England (1216–72)	Jenghiz Khan	Foundation of Franciscan and Dominican Orders
	Pope Gregory IX (1227–41)	Louis IX of France (St Louis) (1226–70)		
1250	Pope Innocent IV (1243–54)			
	Pope Clement IV (1265–8)			
	Pope Gregory X (1271–76)			St Thomas Aquinas
	Rudolf of Habsburg (1273–91)	Edward I of England (1272–1307)		Roger Bacon
				Marco Polo in China
	Pope Nicholas IV (1288–92)			Roman de la Rose
	Pope Boniface VIII (1294–1303)			Dante
1300	Henry VII, emperor (1308–13)	Edward II of England (1307–27)		Robert of Anjou, King of Naples
	Louis IV, emperor (1314–47)			William of Occam
	Popes at Avignon (1309–77)	Edward III of England (1327–77)		Beginning of Hundred Years' War
				Battle of Crécy
	Charles IV, emperor (1347–78)	Death of the Black Prince (1330–76)	Petrarch	Black Death
1350				Battle of Poitiers
		Wenceslaus IV of Bohemia (1363–1419)		
		Charles V of France (1364–80)		
	Pope Gregory XI (1570–78)		Jean duc de Berry	Piers Plowman written
	Pope Urban VI (1378–89)	Richard II of England (1377–99)		Boccaccio
				Chaucer's Canterbury Tales
	Great Schism (1370–1415)	Charles VI of France (1380–1422)		
1400	Pope Gregory XII (1406–15)	Henry IV of England (1399–1415)		Giangaleazzo Visconti
	Pope Martin V (1417–31)	Henry V of England (1413–22)		Battle of Agincourt
	Pope Eugenius IV (1431–47)	Henry VI of England (1422–61)		John Huss burnt
1450	Pope Nicholas V (1447–55)	Wars of the Roses		Council of Florence

Art and Architecture

1100

St Denis narthex and east end
Noyon begun

Chartres west front figures

1150 Notre Dame, Paris, begun
Leon begun
Canterbury east end rebuilt

Nicolas of Verdun

Laon west front	Bourges begun	Chartres transept figures	Munich Psalter
1200 Chartres rebuilt after fire	Wells nave	Sculpture of Amiens and	Queen Ingeborg Psalter
Rheims begun		Rheims	Villard de Honnecourt
Salisbury, Amiens and Toledo		Wells west front figures	Psalter of Blanche of
begun			Castile
Strasbourg nave	Lincoln nave	Antelami of Parma	

1250 Ste Chapelle, Paris	Cologne begun	Sculpture of Naumburg	Matthew Paris
St Urbain, Troyes	Westminster	Tomb of Louis de France	St Louis Psalter
		Nicola Pisano	Douce Apocalypse
Strasbourg west front			Master Honoré
Exeter nave		Arnolfo di Cambio	Cimabue
Orvieto begun		*Portada del Virgen Blanca*, Leon	
Foundation of Florence Cathedral		West portal of Strasbourg	St Francis Master, Assisi
York nave		Giovanni Pisano	Giotto Duccio
1300 Orvieto west front		Tomb of Edward II	Simone Martini
		Andrea Pisano	Lorenzetti brothers
Gloucester choir remodelled			
Choir of Aachen			Jean Pucelle

Monument to Robert of
Naples

Prague begun	Angers Tapestry
1350 St Sebald, Nürnberg, begun	*Parement de Narbonne*
Cloister of Gloucester begun	*Très Belles Heures*
Milan begun	

1400

Claus Sluter

Très Riches Heures

1450

Select Bibliography

The bibliography has been compiled with two aims in view: to provide the interested non-specialist with access to further information, and to provide further illustrations. In some books these features are happily combined. To avoid excessive length, no monographs on particular artists, monuments or buildings are included, and no reference is made to articles in periodicals. Most of the books listed have their own bibliographies to which reference can be made for such writing. The arrangement within sections is by subject.

General

DEHIO, G. *Geschichte der deutschen Kunst*, vols I and II, 4th ed. Berlin and Leipzig, 1930

BOASE, T. S. R. *English Art 1100–1216*, Oxford, 1953

BRIEGER, P. *English Art 1216–1307*, Oxford, 1957

EVANS, J. *English Art 1307–1461*, Oxford, 1949

MALE, E. *The Gothic Image*, London, 1961

EVANS, J. *Art in Medieval France*, Oxford, 1948

WHITE, J. *Italian Art and Architecture 1250–1400*, London, 1966

ANTAL, F. *Florentine Painting and its Social Background*, London, 1948

VARIOUS AUTHORS. *Ars Hispaniae*, vols VII, VIII and IX. Madrid, 1952, 1956 and n.d.

Architecture

FRANKL, P. *Gothic Architecture*, London, 1962

WEBB, G. *Architecture in Britain. The Middle Ages*, London, 1956

KIDSON, P., MURRAY, P. and THOMPSON, P. *A History of English Architecture*, London, 1965

GALL, E. *Gotische Baukunst*. Part I, Brunswick, 1955

LASTEYRIE, R. DE. *L'Architecture religieuse en France II (Epoque Gothique)*, Paris, 1926–7

AUBERT, M. *L'Architecture Cistercienne en France*, Paris, 1947

BRANNER, R. *St Louis and the Court Style*, London, 1965

BONY, J. and HÜRLIMANN, M. *French Cathedrals*, London, 1961

GALL, E. *Dome und Kloster-kirchen am Rhein*, Munich, 1956

BAUM, J. and SCHMIDT-GLASSNER, H. *German Cathedrals*, London, 1956

LONGHI, L. F. DE. *L'Architettura delle Chiese Cisterciensi Italiane*, Milan, 1958

WAGNER-RIEGER, R. *Die Italienische Baukunst zu Beginn der Gotik*, Graz-Cologne, 1956

Painting

STANGE, A. *Deutsche Malerei der Gotik I and II*, Berlin, 1934 and 1936

SWARZENSKI, H. *Deutsche Buchmalerei des 13. Jahrhunderts*, Berlin, 1936

BOECKLER, A. *Deutsche Buchmalerei. Vorgotische Zeit*, Königstein im Taurus, 1959

STANGE, A. *Deutsche Gotische Malerei 1300–1400*, Königstein im Taurus, 1964

BOECKLER, A. *Deutsche Buchmalerei. Der Gotik*, Königstein im Taurus, 1959

VITZTHUM, G. *Die Pariser Miniaturmalerei*, Leipzig, 1907

PORCHER, J. *French Miniatures from Illuminated Manuscripts*, London, 1960

RICKERT, M. *Painting in Britain. The Middle Ages*, London, 1966

SAUNDERS, O. E. *English Illumination*, Florence and Paris, 1928

MILLAR, E. G. *English Illuminated Manuscripts from the Xth to the XIIIth centuries*, Paris and Brussels, 1926

MILLAR, E. G. *English Illuminated Manuscripts of the XIVth and XVth centuries*, Paris and Brussels, 1928

DVORAKOVA, V. and others. *Gothic Mural Painting in Bohemia and Moravia 1300–78*, London, 1964

MALEJCĚK, A. and PESINA, J. *Gothic Painting in Bohemia 1350–1450*, Prague, 1955

SALMI, M. *Italian Miniatures*, London, 1957

BORSOOK, E. *The Mural Painters of Tuscany*, London, 1960

MEISS, M. *Painting in Florence and Siena after the Black Death*, Princeton, 1951

CECCHI, E. *Trecentisti Senesi*, Milan, n.d.

Sculpture

PANOFSKY, E. *Die deutsche Plastik des 11. bis 13. Jahrhunderts*, Florence-Leipzig, 1924

PINDER, W. *Die deutsche Plastik des 14. Jahrhunderts*, Florence-Leipzig, 1925

AUBERT, M. *La Sculpture Française au Moyen Age*, Paris, 1946

STONE, L. *Sculpture in Britain. The Middle Ages*, London, 1955

CRICHTON, G. H. *Romanesque sculpture in Italy*, London, 1954

HUTTON, E. *The Cosmati*, London, 1950

POPE-HENNESSY, J. *Italian Gothic Sculpture*, London, 1955

The following short selection from numerous printed sources will throw light on patronage in the fourteenth and early fifteenth centuries, and other problems of general interest.

GUIFFREY, J. *Inventaires de Jean duc de Berry 1401–1416*, Paris, 1894 and 1896

DELISLE, L. *Recherches sur la Librairie de Charles V*, Paris, 1907

PELLEGRIN, E. *La Bibliothèque des Visconti et des Sforza, ducs de Milan, au XVe siècle*, Paris, 1955

DEHAISNES. *Documents et extraits divers concernant l'histoire de l'Art dans la Flandre, L'Artois, et le Hainaut avant le XVe siècle*, Lille, 1886

List of Illustrations

Measurements are given in inches and centimetres, height preceding width

Frontispiece Detail of the right-hand wing of the altarpiece of the Chartreuse de Champmol near Dijon. Carved for Philippe le Hardi by a Flemish sculptor, Jacques de Baerze, and gilded by Melchior Broederlam. The saints are St Anthony, St Margaret, a royal saint, St Barbara and St Judoc. 1391–9. Musée de Dijon. Photo: Scala.

1 Detail of a statue of St Louis from the portal of Chapelle des Quinze-Vingt, Paris. *c.* 1370. No adequate representations of St Louis (1226–70) survive from the thirteenth century. This image, carved about a century after his death, must suffice to underline the importance of his reign in this book. The sculptor actually reproduced the features of the reigning king, Charles V. Louvre, Paris. Photo: Giraudon.

2 Laon Cathedral. Interior looking east. Begun *c.* 1165; choir built probably after 1205. Photo: Martin Hürlimann.

3 Abbey of St Denis, near Paris. Interior of the thirteenth-century ambulatory from the south-west 1140–4. The rayonnant triforium is visible. Photo: Bildarchiv Foto Marburg.

4 Abbey of St Denis, near Paris. Plan of existing church.

5 Laon Cathedral. Exterior from the south-west. Probably 1190–1200. Photo: Jean Roubier.

6 Laon Cathedral. Plan. Begun *c.* 1170; choir built probably after 1205.

7 Noyon Cathedral. Plan. Begun *c.* 1150.

8 Notre Dame, Paris. Original plan, 1163.

9 Cistercian Abbey of Fontenay. Interior looking east. Begun 1139, consecrated 1147. Photo: Archives Photographiques.

10 Poitiers Cathedral. Interior looking east. Begun 1162, completed in the thirteenth century. Photo: Bildarchiv Foto Marburg.

11 Chartres Cathedral. Interior of the north transept looking north-east. First quarter of the thirteenth century. Photo: Martin Hürlimann.

12 Rheims Cathedral. Interior of the nave looking east. Begun 1210. Photo: Martin Hürlimann.

13 Bourges Cathedral. Exterior from the south-east. Begun 1195, choir finished 1218, nave *c.* 1260. Photo: Martin Hürlimann.

14 Bourges Cathedral. Interior of the church looking east. Begun 1195. Photo: Martin Hürlimann.

15 Wells Cathedral. Interior of the nave looking east. *c.* 1200–20. Photo: Courtauld Institute of Art.

16 Canterbury Cathedral. Eastern end of the choir, the Trinity Chapel. This part was built 1179–84. Photo: Martin Hürlimann.

17 Lincoln Cathedral. Interior of nave looking east. Begun *c.* 1225. Photo: Martin Hürlimann.

18 Salisbury Cathedral. Interior of the nave looking east. Present church begun 1220. Photo: Edwin Smith.

19 Cathedral of Limbourg-an-der-Lahn. Interior of nave looking east. Church begun *c.* 1220. Photo: Helga Schmidt-Glassner.

20 Liebfrauenkirche, Trier. Interior of choir from south transept. Church begun *c.* 1235. Photo: Helga Schmidt-Glassner.

21 Elizabethkirche, Marburg. Interior of nave looking west. Church begun 1235. Photo: Bildarchiv Foto Marburg.

22 Toledo Cathedral. Interior, from the liturgical choir towards the presbytery. Church begun 1226 Photo: Mas.

23 Abbey of St Denis. West front. Lower part *c.* 1137–40, towers after 1144, spire *c.* 1200. (From an engraving by Chapuy, 1832.)

24 Chartres Cathedral. South jamb figures on central west portal. Mid-twelfth century. Photo: Bildarchiv Foto Marburg.

25 Chartres Cathedral. East jamb figures on central portal of north transept: Melchizedek, Abraham and Isaac, Moses, Samuel and King David. *c.* 1200–10. Photo: Martin Hürlimann.

26 Senlis Cathedral. North jamb figures on central west portal. *c.* 1175. (Heavily restored, the heads are nineteenth century.) Photo: Archives Photographiques.

27 Rheims Cathedral. East jamb figures on The Last Judgment portal, north transept. To the right, St Andrew and St Peter. *c.* 1220. Photo: Bildarchiv Foto Marburg.

28 Nicolas of Verdun: Klosterneuberg Altar. 1181. The Adoration of the Magi. Enamel, originally part of an *ambo* or pulpit. $8\frac{1}{8} \times 6\frac{1}{2}$ (20·5 × 16·5). Photo: Stiftsmuseum, Klosterneuberg.

29 Amiens Cathedral. South jamb figures on south-west portal. The Annunciation. *c.* 1225. Photo: Martin Hürlimann.

30 Rheims Cathedral. North jamb figures on the central west portal. The Presentation in the Temple. *c.* 1230–40. Photo: Martin Hürlimann.

31 Rheims Cathedral. Detail of St Joseph from the Presentation group. *c.* 1240. Photo: Martin Hürlimann.

32 Rheims Cathedral. Nave capital with foliage and fabulous monsters. Photo: Martin Hürlimann.

33 Amiens Cathedral. The west front. Façade to above the level of the rose window completed 1236, towers completed in second half of fourteenth and early fifteenth century. Photo: Martin Hürlimann.

34 Rheims Cathedral. West front. Second quarter of the thirteenth century. Photo: Martin Hürlimann.

35 Fragment of a statue of St John, from St Mary's Abbey, York. *c.* 1195. Castle Museum, York. Photo: Warburg Institute.

36 Wells Cathedral. West front. Begun 1225. Photo: A. F. Kersting.

37 Wells Cathedral. Figures above the central west portal. Coronation of the Virgin. *c.* 1230. Photo: Courtauld Institute of Art.

38 Strasbourg Cathedral. Tympanum of west portal of south transept. The Death of the Virgin. *c.* 1230. Photo: Bildarchiv Foto Marburg.

39 Bamberg Cathedral. Figure of Virgin from Visitation group now in the choir aisle. (Original location unknown.) *c.* 1230–5. Photo: Helga Schmidt-Glassner.

40 Magdeburg Cathedral. The 'Wise Virgins' from the Paradise portal. *c.* 1245. Photo: Helga Schmidt-Glassner.

41 Naumburg Cathedral. The Crucifixion group on the entrance to the choir. *c.* 1245. Photo: Helga Schmidt-Glassner.

42 Naumburg Cathedral. Count Eckhardt and Uta. Figures from the west choir. *c.* 1245. Photo: Helga Schmidt-Glassner.

43 Naumburg Cathedral, the west choir. Photo: Helga Schmidt-Glassner.

44 Naumburg Cathedral. Foliage capital from the west choir. Photo: Helga Schmidt-Glassner.

45 Burgos Cathedral. South transept. La Portada del Sarmental. *c.* 1235. Photo: Mas.

46 Psalter of Queen Ingeborg of Denmark. Before 1210. $12 \times 8\frac{1}{8}$ (30·5 × 20·5). Musée Condé, Chantilly. Ms 9 (1695) f.32v. Photo: Giraudon.

47 The Munich Psalter. Beatus page. *c.* 1200. $10\frac{7}{8} \times 7\frac{3}{8}$ (27·5 × 18·8). Bayerische Staatsbibliothek, Munich. Cod.Lat.835 f.31r.

48 Vilars de Honnecourt: Drawing possibly of a king with his courtiers. *c.* 1220. $9\frac{3}{8} \times 6\frac{1}{4}$ (24·0 × 16·0). Bibliothèque Nationale, Paris. Ms Fr. 19093 f.13r.

49 The Munich Psalter. Christ in Glory. *c.* 1200. $10\frac{7}{8} \times 7\frac{3}{8}$ (27·5 × 18·8). Bayerische Staatsbibliothek, Munich. Cod.Lat.835 f.29r.

50 The Westminster Psalter. Christ in Glory. *c.* 1200. $9 \times 6\frac{1}{4}$ (23·0 × 16·0). British Museum, London. Royal Ms 2 A.XXII. f.14r.

51 The Psalter of Robert de Lindeseye. The Crucifixion. Before 1222. $9\frac{1}{2} \times 6\frac{1}{4}$ (24·0 × 16·0). The Society of Antiquaries, London. Ms 59 f.35v.

52 The Psalter of Blanche of Castile. The Crucifixion and Deposition, with the Church and the Synagogue. *c.* 1235. $11 \times 7\frac{7}{8}$ (28·0 × 20·0). Bibliothèque de l'Arsenal, Paris. Ms 1186 f.24.

53 The Amesbury Psalter. Virgin and Child with donor. *c.* 1240–50. $12 \times 8\frac{1}{2}$ (30·5 × 21·6). All Souls College. Ms Lat.6 f.4v. Photo: Colour Centre Slides.

54 William de Brailes: Christ walking on the waters. *c.* 1240–60. $5\frac{1}{4} \times 3\frac{7}{8}$ (13·4 × 9·8). Walters Art Gallery, Baltimore, USA. Ms W.106 f.20.

55 Matthew Paris: *Historia Anglorum* frontispiece. Virgin and Child, with the artist kneeling. *c.* 1250. $14 \times 9\frac{3}{8}$ (35·6 × 23·8). British Museum, London. Ms Royal 14 C VII f.6r.

56 The Weingarten Missal. Crucifixion. *c.* 1216. $11\frac{1}{2} \times 8$ (29·2 × 20·3). The Pierpont Morgan Library, New York. Ms 710 f.10v.

57 Church of St Michael, Hildesheim. Ceiling painting. Detail from a Tree of Jesse. *c.* 1230–40. Photo: Bildarchiv Foto Marburg.

58 Soest Altarpiece. The Virgin Mary, Holy Trinity and St John the Evangelist. Tempera on wood. *c.* 1230–40. $47\frac{1}{4} \times 28$ (120·0 × 71·0). Gemäldegalerie, Staatliche Museen, Berlin (No. 1216 B).

59 Evangeliary from Kloster Neuwerk, Goslar. Title page of St

Matthew's Gospel showing Adoration of the Kings, St Matthew and Joseph's Dream. *c.* 1235–40. $13\frac{1}{4} \times 9\frac{7}{8}$ (33·5 × 25·0). Städtische Sammlungen, Rathaus, Goslar.

60 Abbey of St Denis, near Paris. North transept interior. Rebuilding begun 1231. Photo: A.F. Kersting.

61 Notre Dame, Paris. South transept front exterior. Begun 1258. Photo: Martin Hürlimann.

62 Ste Chapelle, Paris. Interior of the upper chapel looking east. 1243–8. Photo: Giraudon.

63 Ste Chapelle, Paris. Exterior from the south-west. 1243–8. Photo: A.F. Kersting.

64 St Nazaire, Carcassonne. East end interior showing north transept end. After 1269 Photo: Jean Roubier.

65 St Urbain, Troyes. Interior of nave looking east. Founded 1262. Photo: Bildarchiv Foto Marburg.

66 St Urbain, Troyes. Exterior from the south-east. Founded 1262. Photo: Bildarchiv Foto Marburg.

67 St Thibault-en-Auxois. Interior of presbytery facing east. *c.* 1300.

68 Cologne Cathedral. Interior of choir. Begun 1248, consecrated 1322. Photo: Helga Schmidt-Glassner.

69 Strasbourg Cathedral. Interior of nave looking west. Rebuilding begun *c.* 1245. Photo: Helga Schmidt-Glassner.

70 Strasbourg Cathedral. Drawing for façade B. Probably 1277. From Dehio's *Geschichte der deutschen Kunst*, 1930.

71 Cathedral of Freiburg-im-Breisgau. Western tower and spire. *c.* 1330. Photo: Helga Schmidt-Glassner.

72 Wiesenkirche, Soest. Interior of nave looking east. Begun 1331. Photo: Bildarchiv Foto Marburg.

73 Westminster Abbey, London, Interior of south transept. After 1245. Photo: National Monuments Record.

74 Old St Paul's Cathedral, London. Exterior of east end. Rebuilding begun 1258. Engraving by Hollar, from Dugdale's *History of St Paul's Cathedral*, 1658.

75 Exeter Cathedral. Interior of nave looking east showing vault. Rebuilding begun before 1280, nave fourteenth century. Photo: Martin Hürlimann.

76 York Minster. Interior of nave. Founded 1291. Photo: Walter Scott.

77 Gloucester Cathedral. Interior of choir looking east. Begun soon after 1330. Photo: National Monuments Record.

78 Leon Cathedral. Interior of nave looking east. Rebuilding begun 1225. Photo: Mas.

79 Barcelona Cathedral. Interior of nave looking east. Begun 1298. Photo: Mas.

80 Statue in silver-gilt and enamel of the Virgin and Child. 1339. Height $27\frac{1}{8}$ (69·0). Louvre, Paris. Photo: Giraudon.

81 Ste Chapelle, Paris. Figure of Apostle (from a cast). *c.* 1243–8.

82 Notre Dame, Paris. Virgin and Child from St Aignan. *c.* 1330. Photo: Bildarchiv Foto Marburg.

83 Abbey of St Denis, near Paris. Tomb of Dagobert I. *c.* 1260. Photo: Courtauld Institute of Art.

84 Abbey of St Denis, near Paris. Stone mourners on the base of the tomb of Louis de France, from the Abbey of Royaumont. *c.* 1260. Photo: Bildarchiv Foto Marburg.

85 Abbey of St Denis, near Paris. Head of the effigy of Philippe IV le Bel. Ordered in 1327. Photo: Archives Photographiques.

86 Southwell Minster. Foliage capitals on entrance to the Chapter House. *c.* 1295. Photo: Edwin Smith.

87 Westminster Abbey, London. Censing angel at west angle of south transept. Probably 1250s. Photo: Walter Scott.

88 Westminster Abbey, London. Virgin of the Annunciation, in the Chapter House. Probably 1253. Courtesy the Dean and Chapter of Westminster.

89 Westminster Abbey, London. Tomb of Edmund Crouchback, in the Presbytery. 1296. Photo: National Monuments Record.

90 Gloucester Cathedral. Tomb of Edward II with stone canopy and alabaster effigy. *c.* 1330–5. Photo: A. F. Kersting.

91 Cologne Cathedral. Statue of St Matthew in the choir. Probably shortly before 1322. Photo: Helga Schmidt-Glassner.

92 Strasbourg Cathedral. Prophets on right jamb of central west portal. *c.* 1300. Photo: Helga Schmidt-Glassner.

93 Leon Cathedral. West portal, *Portada del Virgen Blanca*. Second half of thirteenth century. Photo: Mas.

94 Burgos Cathedral. Tomb of Archbishop Gonzalo de Hinojosa. Probably *c.* 1327. Photo: Mas.

95 The Psalter of St Louis. Balaam and his Ass. Between 1252 and 1270. $8\frac{1}{4} \times 5\frac{3}{4}$ (21·0 × 14·5). Bibliothèque Nationale, Paris. Ms Lat. 10525 f.39v.

96 *La Somme le Roy*. Page showing Humility, Ahaziah typifying Pride, the Sinner and the Hypocrite. Probably *c.* 1290, from the workshop of Master Honoré. $9\frac{1}{4} \times 5$ (23·5 × 12·7). British Museum, London. Ms Ex-Millar f.97v.

97 Book of Hours. Death of the Virgin. Probably *c.* 1290, from the workshop of Master Honoré, Stadtbibliothek, Nürnberg. Solger in 4, no.4 f.22.

98 The Belleville Breviary. Probably between 1323 and 1326, from the workshop of Jean Pucelle. $9\frac{1}{2} \times 6\frac{3}{4}$ (24·0 × 17·0). Bibliothèque Nationale, Paris. Ms Lat.10483–4 f.24v.

99 The Douce Apocalypse. St John and the Angel. Probably *c.* 1270. $5\frac{3}{4} \times 4\frac{1}{2}$ (14·6 × 11·4). Bodleian Library, Oxford. Ms Douce 180 p.33. (35 mm. colour filmstrips of illustrations from Ms Douce 180 etc are obtainable from the Dept. of Western Mss, Bodleian Library.)

100 Westminster Abbey, London. The figure of St Peter from the Retable. Perhaps last quarter of thirteenth century. Figure 19 × 6 (48·3 × 15·2). Tempera on panel. Photo: Warburg Institute.

101 The Alphonso Psalter. Four female saints. Probably shortly before 1284. $9\frac{1}{2} \times 6\frac{1}{2}$ (24·1 × 16·5). British Museum, London. Ms Add 24686 f.3r.

102 The Queen Mary Psalter. Marriage at Cana. *c.* 1310. $10\frac{7}{8} \times 6\frac{7}{8}$ (27·5 ×

17·3). British Museum, London. Ms Royal 2B VII f.168v.

103 The Hours of Jeanne d'Evreux. Frontispiece showing the Annunciation, with the letter 'D' enclosing Queen Jeanne d'Evreux reading. 1325–8, from the workshop of Jean Pucelle. $3\frac{1}{2} \times 2\frac{3}{8}$ (9·0 × 6·0). The Metropolitan Museum of Art, The Cloister Collection, Purchase 1954.

104 The Peterborough Psalter. Beatus page. Early fourteenth century. $11\frac{3}{4} \times 7\frac{5}{8}$ (30·0 × 19·3). Bibliothèque Royale, Brussels. Ms 9961–2 f.14.

105 The St Omer Psalter. Beatus page. Probably c. 1330. $13\frac{1}{8} \times 8\frac{1}{4}$ (33·4 × 21·2). British Museum, London. Ms Add 39810 f.7.

106 The Gorleston Psalter. The Crucifixion. c. 1330. $14\frac{3}{4} \times 9\frac{1}{4}$ (37·5 × 23·5). British Museum, London Ms Ex-Dyson Perrins f.7r.

107 Klosterneuberg Altar. Noli me Tangere. Between 1324 and 1329. $46\frac{7}{8} \times 42\frac{1}{2}$ (119·0 × 108·0). Tempera on wood. Photo: Kunsthistorisches Museum, Vienna.

108 Diptych from St Georg, Cologne. Virgin and Child and Crucifixion. Perhaps second quarter of fourteenth century. $19\frac{1}{4} \times 13\frac{3}{8}$ (49.0 × 34·0). Tempera on wood. Gemäldegalerie, Staatliche Museen, Berlin (No.1627).

109 Monastery of Pedralbes, Barcelona. Paintings by Ferrer Bassa in the Chapel of S. Miguel. 1346. Photo: Mas.

110 Fossanova Abbey. Nave from crossing. Church consecrated 1208. Photo: Mansell/Alinari.

111 Orvieto Cathedral. Interior of nave looking east. Begun 1290. Photo: Mansell/Alinari.

112 S. Andrea, Vercelli. Interior of nave looking east. Founded 1219, consecrated 1224. Photo: Mansell/Alinari.

113 Sta Maria Donnaregina, Naples. Interior showing east end. Founded 1307. Photo: Courtauld Institute of Art.

114 Florence Cathedral. Parchment elevation of campanile with rejected spire and octagon. Probably 1334–40. Opera del Duomo, Siena. Photo: Grassi.

115 Benedetto Antelami: Parma Baptistery, north porch. Virgin and Child. Early thirteenth century. Photo: Mansell/Alinari.

116 Nicola Pisano: Pulpit in Pisa Baptistery. 1259–60. Photo: Mansell/Alinari.

117 Nicola Pisano: Pulpit in Pisa Baptistery. Detail of Adoration of the Kings. 1259–60. $44\frac{1}{2} \times 33\frac{1}{2}$ (113·0 × 85·0). Photo: Mansell/Alinari.

118 Giovanni Pisano: Pulpit in Pisa Cathedral. 1302–10. Photo: Mansell/Alinari.

119 Nicola Pisano: Pulpit in Siena Cathedral. Detail of the Apocalyptic Christ. 1265–8. Photo: Grassi.

120 Siena Cathedral. West façade. Begun probably 1284–5. Upper part completed from 1376. Photo: Mansell/Anderson.

121 Giovanni Pisano. Plato, from the west façade of Siena Cathedral. c. 1290. Opera del Duomo, Siena. Photo: Grassi.

122 Pietro Oderisi: Monument to Clement IV in S. Francesco, Viterbo. c. 1271. Photo: Mansell/Brogi.

123 Arnolfo di Cambio: Monument to Cardinal de Braye in S. Domenico,

Orvieto, Detail of head of effigy. 1282 or after. Photo: Mansell/Alinari.

124 Arnolfo di Cambio: Madonna and Child from Florence Cathedral. *c.* 1300. Florence, Museo dell'Opera del Duomo. Photo: Mansell/Alinari.

125 Tino da Camaino: Madonna and Child from the Orso Monument. 1320–1. Bargello, Florence. Photo: Gabinetto Fotografico della Soprintendenza alle Gallerie, Florence.

126 Giovanni and Paccio da Firenze: Monument to Robert of Anjou, King of Sicily, in S. Chiara, Naples. Still incomplete, October 1345. Photo: Mansell/Anderson.

127 Giovanni di Balduccio: Shrine of St Peter Martyr in S. Eustorgio, Milan. 1335–9. Photo: Mansell/Alinari.

128 Sta Maria della Spina, Pisa. Exterior from the south-west. *c.* 1330. Photo: Scala.

129 Orvieto Cathedral. Parchment design (never executed) for the façade. Probably shortly before 1310. Opera del Duomo, Orvieto.

130 Lorenzo Maitani: Madonna and Child over the central west portal, Orvieto Cathedral. Probably 1325–30. Photo: Mansell/Alinari.

131 Orvieto Cathedral. West façade. Begun 1310. Photo: Scala.

132 Andrea Pisano: Bronze doors of Florence Baptistery. 1330–6. Photo: Mansell/Alinari.

133 Andrea Pisano: Florence Baptistery. Detail from bronze doors. Burial of John the Baptist. 1330–6. Photo: Mansell/Brogi.

134 The St Francis Master: Institution of the Crib at Greccio. Upper church of S. Francesco, Assisi. *c.* 1295. Photo: Scala.

135 SS. Quattro Coronati, Rome. Chapel of S. Sylvester. Christ in Glory between Apostles, with below, scenes from the legend of S. Sylvester and Emperor Constantine. Chapel consecrated 1246. Photo: Mansell/Alinari.

136 Upper church of S. Francesco, Assisi. The Sacrifice of Isaac. 1280s. Photo: Mansell/Alinari.

137 The Isaac Master: Isaac and Esau. Upper church of S. Francesco, Assisi. *c.* 1290. Photo: Mansell/Alinari.

138 Jacopo Torriti: Presentation in the Temple. Mosaic. Sta Maria Maggiore, Rome. *c.* 1296. Photo: Mansell/Alinari.

139 Pietro Cavallini: Two Apostles from the Last Judgment. Sta Cecilia, Rome. *c.* 1290. Photo: Gabinetto Fotografico Nazionale, Rome.

140 Arena Chapel, Padua. Interior looking east. Founded 1303, decorated probably by 1313. Photo: Mansell/Anderson.

141 Giotto: Marriage at Cana. Arena Chapel, Padua. Probably between 1305 and 1313. Photo: Scala.

142 Giotto: Raising of Drusiana (detail). Peruzzi Chapel, Sta Croce, Florence. *c.* 1320. Photo: Scala.

143 Giotto: Presentation in the Temple. Arena Chapel, Padua. Probably between 1305 and 1313. Photo: Mansell/Anderson.

144 Giotto: The Raising of Drusiana. Peruzzi Chapel, Sta Croce, Florence. *c.* 1320. Photo: Mansell/Anderson.

145 Duccio: Saints and angels (detail). Right-hand side of front face of the Maestá. 1308–11. Museo dell' Opera del Duomo, Siena. Photo: Grassi.

146 Duccio: Entry into Jerusalem. Panel from rear face of the Maestá. 1308–11. Museo dell'Opera del Duomo, Siena. Photo: Grassi.

147 Duccio: Rear face of the Maestá. 1308–11. $161\frac{3}{4} \times 107\frac{1}{2}$ ($411\cdot0 \times 273\cdot0$). Museo dell'Opera del Duomo, Siena. Photo: Grassi.

148 Duccio: Madonna of the Franciscans. c. 1295. $9\frac{1}{4} \times 6\frac{1}{4}$ ($23\cdot5 \times 16\cdot0$). Pinacoteca, Siena. Photo: Mansell/Alinari.

149 Simone Martini: Maestá. Fresco. Palazzo Pubblico, Siena. 1315, repaired by Simone 1321. Photo: Grassi.

150 Simone Martini: Polyptych from Sta Caterina, Pisa. 1319. Museo Nazionale, Pisa. Photo: Mansell/Anderson.

151 Simone Martini: Altar of St Louis of Toulouse. c. 1317. Galleria Nazionale, Naples. Photo: Scala.

152 Simone Martini: The Annunciation. 1333. $120\frac{1}{8} \times 104\frac{1}{4}$ ($265\cdot0 \times 305\cdot0$). Uffizi, Florence.

153 Simone Martini: Christ returning to His Parents. 1342. $19\frac{1}{2} \times 13\frac{3}{4}$ ($49\cdot5 \times 35\cdot0$). Walker Art Gallery, Liverpool.

154 Simone Martini: The Knighting of St Martin. Fresco. Lower Church of S. Francesco, Assisi. Perhaps c. 1330. Photo: Mansell/Alinari.

155 Simone Martini: Guidoriccio da Fogliano. Fresco. Palazzo Pubblico, Siena. 1328. Photo: Scala.

156 Pietro Lorenzetti: Virgin and Child with Saints. Pieve, Arezzo. 1320. Photo: Mansell/Alinari.

157 Simone Martini: *Salvator Mundi*. Upper sinopia of fresco, in the porch of Notre Dame des Doms, Avignon. c. 1340–4. Photo: Archives Photographiques.

158 Pietro Lorenzetti: Crucifixion. Lower church of S. Francesco, Assisi. c. 1330. Photo: Mansell/Alinari.

159 Follower of Pietro Lorenzetti: The Last Supper. Fresco. Lower church of S. Francesco, Assisi. Probably 1330s. Photo: Mansell/Anderson.

160 Ambrogio Lorenzetti: Good Government in the City. Fresco. Sala del Nove, Palazzo Pubblico, Siena. 1338–40. Photo: Grassi.

161 Ambrogio Lorenzetti: Good Government in the Country. Fresco. Sala del Nove, Palazzo Pubblico, Siena. 1338–40. Photo: Grassi.

162 Prague Cathedral. Exterior from the south-west. Founded 1344. Photo: Helga Schmidt-Glassner.

163 Prague Cathedral. Interior of the choir. Founded 1344, upper parts last quarter of the fourteenth century. Photo: Courtauld Institute of Art.

164 Prague Cathedral. Skeleton vault in the south transept porch. Photo: Bildarchiv Foto Marburg.

165 Prague Cathedral. Head of Charles IV on the triforium of the apse. Last quarter of the fourteenth century. Photo: Helga Schmidt-Glassner.

166 Bohemian Master: The Glatz Madonna. *c.* 1350. $73\frac{1}{4} \times 37\frac{3}{8}$ (186·0 × 95·0). Gemäldegalerie Staatliche Museen, Berlin (No.1624).

167-8 Karlstein Castle. Chapel of the Virgin. Relic scenes, and part of decoration of dado. Probably 1357 or slightly before.

169 Karlstein Castle. Chapel of the Holy Cross, interior. Decoration 1357-65. Photo: Helga Schmidt-Glassner.

170 Karlstein Castle. Chapel of the Holy Cross. A prophet by Master Theodoric. The illustration also shows part of the raised patterning which is one of the features of the decoration of the chapel. *c.* 1357-67.

171 Aachen Cathedral. Interior of the choir facing east. Begun 1335. Photo: Bildarchiv Foto Marburg.

172 Portrait of John the Good. Before 1364. $23\frac{5}{8} \times 17\frac{3}{8}$ (60·0 × 44·0). Louvre, Paris. Photo: Giraudon.

173 Angers Tapestry, scene from Apocalypse. 1375-81. Château, Angers. Photo: Courtauld Institute of Art.

174 The Parement de Narbonne. Painted silk altar frontal. Detail. Shortly before 1377. Height $30\frac{3}{4}$ (78·0). Louvre, Paris. Photo: Giraudon.

175 *Liber Viaticus* of Johann von Neumarkt. Before 1364. $17\frac{1}{8} \times 12\frac{1}{4}$ (43·5 × 31·0). Library of National Museum, Prague. Ms XIII A 12. f.9.

176 Master of Wittingau: The Entombment from the Wittingau Altar. Probably 1380s. $52\frac{3}{8} \times 36\frac{1}{4}$ (133·0 × 92·0). National Gallery of Prague.

177 Papal Palace, Avignon. Tour des Agnes. Interior of the *Camera Tunis*. *c.* 1340. Photo: Archives Photographiques.

178 Palazzo Davanzati, Florence. Interior of Bridal Chamber. *c.* 1395. Photo: Mansell/Alinari.

179 Westminster Abbey, London. Angel from the Last Judgment. Detail of wall-painting on the east wall of the Chapter House. *c.* 1370. Approximately 4 feet (122 metres) wide. Photo: Courtesy Dean and Chapter of Westminster.

180 The Bohun Book of Hours. *c.* 1380. $6\frac{5}{8} \times 4\frac{1}{2}$ (16·8 × 11·5). Bodleian Library, Oxford. Ms Auct. D.4.4. f.206v.

181 Westminster Abbey. Portrait of Richard II by unknown artist. Perhaps *c.* 1395. 84 × 43 (214·0 × 110·0). Photo: Courtesy Dean and Chapter of Westminster.

182 Miniature of Jean Bandol inserted in the Bible of Charles V showing presentation of the manuscript to Charles V by Jean de Vaudetar. 1372. Rijksmuseum, Meermanno-Westreenianum. The Hague. Ms 10 B 23, frontispiece.

183 The *Très Belles Heures* of the Duc de Berry. The Nativity. *c.* 1380-90. $11 \times 7\frac{7}{8}$ (28·0 × 20·0). Bibliothèque Nationale, Paris. Ms N.Aqu.Lat. 3093 f.42r.

184 Carmelite Missal. Initials. *c.* 1395. British Museum, London. Ms Add. 2970-5 f.68v.

185 Claus Sluter: Tomb of Philip the Bold, Duke of Burgundy, from the Chartreuse of Champmol, near Dijon. Begun *c.* 1390, still unfinished 1406. Musée de Dijon. Photo: Giraudon.

186 Westminster Abbey, London. Wooden effigy of Edward III, 1377. Undercroft Museum. Photo: Courtesy Dean and Chapter of Westminster.

187 Jean de Liège: White marble effigy of Philippa of Hainault. c. 1365–7. Westminster Abbey, London. Photo: Courtesy Dean and Chapter of Westminster.

188 Title-page of the Golden Bull of 1356, from the copy of c. 1390. $16\frac{1}{2} \times 11\frac{7}{8}$ ($42\cdot0 \times 30\cdot0$). Osterreichisches Nationalbibliothek, Vienna. Cod.338 f.1r.

189 Book of Hours attributed to Zebo da Firenze. c. 1405–10. British Museum, London. Ms Add. 29433 f.20r.

190 St Sebald, Nürnberg. Interior of choir looking east. 1361–79. Photo: Deutscher Kunstverlag.

191 St Sebald, Nürnberg. Exterior from the south-east. 1361–79. Photo: Bildarchiv Foto Marburg.

192 Gloucester Cathedral. View of south walk of cloisters. Rebuilding begun before 1377. Photo: Martin Hürlimann.

193 The *Très Riches Heures* of the Duc de Berry. The Temptation, with the castle of Mehun-sur-Yèvre. c. 1415. $11\frac{3}{8} \times 8\frac{1}{4}$ ($29\cdot0 \times 21\cdot0$). Musée Condé, Chantilly. Photo: Giraudon.

194 Palais de Justice, Poitiers. The fireplace in the Great Hall. 1384–6. Photo: Archives Photographiques.

195 Palais de Justice, Poitiers. Statue of Jeanne, Duchess of Bourbon, attributed to Guy de Dammartin, above the fireplace in the Great Hall. c. 1384–6. Photo: Bildarchiv Foto Marburg.

196 Florence Cathedral. Exterior from the east. Redesigned 1366–8, dome completed in fifteenth century. Photo: Mansell/Alinari.

197 Parchment elevation of the façade of the Baptistery at Siena. Before 1382. Museo dell'Opera del Duomo, Siena. Photo: Mansell/Alinari.

198 Milan Cathedral. Interior of the nave from the south aisle. Begun 1387. Photo: A. F. Kersting.

199 Nino Pisano: Madonna and Child. c. 1360. Sta Maria Novella, Florence. Photo: Mansell/Alinari.

200 Milan Cathedral. Exterior of the choir. Cathedral begun 1387.

201 Bonino da Campione: Monument to Bernabo Visconti. Effigy before 1363, sarcophagus probably later. Castello Sforzesco, Milan.

202 Bonino da Campione: Monument to Cansignorio della Scala. Completed by 1374. Sta Maria Antica, Verona.

203 The Hours of Blanche of Savoy by Giovanni Benedetto da Como. Miracle at Cana. Between 1350 and 1378. $7\frac{5}{8} \times 4\frac{3}{4}$ ($19\cdot3 \times 12\cdot0$). Bayerische Stadtsbibliothek, Munich. Ms 23215 f.126v.

204 Michelino da Besozzo: Elogium on Giangaleazzo Visconti by Pietro da Castelleto 1403. $14\frac{3}{4} \times 9\frac{1}{2}$ ($37\cdot6 \times 24\cdot2$). Bibliothèque Nationale, Paris. Ms Cat.5888 f.1.

205 Giovannino dei Grassi: Offiziolo Visconti. Flight into Egypt. Begun c. 1380. $4\frac{1}{8} \times 4\frac{1}{3}$ ($11\cdot0 \times 10\cdot4$). Biblioteca Nazionale, Florence. Fondo Landau-Finaly n.22. f.25v.

Index